PREVENTING VIOLE
WOMEN AN

Educational work with children
and young people

Edited by Jane Ellis and Ravi K. Thiara

(2015)

P P

First published in Great Britain in 2014 by

Policy Press
University of Bristol
1-9 Old Park Hill
Clifton
Bristol BS2 8BB
UK
t: +44 (0)117 954 5940
pp-info@bristol.ac.uk
www.policypress.co.uk

North America office:
Policy Press
c/o The University of Chicago Press
1427 East 60th Street
Chicago, IL 60637, USA
t: +1 773 702 7700
f: +1 773 702 9756
www.press.uchicago.edu
sales@press.uchicago.edu

Reprinted 2015

British Library Cataloguing in Publication Data
A catalogue record for this book is available from the British Library

Library of Congress Cataloging-in-Publication Data
A catalog record for this book has been requested

ISBN 978 1 44730 731 0 paperback
ISBN 978 1 44731 859 0 hardcover

Cover design by Policy Press
Front cover illustration kindly supplied by www.alamy.com
Printed and bound in Great Britain by CPI Group (UK) Ltd, Croydon, CR0 4YY
Policy Press uses environmentally responsible print partners.

To Sophie and Matthew [JE]

To Maanuv, Jyoi and Bhavan [RKT]

and for those who work tirelessly to challenge
violence in all its forms

Contents

List of tables and figures

Notes on contributors

Peter Aggleton is Strategic Professor in Education and Health in the Centre for Social Research in Health at UNSW Australia. He holds visiting professorial positions at several UK universities. His work focuses on sexuality, gender, youth, health and education. He is Editor-in-Chief of three international journals (*Culture, Health & Sexuality*, *Sex Education* and the *Health Education Journal*). Together with Sally Power (Cardiff University) and Michael Reiss (Institute of Education, University of London), he jointly edits the Foundations and Futures of Education series of books published by Routledge.

Michelle Barry worked as lead practitioner at the Star Project, the education and outreach initiative of Southampton Rape Crisis (SRC) from 2000 to 2014. She holds a Masters in Youth and Community Work and received an Outstanding Award for best practice in PSHE delivery from the Department for Education in 2010. She is an associate trainer for the sexual health charity, the Family Planning Association (FPA), and continues to provide training and consultancy on a freelance basis on Sex and Relationships Education (SRE).

Christine Barter is an NSPCC Senior Research Fellow at the School for Policy Studies, University of Bristol. She has published widely on a range of children's welfare issues including children who run away, protecting young people from racism and racial abuse, boys' use of advice and counselling services, and institutional abuse and peer violence in residential children's homes. Her most recent work has focused on violence and control in teenage intimate relationships. She has acted as a consultant for the Home Office since 2009 and presented findings to a wide range of inquiries and commissions. Christine has recently co-edited a book on peer violence between children and young people entitled *Children Behaving Badly?* for Wiley. She is currently leading on a European research project focusing on the use of new technologies in young people's relationships.

Anita Bhardwaj is a development consultant, coach and facilitator. She has created highly successful and recognised support projects

working for some of the most pioneering women's groups in the country (Southall Black Sisters, Women and Girls' Network, Newham Asian Women's Project and EACH – Ethnic Alcohol Counselling in Hounslow). As a Feminist, her passion is to provide empowering projects that address issues of inequality and injustice both at a community and strategic campaigning level. Anita was the project worker at Southall Black Sisters, delivering the Prevention in Schools Project. Her experience has informed her belief that investing and supporting young people to develop an alternative understanding and definition of gender and equality is essential in truly realising an end to violence against women and girls.

Maddy Coy is Deputy Director of the Child and Woman Abuse Studies Unit (CWASU) and a Reader in Sexual Exploitation and Gender Inequality at London Metropolitan University. Prior to becoming a researcher, Maddy worked for several years with sexually exploited girls and women. She has published a number of articles and book chapters on the sex industry, including links between local authority care and sexual exploitation, women's experiences of selling sex and men's motivations for buying sex. More recently Maddy has focused on developing a gendered analysis of sexualised popular culture, including how this might be addressed in policy approaches and everyday practice with young people. She also coordinates, and teaches on, CWASU's MA in *Woman and Child Abuse*. A full list of Maddy's publications on sexual exploitation and sexualised popular culture can be found at www.cwasu.org.

Jane Ellis is Senior Lecturer in Social Policy at Anglia Ruskin University and Senior Research Fellow at the University of Central Lancashire where she is involved in the PEACH Project, a scoping review of evidence on preventive interventions in domestic abuse for children and young people in the general population. Previously she has conducted research and consultancy on prevention work in schools for voluntary organisations and government, and was a member of the DCSF/DfE Advisory Group on Violence Against Women and Girls. She has written a number of publications on violence prevention. Before undertaking her PhD, she worked with children, young people and their families in formal and non-formal educational settings as a teacher and community education worker.

Carlene Firmin is Head of the MsUnderstood Partnership and Research Fellow at the University of Bedfordshire, running a three year project on peer-on-peer abuse in young people's relationships and peer groups. For two years, Carlene was the Principal Policy Advisor to the Office of the Children's Commissioner's Inquiry into child sexual exploitation in gangs and groups, and she acts as an advisor to them on these issues. Carlene writes a monthly column in Society Guardian, and has had a number of papers published in academic books and journals. She authored the Female Voice in Violence reports and for five years researched the impact of criminal gangs on women and girls at the charity Race on the Agenda. Following this, Carlene took up the post of Assistant Director of Policy and Research at children's charity Barnardo's with responsibility for youth justice and child sexual exploitation. In 2010, she founded 'The GAG Project' to train young women to influence policy on gangs and serious youth violence. In 2011 she was awarded an MBE for services to Women and Girls' Issues in the New Years' Honours list.

Pattie Friend: After teaching in secondary schools for nearly 20 years, Pattie has spent the last 17 years working in the field of domestic violence as a front line worker, Domestic Violence Co-ordinator and as a consultant. She currently works for the London Borough of Hounslow Early Intervention Service and has been responsible for establishing and developing the Learning to Respect Domestic Violence Education Programme, now in its tenth year. The programme received the Mayor of London award in November 2005 for furthering the aims and objectives of the London Domestic Violence Strategy, and it has been variously cited as an example of good practice in domestic violence prevention.

Chris Greenwood was the lead local authority education officer for child protection working in Cheshire for over 37 years. In her role as Safeguarding Manager for Schools and Settings, she managed a team of education professionals specialising in providing services to facilitate the protection of vulnerable young people. Their education programmes aimed to empower, support and protect those affected by domestic abuse. The team produced teacher resource packs including *Heartstrings*, *Standing By*, and *Out of Harm's Way*. Their work was acclaimed as an example of best practice in DA prevention

and was nominated for several national awards including the Emma Humphreys Memorial Prize and Community Care Award. They won the David Bromham Memorial Award given for work which through inspiration, innovation or energy has furthered the practice of sexual and reproductive health.

Claire Maxwell is a senior lecturer in the sociology of education in the Department of Humanities and Social Sciences at the Institute of Education, University of London. Her research interests focus on young femininities, the concept of agency, and the promotion of gender equality in schools. She has held two UK Economic and Social Research Council grants for studies on young women, agency and privilege. Claire has also worked with two national UK organisations who have led school-based initiatives to challenge violence against women and girls. Her most recent book is *Privilege, Agency and Affect* (2013).

Jo Pearce is CEO of Southampton Rape Crisis services and a Group Analytic Psychotherapist for Southern Health NHS Trust. Having worked previously in a variety of voluntary sector, learning disability, mental health, substance misuse and youth service settings, she has extensive experience of developing, managing and delivering prevention, advocacy and therapeutic services for adults, adolescents, families and children that attempt to interrupt patterns of violence and abuse in family and social systems. In recent years she has been actively involved with local partners, including Southampton City Council Safer Communities Team, Southampton & West Hampshire Police Serious Sexual Offences Reduction Group and the PIPPA Alliance of Domestic and Sexual Abuse Services, in progressing a more collaborative, joined-up and strategic approach to understanding and reducing offending behaviour and its impact.

Hannana Siddiqui has worked for Southall Black Sisters (SBS) for 26 years, and she has been working in the field of race, gender and human rights for 30 years. She has done extensive work on violence against black and minority ethnic women and girls, including domestic violence, forced marriage and honour-based violence, and inter-related issues of suicide, self-harm, immigration and no recourse to public funds. She has been involved in some high profile

campaigns of battered women who kill which reformed the law on provocation in 1992 and helped introduce the Domestic Violence Immigration Concession (1999) and the Destitution Domestic Violence Concession (2012). She was an original member of the Home Office Working Group on Forced Marriage (1999–2000), and worked with Lord Lester to introduce the Forced Marriage (Civil Protection) Act 2007 and to found the End Violence against Women coalition (2005) and Women Against Fundamentalism (1989). She has published widely, including a recent co-edited book entitled *Moving in the Shadows: Violence in the Lives of Minority Women and Children* (2013). Hannana was the supervisor for the SBS Schools' Prevention Project.

Nan Stein is a Senior Research Scientist at The Center for Research on Women at the Wellesley Centers for Women, Wellesley College in Wellesley, Massachusetts, USA. She has conducted research on teen dating violence, sexual harassment, and gender violence in kindergarten to 12th grade (K-12) schools for over 30 years, and she has published teachers' guides on sexual harassment, bullying, and gender violence as well as many book chapters, and also many articles for law reviews, academic journals, and the educational press. She has served as an expert witness in multiple lawsuits about sexual harassment in schools. In 2007, she received the Outstanding Contribution to Education award from her *alma mata*, the Harvard University Graduate School of Education.

Ravi K. Thiara is Principal Research Fellow in the Centre for the Study of Safety and Wellbeing, University of Warwick. Over the last 25 years, she has conducted extensive research and evaluation, training and service development in the violence against women field, in the UK and overseas. She has a particular interest and expertise in violence against women and children in black and minority ethnic communities and issues for abused disabled women. She teaches and supervises PhD students on gendered violence and has published widely. She has also conducted research on the Indian diaspora in South Africa, bride price and poverty in Uganda, and black and minority ethnic young people in the UK.

Leslie Tutty is a Professor Emerita with the Faculty of Social Work at the University of Calgary, Canada, where she taught courses in both clinical social work methods and research. Over the past 25 years, her research has focused on prevention programmes and services for intimate partner violence and child abuse, including a number of evaluations of shelter and post-shelter programmes for abused women, support groups for abused women, treatment for adult and child victims of sexual abuse and groups for men who abuse their partners. She has authored or co-authored four books, over 45 peer-reviewed journal articles, 90 research reports and 58 book chapters. From 1999 to 2011, Leslie served as the Academic Research Co-ordinator of RESOLVE Alberta, a tri-provincial research institute on family violence.

Acknowledgements

This book would not have been possible without the commitment of all the contributors and we thank them for embracing this project with great enthusiasm, especially those for whom it was not part of their 'day job' and a new challenge. Many people have been supportive to us in this venture and we want to thank all those who have given us the space to talk about some of our ideas and dilemmas. Finally, we want to thank Policy Press, and Rebecca Tomlinson in particular, for their patience and guidance.

Foreword

by Emeritus Professor Audrey Mullender

This is an important book. It should be read by all teachers, youth workers, social workers and, indeed, anyone who comes into contact with children and young people. All politicians and the general public should read it, too, in order to gain a better understanding of the world in which young people these days are seeking to thrive or at least to survive. Without an appreciation of the pressures upon them and the dangers they face, how can we hope to offer the younger generation our protection, support or help with recovery if the worst does happen to them?

During my academic career, when I was actively researching violence against women and children, I was often asked how I could bear to work in such a painful area. Certainly, there were times when I wept over my computer, so harrowing were the accounts that were shared with our teams in research interviews. Yet two factors outweighed this. First was the privilege of encountering the enormous strength and resilience of survivors. One young man, for example, insisted on carrying on with his interview, through tears, in a fervent wish to enable others to benefit from his experiences. He trusted us to listen, learn and do all we could to bring about change. Consequently, the second factor that motivated us was the crucial challenge of attempting to find out what we could do about violence and abuse: what would help those on the receiving end; what would make the abusers stop; and, the Holy Grail, what would stop abuse from happening in the first place. This book focuses on the last of these goals – primary prevention – and demonstrates that there are indeed many inspiring projects already in place over a wide geographical area, tackling a range of forms of violence and abuse against women and girls. Critically, all the projects outlined in the chapters that follow place gender at the heart of their work and give

us reason to hope that, with our help, both young men and young women may learn a new way of relating in the future.

This is certainly needed. In our research, colleagues and I discovered that one in three secondary-age boys we questioned believed that some women deserve to be hit while, even among girls, one in five agreed with this chilling statement. Boys' attitudes hardened as they got older, peaking at two-fifths of the 15- to 16-year-olds taking this view, whereas the older girls moved away just a little from woman-blaming (Mullender et al, 2002, p 70). We concluded from these findings that preventive work in schools needs to start as early as possible, ideally in junior school or certainly at the beginning of secondary school.

This book's concluding comments show that anyone with the right ideas and a modicum of energy can assist in this endeavour. If you find the right partners and allies, prepare the ground, involve people with the necessary groupwork skills and work to clearly defined principles, then change really is possible. So I urge you to read on, take courage from what others have achieved – often against the odds – and, like them, become part of the solution rather than part of the problem.

Reference

Mullender, A., Hague, G., Imam, U., Kelly, L, Malos, E. And Regan, L. (2002) *Children's Perspectives on Domestic Violence*, London: Sage.

Introduction

Jane Ellis and Ravi K. Thiara

This collection, the first of its kind to bring together research and practice, addresses the fragmentary knowledge base on prevention work in schools on violence against women and girls (VAWG)[1] at a time when it has received unprecedented attention. It arose out of conversations that took place between the editors about the absence of a wider critical conversation, and the lack of a discursive space, about school-based prevention work with children and young people and indeed about prevention itself – what it is, how and if it can be achieved, why is it desirable, what assumptions it makes about schools, and what view of children and young people it adopts and extends. The editors were very aware of the absence of a body of work that brought together knowledge about the disparate, and often exciting, school-based work taking place in many parts of the country. Such a body of work could also reflect on the many dilemmas and challenges faced by those at the cutting edge of developing this work and how these have been, if at all, addressed. Through drawing together researchers and practitioners in a conversation for the first time, this collection highlights the important work that has been developed thus far in this area and raises, and responds to, some of the questions that might be encountered by those seeking to take this work forward in the future. While the majority of contributors are drawn from the UK, we have included contributions from elsewhere on issues not yet written about in the UK to extend the critical conversation.

VAWG is widely considered a major social problem, the prevalence and universality of which is well documented (Abramsky et al, 2011; Council of Europe, 2011; WHO, 2013). The United Nations defines VAWG as 'any act of gender-based violence that results in, or is likely to result in, physical, sexual or psychological harm or suffering to women, including threats of such acts, coercion or

1

arbitrary deprivation of liberty, whether occurring in public or in private life' (United Nations General Assembly Resolution 48/104 *Declaration on the Elimination of Violence against Women*, 1993). Whilst all forms of VAWG are highly under-reported, the most commonly reported and recorded forms in the UK are domestic violence, rape and sexual assault, and sexual harassment. Issues of sexual exploitation, sexual trafficking, female genital mutilation (FGM), forced marriage, violence committed in the name of so-called 'honour', and femicide have also received increased attention over recent years, and there is now a growing evidence base on these issues. Although VAWG is considered to affect all sections of society, there is recognition that it may impact differently on different groups of girls and young women, some of whom might be rendered more vulnerable as a result of their dis/location in or from society, though the explanations for why this is so continue to be contested. The editors view VAWG as being rooted in gendered power relations (resulting in gender inequality) that also intersect with other axes of power and inequality and serve to re/produce particular experiences and responses along these axes, depending on the location of women and girls (Thiara and Gill, 2010; Rehman et al, 2013).

Although there is an increasing debate about 'gender symmetry' in the perpetration and victimisation of intimate partner violence, which we will not rehearse here, VAWG is overwhelmingly, though not exclusively, enacted by men and boys (Walby and Allen, 2004; Barter et al, 2009; WHO, 2013). While men and boys are also victims of violence, it is women and girls who are disproportionately affected, something clearly highlighted in Hester's (2009) examination of 'who does what to whom?' and also discussed by some authors in this book. This shows that men perpetrate abuse of greater intensity and severity and are more likely to be repeat perpetrators of intimate partner violence whilst women are more likely to experience fear (Hester, 2009).

It is an undisputed reality that significant numbers of girls and young women experience some form of gender-based violence by the time they are 18 years old (Forward, 2007; Radford et al, 2011; Office for National Statistics, 2013; FRA [European Union Agency for Fundamental Rights], 2014). The most recent national prevalence study of child maltreatment suggests that one in seven are affected by domestic violence in their parents/carers' relationship (Radford

et al, 2011) while significant numbers of children and young people experience violence in their own intimate relationships, as discussed in Chapter Three. UK research also demonstrates high levels of sexual and homophobic bullying in schools (Rivers and Duncan, 2013) and that there is 'a small, but significant group' of children and young people who display sexually harmful behaviour (Smith et al, 2013). Many children and young people experience multiple and intersecting forms of violence, something also referred to as polyvictimisation (Radford et al, 2011).

A great deal has been written about VAWG, particularly about domestic violence, and feminist research and activism has brought attention to the impact on those who experience it. Not only is physical and mental health affected but social functioning, relationships with family, friends and colleagues, capacity to parent, housing and homelessness, and financial status are compromised (Riger et al, 2002). There are also a significant number of homicides (Coleman and Osborne, 2010). Until the late 1980s the focus had been on women survivors, but at this time the consequences and implications for children began to be considered. This was not only because of the co-occurrence of domestic violence and direct child abuse (Hester and Pearson, 1998) but also because the impact was seen to be as potentially damaging as direct abuse (Jaffe et al, 1990). It is now widely recognised that children living with domestic violence are at risk of significant harm (Children and Adoption Act 2002) and that the short and long-term impact for children varies depending on a range of factors but for many the outcomes can be negative (Stanley, 2011). Initially children were positioned as 'silent witnesses' or 'hidden victims'. More recently, within shifting discourses of childhood, children have emerged on the domestic violence agenda in their own right, able to articulate their own experiences and needs and with agency to take action in protecting themselves and others (Mullender et al, 2002; Voice Against Violence, 2012). Anxieties and concerns over the impact of domestic violence on children, and other forms of violence, as well as its high social and economic costs (Walby, 2009) make a compelling case for action to stop it from happening in the first place; to prevent it, rather than reactively responding to it.

Additionally the UK is a signatory to the United Nations Convention on the Rights of the Child (UNCRC) which provides a legal imperative for educational work on VAWG. The UNCRC

stipulates that 'State Parties shall take all appropriate legislative, administrative, social and *educational* measures to protect children from all forms of physical and mental violence, ...' (1989:Article 19, para 1, emphasis added). Articles 13 and 17 concern children's right to information, particularly Article 17 which states that children shall have 'access to information and material ... especially those aimed at the promotion of [their] social, spiritual and moral wellbeing and physical and mental health' (1989:Article 17, para 1).

A brief history of VAWG[2] prevention policy and practice

Calls to prevent different forms of VAWG through educating children and young people about it in schools have been voiced by feminists and women's organisations since the 1980s. These calls, firmly rooted in promoting what was then termed 'equal opportunities' and in the context of an already established feminist movement against rape and domestic violence (Hanmer and Saunders, 1984; Hanmer and Maynard, 1987; Kelly, 1988), were mainly a response to the high levels of sexual harassment and violence that girls and women staff experienced in schools (Jones, 1985; Jones and Mahoney, 1989). Similarly, the 'Girls' Work' movement in youth work flourished in the 1970s and 1980s, encouraging young women to challenge violence through emancipatory pedagogies, as part of a claim for gender equality (Batsleer, 2013). The focus then shifted to preventing domestic violence with resources for schools appearing in the 1990s (Equalities Unit, London Borough of Islington, 1994; Morley, 1999). At the same time media campaigns targeted at adults emerged, the most well known being Edinburgh's Zero Tolerance in 1992-93 (Greenan, 2004). Many feminists promoting this work were also part of the peace movement of that time and thus involved in promoting nonviolence on many levels (Jones, 1983; Thompson, 1984). The problematisation of child sexual abuse (Parton, 1985) in the 1980s also led to campaigns against this form of violence. Often led by children's organisations, arguably this was also part of feminist activisms making public the position of women and children in the heteropatriarchal family. Concern about the short- and long-term impact of VAWG on children and young people, particularly domestic violence and child sexual abuse, began to grow at this time (Finkelhor and Browne, 1985; Jaffe et al, 1990), although with the move to a

4

neoliberal political economy, the emphasis is now on reducing harm and future spending rather than promoting or achieving gender equality (Bumiller, 2008) or children's rights.

Nonetheless, it is only recently that the prevention of VAWG through work with children and young people has firmly emerged on the national policy agendas (Home Office, 2009; HM Government, 2011, 2013). Although it appeared in earlier documents, (Home Office, 2003), it was marked by a fragmentary approach and, to date, there has never been a national prevention strategy in England, unlike Scotland (Scottish Executive, 2003). However, this absence in policy and strategy has not held back the development of work at a local level as, in 2004, some form of educational work was taking place in 102 local authority areas in England, Wales and Northern Ireland. This work had rapidly developed since 2000 and was associated with funding from initiatives such as the Children's Fund and its preventative agenda, with moves to prevent domestic violence as a crime through initiatives such as the Home Office Crime Reduction Programme Violence Against Women Initiative (2002) and the creation of local Crime and Disorder Reduction Partnerships in 1997 (Ellis, 2004), as discussed in Chapters Seven and Nine. Despite this the work was localised and fragmented, although in a few areas multiagency approaches had been developed that were led by, and embedded in, the local authority education service and reached many more schools and children and young people, as discussed in Chapters Six and Seven.

The inclusion of an education pack 'specifically designed for use in schools and with youth groups' (ODPM, 2005: 242) in the Best Value Performance Indicators for domestic violence was met with some optimism that it would lead to the development of a more widespread and comprehensive approach. However, its use was not mandatory since 'schools and youth groups cannot be forced to run a programme' (ODPM, 2005: 242). The impact of this directive on the amount or quality of prevention work with young people is unknown and its focus was only on domestic violence. Anecdotal evidence suggests there is still a piecemeal approach to work with all children and young people. At a recent domestic violence conference aimed at practitioners, which the authors attended, not one member of the 50 or so people in the audience knew of schools work in

their local areas; nor had any of their own children been given the opportunity to formally learn about it at school.

Current policy in the four UK governments varies considerably. Since 2008, the Scottish Government has developed a more joined-up approach to child welfare, education and domestic abuse working closely with the voluntary sector. Funding for a number of initiatives has been forthcoming, including the 'Prevention Network', enabling policymakers, academics and practitioners to share research and good practice. Innovative practice such as bystander education and training in high schools in Scotland has also been supported.[3] Prevention is incorporated into to the domestic abuse or VAWG policies and strategies of both the Northern Ireland Executive and the Westminster (English) government. 'Schools play a vital role in education and safeguarding and we will continue to identify ways to engage with schools and support the education of young people on healthy relationships and, in particular, raise awareness around consent.' (HM Government, 2014: 11). However, there is no distinct element or clear mandate for schools to address VAWG and it appears that it is left down to individual schools to act. At a ministerial level, the Department for Education remains noncommittal (EVAW, 2013). There is very little specific 'how to' guidance, with the exception of Women's Aid Northern Ireland Federation (2005) and Debbonaire and Sharpen (2008). On a positive note, since 2010 the Home Office has funded the national 'This is Abuse' media campaign aimed at young people[4]. Still, the boldest move is the proposal by the Welsh Government to mandate all schools in Wales to incorporate domestic abuse prevention into the curriculum; laid out in the 2012 White Paper this is due to come into law in 2014 and we are to see how this will be implemented.

Outline of the book

The book begins with a consideration of prevention, which is rarely discussed since it is taken for granted that we know what it is and that it is a 'good thing' (Freeman, 1992: 41). Freeman went on to note in his analysis of prevention in health that 'being for prevention is the health political equivalent to being against sin … it is a political promise with a strong utopian aspect: successful prevention might mean a world without disease, crime, unemployment or poverty'

(1992: 41). It is possible to add a host of other issues regarded as social problems, including VAWG, to Freeman's list. The term 'prevention' has circulated in discourses of justice and welfare since the late 19th century with the Children Act 1948 considered the beginning of the contemporary debate about it (Hardiker et al, 1991). There is, however, no history of its overt use in educational discourses, yet education has been harnessed as a strategy for prevention in health (Petersen, 1996; Khambalia et al, 2012), child abuse (Finkelhor, 1986; Bagley et al, 1996; Topping and Barron, 2009), crime (HO, 2004; Ross et al, 2011) and family support, where it manifests itself mostly as parenting programmes (Pugh et al, 1994; HO, 1998; Lindsay et al, 2011).

Ellis, in Chapter One, explores the public health and prevention science models, which have come to dominate the contemporary theory and practice of prevention, and considers the complexities of working to end VAWG within these frameworks. The public health model of primary, secondary and tertiary levels is widely used in violence prevention (Krug et al, 2002; Department of Health (DH), 2009) though the use of 'prevention' usually refers to the primary level (HO, 2009; HMG, 2013) which is a stage prior to the onset of a problem. Ordinarily, primary prevention, the focus of this book, would encompass activities such as work in schools with children and young people, public education and social marketing campaigns, bystander education and community initiatives. Rarely is there debate about prevention per se and yet how it is conceptualised shapes policy, practice, funding for, and research in, interventions labelled as such. Beyond the dilemmas and challenges that the dominant models raise, there are a number of contested issues in prevention work on VAWG in schools, and it is to these debates in theory, policy and practice, briefly discussed below, that we hope this book will make a contribution.

Gender

The significance of gender in explanations of and in work to prevent VAWG is one of the most controversial and yet key areas in prevention work. How the 'cause' of VAWG is understood by those commissioning, designing and delivering prevention work is crucial since it shapes the approach, content, methods of delivery

and outcomes of prevention and its evaluation. Whilst most of the contributors to this book take the gendered nature of VAWG as a starting point and base their approach on feminist theory, there are numerous competing explanations. Broadly, these can be grouped into bio/psycho/social, feminist/profeminist and multivariate. The first, derived from a vast range of academic disciplines and theories, including biology, psychoanalysis, social learning theory and family systems theory, mostly locates VAWG in individual or family pathology. Feminist discourses, on the other hand, locate cause in differential power relations, where VAWG is viewed as an outcome of, and serves, too, to reinscribe gender inequality (Radford et al, 1996). Multivariate approaches, principally the ecological model (Heise, 1998; Krug et al, 2002), dominate the public health approach to VAWG prevention (see Chapter One). In Chapter Two, Tutty, drawing on work in Canada where there is a much longer history of VAWG prevention than in the UK (Hague et al, 2001), discusses gender in the context of a number of forms of VAWG and chronicles how these developed over time in response to the emergence of each as a 'social problem'. She concludes that a gendered analysis and a strong feminist perspective are crucial in understanding VAWG and how prevention work is approached.

In Chapter Three, Barter presents the findings of research on violence in young people's intimate relationships. Significant numbers of young people experience some form of abuse with greater numbers of girls than boys reporting sexual, physical and emotional violence. Whilst this raises issues for safeguarding it also makes a compelling case for prevention work which both reflects and addresses the gendered aspects of violence. The implications of the research evidence for schools are explored in the latter part of the chapter.

Challenging cultural justifications and diversity

While a broad agreement exists in the literature that prevention work should target both boys/young men and girls/young women (Carmody et al, 2009; Flood et al, 2009; Weisz and Black, 2009), there are differing ideas about the age of children with which to undertake school-based work and a consensus is yet to emerge (O'Brien, 2001; Tutty et al, 2005; Foshee et al, 2009). In the UK, there has been less

discussion about nuanced approaches to particular groups of children and young people and the intersection of gender with class, disability, sexuality and ethnicity. In Australia, and to some extent in North America, there is some recognition of the heterogeneity of young people, with work being targeted at specific groups (Indermaur et al, 1998; Jaycox et al, 2006; State of Victoria, 2012). Flood et al maintain that 'Good practice programs are informed *in all cases* by knowledge of their target group or population and their local contexts' (2009: 55, emphasis added), otherwise work risks being irrelevant, unacceptable, discriminatory or dangerous (Carmody et al, 2009). Such work provides valuable insights for those in the UK. In relation to prevention work with children and young people from black and minority ethnic (BME) backgrounds, the numerous questions raised include: how should prevention work be developed in schools where the overwhelming majority of students are from such backgrounds; should this work be different to that done with other students; and should issues of the cultural specificity of VAWG – forced marriage, honour based violence and female genital mutilation, for instance – be incorporated into wider VAWG prevention work or does it require specific attention? In Chapter Four, Siddiqui and Bhardwaj discuss a whole school initiative aimed at addressing violence against BME women in schools with a majority of BME students, and they provide a useful reflection about the possibilities and challenges of developing such work.

Whole school approach

Some prevention programme developers stress the importance of a whole school approach (WSA) in order to change school culture and to create an ethos where violence, including gender violence, is not tolerated (Thurston et al, 1999; Flood et al, 2009; Ollis, 2011). A whole school approach is widely adopted in the UK to help children and young people learn about many issues including health, bullying and, more broadly, values and affective education. It is an appropriate strategy for addressing VAWG since where violence is viewed as socially and culturally produced, rather than as an individual problem, challenges to school culture seem essential, if for no other reason than that schools are not safe places for children (EVAW, 2012; Rivers and Duncan, 2013). Additionally, evidence suggests short instructional

programmes are ineffective (Dusenbury et al, 1997; Nation et al, 2003; Flood et al, 2009). In Chapter Five, Maxwell and Aggleton discuss the WSA and, by drawing on the work of Pierre Bourdieu, provide a theoretical framework for it and discuss its implementation in five schools in England and Wales.

Engaging schools, sustaining the work

One of the key challenges for school-based work frequently cited, both anecdotally and in research, is in engaging schools. VAWG prevention can help schools with other aspects of their work such as safeguarding, gender equality and in fulfilling their duty to 'promote[s] the spiritual, moral, cultural, mental and physical development of pupils' (Education Act 2002: Part 6, section 78); however, as noted earlier, there is no clear policy mandate (in England) for schools to address it and little 'how to' guidance. Where VAWG is addressed, it is mostly in personal, social and health education (PSHE) where more general but relevant material is available from nongovernmental organisations, for example, the PSHE Association and Sex Education Forum. Furthermore, one of the most frequently mentioned barriers is teacher's anxieties about eliciting disclosures of maltreatment and their feeling ill-equipped to manage these. Despite this, three examples of how these barriers have been overcome are discussed in Chapters Six, Seven and Eight (Friend, Greenwood, and Barry and Pearce respectively). Each has implemented a distinct model of working and 'hooked' on to different agendas for schools; however, all share having a dedicated post to lead the work and have worked flexibly in responding to schools. Each has successfully sustained work over a period of up to 10 years in the majority of schools in their areas. This is indeed an achievement given the changing and arguably diminishing space in schools for work with a non-academic focus, the fact that PSHE is non-statutory and the extent and quality of it varies, (Formby et al, 2011) and given that the reported average length of time programmes ran was two years (Ellis, 2004).

Beyond domestic violence and schools

In 2004, the majority of school-based work addressed domestic violence (82%) with 40% of programmes also covering 'dating

violence'[5] (Ellis, 2004). At that time, very few programmes included other forms of VAWG although a small number reported pornography (5%) and prostitution (7%) as their main focus. Since that time, however, there has been a shift in the focus of prevention work to other forms of violence viewed to be issues encountered by children and young people (EVAW, 2011), echoing developments in Canada discussed in Chapter Two. Barry and Pearce, in Chapter Eight, discuss the need for and implementation of work focusing on rape and sexual violence led by a specialist voluntary sector organisation. In Chapter Nine, Thiara and Coy make a similar argument and present findings from an evaluation of work on sexual exploitation. Firmin, in Chapter Ten, presents a discussion of a project involving young women in the development of policy to address girls and young women associated with gangs and the violence they experience. The latter, again using the work of Bourdieu, makes the case for working with young women in ways which empower them and which result in services being more relevant to them. All three programmes recognise that some children and young people are outside, or on the margins of, the school system and attention needs to be paid to them, particularly as they can be especially targeted for violence and abuse (Radford et al, 2011). To some extent, this has resulted in prevention work through alternative education provision (eg, pupil referral units) but also in community settings, such as young people's centres, where more participatory approaches can be used than is often possible in schools.

Evidence-informed practice

There are very few published evaluations of VAWG prevention in the UK, with the exception of those published by Bell and Stanley (2006), Wan and Bateman (2007) and Fox et al (2013).[6] This reflects the fact that only a small amount of work is rigorously evaluated unlike in North America, where there is a substantial evaluation literature, particularly on 'dating violence'. Stein, in Chapter Eleven discusses the rationale for, and use of, a randomised control trial (RCT) in the evaluation of a schools programme. In North America particular methodologies of evaluation prevail, such as quasi-experimental and RCTs which are seen as the 'gold standard' for evaluating interventions.[7] This reflects the dominance of the public

health and prevention science model. Nonetheless, the editors were keen to include an example of such an evaluation since the evidence generated by these particular methodologies is increasingly demanded by funders and policymakers. In the UK qualitative approaches are most often used in evaluation, but are considered, by some, as less rigorous in the hierarchy of knowledge production. Consequently, what is viewed as a lack of 'evidence' has proved to be a stumbling block to obtaining funding for initiatives and their evaluation. The dilemma is that without funding the opportunities to generate evidence to support claims for prevention work are limited and so the debate continues. Emphasis on quantitative evaluation should not diminish the knowledge and insights already produced from the experience of practitioners at a local level or from qualitative methods. Prevention science and public health models demand measurable outcomes to evidence effectiveness in relation to the impact of prevention work on children and young people. Yet not only is VAWG a complex and seemingly intractable issue which reinvents itself in a rapidly changing world but learning is a complex and dynamic process. Schools are complex social organisations – communities within wider communities – where learning cannot always be predicted, shaped as it is by the knowledge and experience children and young people bring to it, amongst myriad other factors.

What is clear in the history of VAWG prevention through education in the UK, and as highlighted by this collection, is that practice, driven by committed and enthusiastic professionals, has preceded policy and research in this area. It is knowledge gained from examples of this practice, along with research, that is presented in this book. At a time when greater attention is focused on prevention work, we hope that this collection will help and inspire others to continue the critical conversation started by the contributors here.

Notes

[1] Definitions of VAWG prevention are rarely offered however Hester and Westmarland propose the following: 'a long-term strategy preventing violence from ever happening by changing attitudes, values and structures that sustain inequality and violence' (2005:15). Whilst adopting this definition we note that it draws on the public health model of prevention, of which we present a critique.

[2] Until 2009, the main focus of policy and legislation had been domestic violence and to a lesser extent rape and sexual assault; the publication of

'Together we can end violence against women and girls' (Home Office, 2009) marked the first integrated approach to addressing multiple forms of VAWG.

[3] Information available at www.actiononviolence.co.uk/content/vrus-mentors-violence-prevention-project-be-rolled-out-across-scotland

[4] http://thisisabuse.direct.gov.uk/

[5] Violence in young people's intimate relationships, see Barter et al (2009) for discussion of these terms.

[6] The PEACH Study, a scoping review of effective interventions to prevent domestic abuse, funded by the National Institute for Health Research, Public Health Programme, will be published in 2015 (Stanley et al, forthcoming). The study has identified and synthesised the evidence on effectiveness, cost-effectiveness and acceptability of preventive interventions addressing domestic abuse for children and young people under 18 in the general population.

[7] There is some debate in the US about the dominance of PH and prevention science, see Tharp et al (2011) and Foubert (2011).

References

Abramsky, T., Watts, C., Garcia-Moreno, C., Devries, K., Kiss, L., Ellsberg, M., Jansen, H. and Heise, L. (2011) 'What factors are associated with recent intimate partner violence? Findings from the WHO multi-country study on women's health and domestic violence', *BioMed Central Public Health*, 11: 109. Available: www.biomedcentral.com/1471-2458/11/109

Bagley, C. and Thurston, W. with Tutty, L. (1996) *Understanding and preventing child sexual abuse: critical summaries of 500 key studies: Volume 1 Children: Assessment, social work and clinical issues, and prevention education*, Aldershot: Arena/Ashgate Publishing.

Barter, C., McCarry, M., Berridge, D. and Evans, K. (2009) *Partner exploitation and violence in teenage intimate relationships*, NSPCC/University of Bristol. Available: www.nspcc.org.uk/inform/research/findings/partner_exploitation_and_violence_report_wdf70129.pdf

Batsleer, J. (2013) *Youth working with girls and women in community settings: A feminist perspective* (2nd edn), Abingdon, Oxon: Ashgate.

Bell, J. and Stanley, N. (2006) 'Learning about domestic violence: young people's responses to a Healthy Relationships programme' *Sex Education*, 6(3): 237-250.

Bumiller, K. (2008) *In an abusive state: How neoliberalism appropriated the feminist movement against sexual violence*, Durham and London: Duke University Press.

Carmody, M., Evans, S., Krogh, C., Flood, M., Heenan, M. and Ovenden, G. (2009) *Framing best practice: National Standards for the primary prevention of sexual assault through education: National Sexual Assault Prevention Education Project for NASASV*, Australia: University of Western Sydney.

Coleman, K. and Osborne, S. (2010) 'Homicide' in K. Smith et al (eds), *Homicides, firearm offences and intimate violence 2008/09: Supplementary Volume 2 to Crime in England and Wales 2008/09*. Home Office Statistical Bulletin 01/10. Available webarchive.nationalarchives.gov.uk/20110218135832/rds.homeoffice.gov.uk/rds/pdfs10/hosb0110.pdf

Council of Europe (2011) *Council of Europe Convention on preventing and combating violence against women and domestic violence: Explanatory report*, Strasbourg: Council of Europe. Available: www.coe.int/t/dghl/standardsetting/equality/03themes/violence-against-women/Exp_memo_Conv_VAW_en.pdf

Debbonaire, T. and Sharpen, J. (2008) *Domestic violence prevention work: Guidelines for minimum standards*, London: Respect and Greater London Domestic Violence Project.

Department of Health (2009) *Improving safety, reducing harm: Children, young people and domestic violence*, London: TSO.

Dusenbury, L., Falco, M., Lake, A., Brannigan, R. and Bosworth, K. (1997) 'Nine critical elements of promising violence prevention programs', *Journal of School Health*, 67(10): 409-14.

Ellis, J. (2004) *Preventing violence against women and girls: A study of educational programmes for children and young people*, London: Womankind Worldwide.

EVAW (End Violence Against Women) (2011) *A different world is possible: Promising practices to prevent violence against women and girls*, London: EVAW.

EVAW (2012) *Interim findings of Bristol secondary schools survey on violence against women and girls*. Available www.endviolenceagainstwomen.org.uk/data/files/resources/50/Bristol-report-Schools-Safe-4-Girlsx.pdf

EVAW (2013) *Deeds or words? Analysis of Westminster Government action to prevent violence against women and girls*, London: EVAW.

Finkelhor, D. (1986) 'Prevention: a review of programs and research' in Finkelhor, D. with Araji, S. (eds) *A sourcebook on child sexual abuse*, London: Sage.

Finkelhor, D. and Browne, A. (1985) 'The traumatic impact of child sexual abuse: A conceptualization', *American Journal of Orthopsychiatry*, 55(4): 530-41.

Flood, M., Fergus, L. and Heenan, M. (2009) *Respectful relationships education. Violence prevention and respectful relationships education in Victorian secondary schools*, Melbourne: Department of Education and Early Childhood Development.

Formby, E., Coldwell M., Stiell, B., Demack, S., Stevens, A., Shipton, L., Wolstenholme, C. and Willis, B. (2011) *Personal, Social, Health and Economic (PSHE) Education: A mapping study of the prevalent models of delivery and their effectiveness*, London: Department of Education.

Forward (2007) *A statistical study to estimate the prevalence of female genital mutilation in England and Wales*, London: Forward.

Foshee, V.A., Reyes, H. and McNaughton, L. (2009) 'Primary prevention of adolescent dating abuse perpetration: When to begin, whom to target, and how to do it', in Whitaker, D.J. and Lutzker, J. R. (eds) *Preventing partner violence: Research and evidence-based intervention strategies*, Washington, DC, US: American Psychological Association, pp 141-68.

Foubert, J. D. (2011) 'Answering the questions of rape prevention research: A response to Tharp et al. (2011)', *Journal of Interpersonal Violence*, 26(1): 3393-402.

Fox, C., Hale, R. and Gadd, D. (2014) 'Domestic abuse prevention education: listening to the views of young people' *Sex Education: Sexuality, Society and Learning*, 14(1): 28-41.

FRA (European Union Agency for Fundamental Rights) (2014) *Violence against women: An EU-wide survey*. Available http://fra.europa.eu/en/publication/2014/vaw-survey-main-results

Freeman, R. (1992) 'The idea of prevention: a critical review' in Scott, S., Williams G., Platt, S. and Thomas, H. (eds) *Private risks and public dangers*, Aldershot: Avebury.

Greenan, L. (2004) *Violence against women: A literature review*, Edinburgh: Scottish Executive.

Hague, G., Kelly, L. and Mullender, A. (2001) *Challenging violence against women: The Canadian experience*, Bristol: Policy Press.

Hanmer, J. and Maynard, M. (1987) (eds) *Women, violence and social control*, Basingstoke: Macmillan

Hanmer, J., and Saunders, S. (1984) *Well-founded fear: A community study of violence to women*, London: Hutchinson.

Hardiker, P., Exton, K. and Barker, M. (1991) *Policies and practices in preventive child care*, Aldershot: Avebury.

Heise, L. (1998) 'Violence against women: An integrated, ecological framework', *Violence Against Women*, 4(3): 262-90.

Hester, M. (2009) *Who does what to whom? Gender and domestic violence perpetrators*, Bristol: University of Bristol in association with the Northern Rock Foundation.

Hester, M and Pearson, C (1998) *From periphery to centre: Domestic violence in work with abused children*, Bristol: Policy Press.

Hester, M. and Westmarland, N. (2005) *Tackling domestic violence: Effective interventions and approaches.* Home Office Research Study 290, London: Home Office.

HM Government (2011) *Call to end violence against women and girls: Action plan,* London: Cabinet Office.

HM Government (2013) *Call to end violence against women and girls: Action plan 2013,* London: HMG.

HM Government (2014) *Call to end violence against women and girls: Action plan 2014,* London: HMG.

Home Office (1998) *Supporting families: A consultation document,* London: Home Office.

Home Office (2003) *Safety and justice: The Government's proposals on domestic violence.* Available http://webarchive.nationalarchives.gov. uk/20131205100653/http://www.archive2.official-documents. co.uk/document/cm58/5847/5847.pdf

Home Office (2004) *The role of education in enhancing life chances and preventing offending*, London: The Stationery Office.

Home Office (2009) *Together we can end violence against women and girls*, London: Home Office.

Indermaur, D., Atkinson, L. and Blagg, H. (1998) *Working with adolescents to prevent domestic violence: Rural town model*, Canberra: National Crime Prevention. Available https://www.socrates.uwa.edu.au/Pub/ PubDetailView.aspx?PublicationID=406577

Jaffe, P.G., Wolfe, D.A. and Wilson, S. (1990) *Children of battered women,* Thousand Oaks, CA: Sage Publications.

Jaycox, L.H., McCaffrey, D., Eiseman, B., Aronoff, J., Shelley, G.A., Collins, R.L. and Marshall, G.N. (2006) 'Impact of a school-based dating violence prevention program among Latino teens: Effectiveness trial', *Journal of Adolescent Health*, 39(5): 694-704.

Jones, C. (1985) 'Sexual tyranny in mixed schools' in Weiner, G. (ed) *Just a bunch of girls*, Milton Keynes: Open University Press.

Jones, C. and Mahony, P. (eds) (1989) *Learning our lines: Sexuality and social control in education*, London: Women's Press.

Jones, L. (ed) (1983) *Keeping the peace*, London: Women's Press.

Kelly, L. (1988) *Surviving sexual violence*, Cambridge: Polity Press.

Khambalia, A.Z., Dickinson, S., Hardy, L.L., Gill, T. and Baur, L.A. (2012) 'A synthesis of existing systematic reviews and meta-analyses of school-based behavioural interventions for controlling and preventing obesity', *Obesity Reviews*, 13(3): 214-33.

Krug, E., Dahlberg, L.L., Mercy, J., Zwi, A. and Lozano, R. (2002) *World report on violence and health*, Geneva: World Health Organization.

Lindsay, G., Cullen, S. and Wellings, C. (2011) *Bringing families and schools together*. London: Save the Children.

London Borough of Islington (1994) *STOP: Striving to prevent domestic violence – resource for working with children and young people*, LBI: Women's Equality Unit.

Morley, R. (1999) *Respect pack*, London: City and Hackney Community NHS Trust.

Mullender, A., Kelly, L., Hague, G., Malos, E. and Iman, U. (2002) *Children's perspectives on domestic violence*, London: Routledge,

Nation, M., Crusto, C., Wandersman, A., Kumpfer, K. L., Seybolt, D., Morrissey-Kane, E., Davino, K. (2003) 'What works in prevention: Principles of effective prevention programs', *American Psychologist*, 58(6/7): 449-56.

O'Brien, M. (2001) 'School-based education and prevention programs' in Renzetti, C., Edleson, J. and Bergen R. (eds) *Sourcebook on Violence Against Women*, London, Sage.

ODPM (Office of the Deputy Prime Minister) (2005) *OPDM Guidance on Best Value performance indicators*, Available: www.odpm. gov.uk/stellent/groups//odpm_localgov/documents/page/odpm_locgov_035599.pdf

Office for National Statistics (2013) *Crime in England and Wales 2012/13: Findings from the British Crime Survey and police recorded crime, Appendix Table 4*, London: ONS.

Ollis, D. (2011) 'A 'Respectful Relationships' approach: Could it be the answer to preventing gender based violence?', Paper presented at the AWA White Ribbon Day *Every Day* Conference Brisbane, 21 May, 2011. Available :www.awe.asn.au/drupal/sites/default/files/Ollis%20 Gender%20Based%20Violence%20Programs.pdf

Parton, N. (1985) *The politics of child abuse*, Basingstoke: Macmillan.

Petersen A. (1996) 'Risk and the regulated self: the discourse of health promotion and the politics of uncertainty', *Australian and New Zealand Journal of Sociology*, 32(1): 44-57.

Pugh, G., De'Ath, E. and Smith, C. (1994) *Confident parents, confident children: Policy and practice in parent education and support*, London: National Children's Bureau.

Radford, J., Kelly, L. and Hester, M. (1996) 'Introduction' in Hester, M., Kelly, L. and Radford, J. (eds) *Women, violence and male power*, Buckingham: Open University Press.

Radford, L., Corral, S., Bradley, C., Fisher, H., Bassett, C., Howat, N. and Collishaw, S. (2011) *Child abuse and neglect in the UK today*, London: NSPCC.

Rehman, Y., Kelly, L. and Siddigui, H. (eds) (2013) *Moving in the shadows: violence in the lives of minority women and children*, Farnham, Surrey: Ashgate.

Riger, S., Raja, S. and Camacho, J. (2002) 'The radiating impact of intimate partner violence', *Journal of Interpersonal Violence*, 17(2): 184-205.

Rivers, I. and Duncan, N. (eds.) (2013) *Bullying: Experiences and discourses of sexuality and gender*, London: Routledge.

Ross, A., Duckworth, K., Smith, D.J., Wyness G. and Schoon, I. (2011) *Prevention and reduction: a review of strategies for intervening early to prevent or reduce youth crime and anti-social behaviour*, London: DfE.

Scottish Executive (2003) Preventing domestic abuse: A national strategy, Edinburgh: Scottish Executive. Available: www.scotland.gov. uk/Resource/Doc/47176/0025563.pdf

Smith, C., Bradbury-Jones, C., Lazenbatt, A. and Taylor, J. (2013) *Provision for young people who have displayed harmful sexual behaviour*, NSPCC: London.

Stanko, E. (1985) *Intimate intrusions: women's experiences of male violence*, London: Routledge Kegan Paul.

Stanley, N. (2011) *Children experiencing domestic violence: A research review*, Dartington, Totnes, Devon: Research in Practice.

Stanley, N., Ellis, J., Farrelly, N., Downe, S., Hollinghurst, S. and Bailey, S. (forthcoming) *The PEACH Study: Preventing domestic abuse for children and young people*, Public Health Research, NHS National Institute for Health Research.

State of Victoria (2012) *Indigenous family violence: Primary prevention framework*, Melbourne: Victorian Department of Human Services Available: www.dhs.vic.gov.au/__data/assets/pdf_file/0005/718439/ Indigenous-family-violence-prim-preventionframework.pdf.

Tharp, A.T., DeGue, S., Lang, K., Valle, L.A., Massetti, G., Holt, M., and Matjasko, J. (2011) 'Commentary on Foubert, Godin, & Tatum (2010): The evolution of sexual violence prevention and the urgency for effectiveness', *Journal of Interpersonal Violence*, 26(16): 3383-92.

Thiara, R.K. and Gill, A. (eds) (2010) *Violence against women in South Asian communities: issues for policy and practice*, London: Jessica Kingsley Publishers.

Thompson, D. (ed) (1984) *Over our dead bodies: Women against the bomb*, London: Virago.

Thurston, W., Meadows, L., Tutty, L. and Bradshaw, C. (1999) *A violence reduction health promotion model: Executive summary*, Calgary: Prairie Partners. Available: www.peace.ca/CBEViolenceReductionModel. pdf

Topping, K. and Barron, I. (2009) 'School-Based Child Sexual Abuse Prevention Programs. A review of effectiveness', *Review of Educational Research* 79(1): 431-63.

Tutty, L., Bradshaw, C., Thurston, W.E., Barlow, A., Marshall, P., Tunstall, L., et al (2005) *School-based violence prevention programs: A resource manual*, Calgary: RESOLVE Alberta, University of Calgary. Revised ed. Available: http://wcm.ucalgary.ca/resolve/files/resolve/final-school-based-resource-manual-2005.pdf

United Nations General Assembly (1993) Declaration on the elimination of violence against women, Resolution A/RES/48/104, Available: http://daccess-dds-ny.un.org/doc/UNDOC/GEN/ N94/095/05/PDF/N9409505.pdf?OpenElement

Voice Against Violence (2012), www.voiceagainstviolence.org.uk

Walby, S (2009) *The cost of domestic violence update 2009*, Lancaster University. Available www.lancs.ac.uk/fass/doc_library/sociology/ Cost_of_domestic_ violence_update.doc

Walby, S. and Allen, J. (2004) *Domestic violence, sexual assault and stalking: Findings from the British Crime Survey*, Research Study 276, London: Home Office.

Wan, M.W. and Bateman, W. (2007) 'Adolescents and intimate partner violence: evaluating a brief school-based education programme', *International Journal of Health Promotion and Education*, 45(1): 17-23.

Weisz, A. and Black, B. (2009) Programs to reduce teen dating violence and sexual assault: Perspectives on what works. New York: Columbia University Press.

WHO (World Health Organisation) (2013) *Global and regional estimates of violence against women: prevalence and health effects of intimate partner violence and non-partner sexual violence,* Geneva: WHO.

Wolfe, D. and Jaffe, P. (2001) 'Prevention of domestic violence: emerging initiatives' in Graham-Bermann, S. and Edelson, J. (eds) *Domestic violence in the lives of children: The future of research, intervention and social policy*, Washington, DC: American Psychological Association.

Women's Aid Northern Ireland Federation (2005) *Delivering domestic violence preventive education programmes in schools and external settings: Good Practice Guidelines*, Belfast: WANIF.

Preventing violence against women and girls through education: dilemmas and challenges

Jane Ellis

Introduction

The prevention of VAWG through education brings with it the imperative to consider its theoretical foundations since it is suggested that effective programmes make explicit two types of theories: one related to the cause of VAWG and a second addressing the means by which change might be brought about, a theory of change (De Grace and Clarke, 2012). Evidence from research in the UK (Ellis, 2004a) and elsewhere (Mulroney, 2003) shows that many programmes lack theoretical clarity in both respects. While this poses difficulties in the design, delivery and evaluation of initiatives, there is also often little consideration of prevention itself; equally problematic, however, is a lack of critical theorising about children[1] and childhood. This chapter considers contemporary ideas of prevention and the implications this has for feminist challenges to VAWG through work with children and young people, principally in schools. Offering prevention as a solution is significant for children, in how VAWG is understood and how efforts to end VAWG are mediated in educational discourse[2]. Beginning with a discussion of prevention and its use in contemporary policy, with a brief outline of the two dominant conceptual models, public health and prevention science, consideration is then given to some of the dilemmas and challenges these present. The chapter concludes with some thoughts on reframing the prevention of VAWG through education within a framework of children's rights and

feminist poststructuralism. In engaging in a critique of prevention, it is not my intention to undermine the project of attempting to end VAWG but more to illuminate the context in which it has developed in order to inform reflective and reflexive policy and practice so that adults might better engage with children in this endeavour.

Prevention in social policy

Prevention is widely deployed as a key strategy for addressing a range of social issues. This is nowhere more evident than in policies concerning children and young people (Chief Secretary to the Treasury (CST), 2003; Sutton et al, 2004; HM Government, 2008; Department for Children Schools and Families (DCSF), 2010; Allen, 2011). Whilst there is an ever-increasing amount of research, policy and practice on prevention, there is a commonsense view that we know what it is. It is, however, a '"slippery" concept' (Billis, 1981: 368). The idea of prevention has been enthusiastically taken up by both the current and last governments in England. A plethora of research and policy has been advanced so that prevention now has an almost uncontested dominance in social policy. It might be argued that current politics and policy are driven by 'preventionism', which Billis defines as 'the belief that social problems can be prevented rather than resolved' (1981: 375). There is little discursive space to argue against it since its intentions appear both benign and compelling.

Prevention is frequently used in criminology, health, and childcare social work, and yet explicit definitions are less often proffered in the literature. Dictionary definitions suggest a number of possible meanings, including 'the action of stopping something from happening or making impossible an anticipated event or intended act' (Trumble, 2002: 2339) and 'action intended to provide against an anticipated danger' (Trumble, 2002: 2340). Two meanings are also offered for 'prevent'; that is, to 'act or do in advance' and to 'stop, hinder, avoid' (Trumble, 2002: 2339). In relation to childcare social work (Hardiker, 1999), and in health (Freeman, 1992), prevention has changing and multiple meanings. As Freeman states, 'prevention means different things in different contexts and eras' (1992: 47). This suggests a plurality of meanings and that a particular practice could be regarded as prevention in one context or time but not in another. This opens up space for a diverse range of activities to be considered

preventive (Morris and Spicer, 2003; Dartington Social Research Unit, 2004), making the case for theoretical clarity pressing.

Nonetheless, it is possible to identify some key elements of prevention; firstly, it entails some sort of action or intervention. Secondly, it incorporates the idea of prediction: x is undertaken in order that y will not happen (Freeman, 1992). Thirdly, and linked to prediction, is a temporal aspect where the event or outcome to be stopped, hindered or avoided is imminent: it is not in the present but always at some point in the future. In this respect, prevention could be regarded as precautionary or pre-emptive. Fourthly, it has a moral connotation where the event or outcome to be prevented is constructed as a problem, as undesirable in some way. Prevention is not then a simple or straightforward concept, policy or practice. It is however 'a normative project' (Freeman, 1999: 234) and, as such, it is difficult to argue against it since it involves 'bad' things that we wish to stop from happening: events or incidences that might or do harm to people, actions or circumstances that are viewed as problems. For example, we wish to prevent people from smoking, committing crime, or girls becoming teenage mothers. We do not expressly devise and employ strategies and call them prevention that hinder people from, say, gaining five A–C grades at GCSE, taking daily exercise or driving within speed limits since these are considered desirable for individuals and society. Lastly, prevention is implicitly associated with social change; it has been deployed by the Left as a means of social reform and by the Right as a way of reducing welfare expenditure and state intervention (Billis, 1981; Gilling, 1997).

Prevention appears to be a sensible and straightforward approach to the problem of VAWG. Nonetheless, implicit in this idea are four assumptions: that VAWG is not an inevitable social phenomenon or aspect of relating; that it is somehow learned; that the cause(s) and causal relationships can be identified; and that it is possible to intervene in some way to ameliorate it. None of these ideas are uncontested and require some examination and clarity about what preventing VAWG might mean and how 'prevention' might be carried out in practice.

Models of prevention

Two conceptual models have come to dominate thinking about prevention: public health and prevention science. These have distinct roots drawn from different academic disciplines but are now used in an interconnected way and often difficult to separate in practice; they are briefly outlined here.

Public health model

The public health model has been widely adopted as an approach to violence prevention (see for example Krug et al, 2002; Violence Reduction Unit (VRU), 2006; DH, 2009) and the division into primary, secondary, tertiary (Caplan, 1964) is well known and often cited. These levels focus on the timing of interventions, the 'when' of prevention, and relate to the stage of development of a 'problem' rather than to specific intended outcome(s) or activity. Primary prevention refers to the stage prior to the onset of a problem with the intention of stopping it from happening at all. Secondary prevention describes a stage when a problem has become evident and action is taken to stop it getting worse or recurring. Where a problem has become intractable or is multifaceted, prevention at a tertiary level would be undertaken in order to reduce or overcome harm such as, for example, one-to-one therapeutic support (Local Government Association (LGA), 2005).

Gordon (1987) proposed an alternative tripartite model – universal, selective, indicated – shifting the focus to the 'who' of prevention. Universal is applied to everybody in an eligible population irrespective of if they have the problem or when an intervention is deemed appropriate for everyone. Selective focuses on individuals or subgroups of a population whose risk of developing a problem is above average. Finally, the target at the indicated level is high risk people; that is, those who display risk factors or conditions that identify them as being 'at risk'. These two classification systems are not dissimilar and for our purposes primary and universal are of interest and these are merged in more recent thinking about work with children on VAWG (LGA, 2005). Primary is usually targeted at whole populations, through universal services, and aims to make small changes in large numbers of people (Partnerships Against

Domestic Violence, 2003). Education is frequently employed as a strategy in the primary prevention of VAWG in the form both of public information campaigns and of programmes for children in schools and young people's services.

Prevention science

In an attempt to overcome some of the problems associated with the tripartite model, principally a lack of focus on outcomes and measures of effectiveness (Little and Mount, 1999), prevention science, or the risk and protective factor model, has emerged. In essence, this is a form of developmental crime prevention (Tonry and Farrington, 1995) which has attained a dominant position in advanced liberal economies as the solution to the 'youth question' (France, 2008).

It focuses on preventing adolescent problem behaviours (Hawkins and Catalano, 1992) and draws on a theory of delinquent development (Farrington and West, 1993) and the social development model of behaviour (Catalano and Hawkins, 1996). Rooted in developmental and social psychology, particularly social learning theory (Bandura, 1977) and Hirschi's criminological social control (bond) theory (1969), it hypothesises that a range of future problem behaviours, variously and interchangeably labelled crime, antisocial behaviour, delinquency, drug (ab)use and violence, can be predicted from a set of risk factors or processes. Although regarded as predictive not causal (Thornberry, 1998), once identified, these risk factors can be diminished through a range of interventions in order to prevent the 'onset, escalation, [and] maintenance' and promote the 'de-escalation, and cessation or desistance' of problem behaviours (Catalano and Hawkins, 1996: 150).

Risk factors are drawn from population-based statistics, mostly empirical data, and children are then assessed to ascertain levels of risk using tools such as the Common Assessment Framework. Risk factors have been identified through longitudinal and small sample experimental studies (Tremblay and Craig, 1997). The Cambridge Study in Delinquent Development, longitudinal research led by West (1969) and then Farrington, is the most often cited work. In contradistinction, protective or prosocial factors are 'those internal and external forces which help children resist or ameliorate risk' (Fraser, 1997: 3). The list of risk factors is extensive and varies from 'indicators

of specific disadvantage such as gender ... to indicators that appear common to all [children]' (Bessant, 2003: 33). Protective factors, of which fewer have been identified, reduce the probability that groups of young people will become involved in problem behaviours.

Prevention science has been wholeheartedly adopted as a framework for work with children and their families in England. Initially, it was utilised solely in relation to youth crime; it has underpinned all youth justice policy, programmes and practice since the *Misspent Youth* report (Audit Commission, 1996) but was also operationalised during the Labour administration (1997-2010) in integrated welfare initiatives such as 'Sure Start', 'Children's Fund', along with comprehensive community initiatives such as 'On Track' and 'Communities that Care'. It has been adopted in relation to all services for children and their families since *Every Child Matters* in which a list of risk and protective factors appeared following the statement that: 'We have a good idea of what factors shape children's life chances. Research tells us that the risk of experiencing negative outcomes is concentrated in children with certain characteristics and experiences' (CST, 2003: 17). More recently, there has been a shift towards talk of early intervention which is often used interchangeably with primary prevention (Allen and Duncan Smith, 2008; DCSF, 2010; Allen, 2011), and where early is used to mean before birth and in the first three years of life (Allen, 2011) – rather than early in the onset of a 'problem'.

These dominant models of prevention not only inform policy but also concomitant funding for both interventions and research. Each brings with it a set of ideas that have implications for feminist explanations of VAWG, for young people and for how schools might engage with challenging VAWG; it is to these discussions we now turn.

The gender agenda

In public health, the ecological theory is adopted to explain the occurrence of VAWG (Krug et al, 2002; VRU, 2006). This advocates a process of interaction between four levels of factors: individual/ personal; interpersonal; community and the social. VAWG is viewed as having effects at each level and should therefore be addressed in each. While this framework can encompass gender since it considers

structural inequalities, societal norms, power relatic
personal history (Heise, 1998), studies of prevention w
that gender is often obscured and there is resistance to a
feminist discourses. This is shown in a number of ways, inc
in programme titles and content, in schools' reluctance to tak
initiatives and in the responses of some adults and young men (Ellis,
2004a; Tutty et al, 2005; Carmody, 2009; Stanley et al, 2011). In
the UK, many programmes do not adopt or promote a gendered
understanding of VAWG; however, in some cases where gender is
acknowledged, a feminist discourse to explain violence is often absent.
The fact that men and boys are overwhelmingly the perpetrators of
violence may be conveyed, such as through crime data, but why this
is the case is not explained as an outcome of gender inequality. Power
and gendered power relations, the core of feminist understandings of
VAWG, are rarely directly addressed and programmes promote the
idea of 'healthy' relationships (Ellis, 2004a) *heath.*

VAWG is clearly a public health issue as it has health implications,
often serious, for those who experience it and this is a good reason
to stop it. However, a focus on outcomes for 'victims' is not an
explanation of why it happens unless it is seen as an outcome of
victimisation; in other words, those who experience it go onto
enact it. The division between primary and secondary prevention is
unhelpful since significant numbers of children already experience
VAWG; consequently, activities categorised as primary prevention
come, in fact, after the event for some children and, therefore, in this
model they are secondary prevention. However, primary prevention
activities might result in children who are experiencing maltreatment
being identified and their then obtaining support. Finally, public
health itself is not uncontested; it is, as Baggott states, 'an essentially
political process' (2000: 2).

Prevention science also poses issues for VAWG prevention as it is
predicated on social learning theory and developmental psychology.
However, the adoption of work based on models of prevention
antithetical to feminist discourses of VAWG might arise from a
political compromise. Rein and Schon suggest that: 'The desire to
do something usually leads to a commitment to make the action
we seek realizable. We often do so by "hitching on" to a dominant
frame and its conventional metaphors, hoping to purchase legitimacy
for a course of action actually inspired by different intentions'

(1993: 151). Organisations wanting to undertake prevention work obtain resources from where they can. This is a pragmatic strategy and knowingly 'hitching on' to the dominant model is politically expedient; funding can be obtained to deliver work in which they might assert their agenda.

The 'slippery' (Billis, 1981: 368) meaning of prevention creates a space in which subjugated discourses and marginalised organisations can insert themselves into the mainstream. An example, from a case evaluation (Ellis, 2004b) illustrates this. For several years, New City Women's Aid (NCWA) had done occasional sessions in schools on domestic violence; money from the Children's Fund enabled them to obtain funding to establish a small team to extend the work. However, 'hitching' on to the prevention agenda raised tensions and contradictions. The funders actively promoted prevention science as *the* approach to work with children, as did other local agencies co-opted into crime prevention through multiagency forums such as community safety partnerships. Although this could be viewed as positive since the increased criminalisation of VAWG has been a key feminist strategy, and it is partly through the recognition of VAWG as crime that funding for prevention was available at all, unknowingly working within the dominant model constrained and undermined NCWA's feminist agenda and created unforeseen tensions. Staff at New City Children's Fund (NCCF) promoted the intergenerational transmission theory of domestic violence, which NCWA categorically rejected, leading to fraught exchanges about the purpose of the work in schools. It was interesting to note that work on domestic violence was within the mental health funding strand of NCCF, firmly locating it within the psychopathological discourses (Ellis, 2004b).

Despite this, school-based work appears to be easier to establish and sustain in a multiagency context (Ellis, 2004a; also see Chapters Six, Seven and Nine). Clearly, engaging a broad constituency and securing alliances is advantageous but this brings together parties who have different ideas about VAWG and dissimilar working practices. This leads to programmes having multiple agendas and diverse content with the potential for inconsistent and contradictory messages and difficulties in evaluating impact. To promote feminist discourses of VAWG effectively necessitates being clear about purpose and good practice in order to identify overlaps and common ground with

others, while retaining what is core to the work, since addressing gender (in)equality and gender power relations is essential in challenging the root causes of VAWG (Pease, 2008; Carmody et al, 2009; Flood et al, 2009).

Children, risk and prevention

While dominant ideas of prevention emerge as problematic in relation to gender, they also, along with a great deal of VAWG prevention work, lack critical theorising about children and childhood, mainly reflecting taken-for-granted knowledge (Ellis, 2004a). As such, this has important implications for children and the potential effectiveness of programmes. As Moss et al note: 'There are many possible ways of thinking and talking about children and childhood, and the choices we make between these possibilities have great consequences for policy and practice – and for the lives and subjectivities of children.' (2000: 251) Foregrounding children in debates about prevention work directed at them seems appropriate especially in the context of the United Nations Convention on the Rights of the Child (UNCRC) and the changed and changing ideas about children and childhood (Qvortrup et al, 1994, 2009; James et al, 1998; Mayall, 2002; Mizen, 2004; Furlong and Cartmel, 2007).

School-based prevention implicitly assumes that children learn violence and schools are sites where it can be relearned/unlearned or nonviolence endorsed. The processes of learning, a theory of change, are often not explained, suggesting that either social learning theory or socialisation is adopted. Both of these theories essentialise children, positioning them as 'becomings', as future adults, rather than as beings (Qvortrup, 1994); as empty vessels to be filled with knowledge, or as having to acquire the 'right behaviour' from adults who model desirable conduct. They are thus either the passive recipients of the norms and values of society imparted to them by the agents of socialisation, such as schools and families, or viewed as passively taking up dominant discourses of violence through imitation of adults who are 'poor' role models, with both discourses positioning children as unknowing and without agency. The former then focuses on inadequate parenting or schooling, and deviant children. The latter shifts the debate to the cycle of violence (intergenerational transmission) which '... change the grounds on which support is

provided to children who have been victimised from a matter of need and rights to a presumed model of future offending' (Radford et al, 1996: 7) and their being 'at risk' which is explored in the next section.

The concept of risk is core to both public health and prevention science, where it is 'largely treated as a taken-for-granted objective phenomenon' (Lupton, 1999: 2). It is employed in its epidemiological form where populations are screened for risk factors which are used to pre-detect potential pathological outcomes (Castel, 1991; Dean, 1999). Demographic information gathered about individuals is aggregated to establish norms against which individuals are then compared. Individuals are categorised and assigned to a specific 'risk group', not on the basis of their past actions or any actual danger they might pose but through a systematic assessment of their characteristics against risk factors which relate to the incidence of particular outcomes in a population. Effectively all children are 'at risk' in some way on a risk continuum; they are either at high or low risk but never at no risk (Dean, 1999), and always positioned as deficient. Prevention focuses on the probability of some undesirable outcome occurring and on the deduction and pre-detection of individuals who are 'at risk' in order to 'anticipate all the possible forms of irruption of danger' (Castel, 1991: 288). Children's behaviour is abstracted from the social, political and economic context in which they live and few attempts are made to ascertain the meaning, for children, of the events or circumstances of their lives (Armstrong, 2004; France, 2008).

These approaches are deficit models in which children's strengths and competences are unnoticed with a focus on avoiding harm or danger, evident in VAWG prevention (Carmody, 2009). As Beck noted: 'One is no longer concerned with attaining something 'good', but rather with *preventing* the worst; *self-limitation* is the goal which emerges.' (1992: 49). Arguably, risk is also deterministic in that the relationships between characteristics, events, or circumstances in early life are seen as precursors to 'poor outcomes' so that 'what happens to a small child sets in stone the pattern of his or her future life' (Waiton, 2001: 35). Problems might also be seen as emerging at younger and younger ages because certain conduct is read as indicative of some future problem; intervention centres on future outcomes not the current circumstances of children's lives. Attention to risk has led to greater anxiety for children's safety (Scott et al, 1998) which, in turn, has increased the supervision, surveillance and regulation of

their lives (Scott et al, 1998; France, 2008). This concern is evident in VAWG prevention work in the contingent use of children's rights with a focus on the right to protection, to be safe, rather than or in addition to other categories of rights, namely provision and participation (Ellis, 2004a).

Education as prevention

Education, like prevention, is generally regarded as a 'good thing' (Harber, 2004: 7) with the belief that it can bring about change through learning. Given the liberal tradition of education as a process of self-improvement, it is unsurprising that education has been harnessed as prevention since both share the political aspiration, and promise, of social reform. In addition, the idea that learning contributes to the development of rationality means the possession of knowledge is regarded as equipping individuals to make the 'right' choices and conduct their lives prudently – to avoid or minimise risks through changing attitudes or 'inner states' (O'Malley, 1992: 267). As institutions for learning, schools are regarded as a 'natural environment for prevention programmes, addressing entire populations of children with an approach that fits with the purpose of the institution' (Tutty et al, 2005:12). There is little clarity, however, as to whether work takes place in schools because it is convenient, it is where young people are a mass and captive audience, or rather from the recognition that schools are a key institution in the production of normative gendered identities and the concomitant violence (Butler, 1993; Connell, 1995; Berkowitz et al, 2005). Schools are a crucial site where violence can be disrupted and yet a tension exists since schools are also the site where violence is learned. Thus schools can be conceptualised as both the producers of violence and the starting point for ending it (Ross Epp, 1996; Harber, 2004).

Many schools are cautious about tackling VAWG particularly where a gendered/feminist approach is taken (Ellis, 2004a; Tutty and Bradshaw, 2004; EVAW, 2011). One of the obstacles is the context created by education policies which have fostered, amongst other things, competitive individualism and competition between schools; decision-making based on cost-effectiveness as opposed to professional standards of equity, care and social justice. The latter has led to a focus on outcomes and effectiveness, rather than educational

process or the quality of relationships between people in schools, and on creating individuals fit for the workforce rather than social or individual wellbeing (Gewirtz et al, 1995; Tomlinson, 2005; Ball, 2013). As a result of intense regimes of accountability, schools 'operate as tightly bounded systems where retaining the stability of within school social practices is a priority for both students and teachers' (Edwards, 2008: 375-76), limiting scope to work interprofessionally. Establishing VAWG in this context is difficult; furthermore education staff view such work as relating to personal and social development, and/or safeguarding, not 'prevention' (Ellis, 2004b). Minimising these barriers at a local level is helped by having a dedicated lead worker who is an educationalist to support schools (Thiara and Ellis, 2005). Such staff speak 'the language of education' and understand the culture and working practices of schools while also having knowledge and understanding of VAWG.

Most prevention work in schools in located in the personal, social and health education (PSHE) curriculum, of which sex and relationship education (SRE) is a part; this is the obvious place to locate it, however, compartmentalising it within PSHE is problematic. PSHE is nonstatutory, and although schools are censured when it is poorly organised or taught, the Office for Standards in Education[3] (Ofsted) reports that it is often patchy and under-resourced (2005, 2013). Certain aspects of SRE are statutory in maintained schools but this is the science element. However, as a non-exam subject PSHE/SRE is often marginalised, particularly in secondary schools, and taught by non-specialists (Formby et al, 2011). Locating the topic in PSHE might mean VAWG is perceived as an individual/private issue, as opposed to a social/public issue as its inclusion in citizenship might suggest, where legal and rights aspects would be more easily incorporated. VAWG competes with a wide range of topics and issues for inclusion in the curriculum, as schools are seen as the panacea for all ills, and any claim for its inclusion necessitates it not only being seen as worthwhile but as more worthwhile than other issues.

There is no consensus in the literature on whether internal or external staff are best placed to facilitate VAWG work (Tutty et al, 2005, Flood et al 2009). While external staff from nongovernmental organisations have knowledge and expertise on VAWG, the capacity to reach all young people is limited and the work is potentially

unsustainable since it is highly dependent on short-term funding which can lead to short and potentially ineffective interventions (Ellis, 2004a) that do not form part of a comprehensive strategy (De Grace and Clarke, 2012). In addition, external staff are less likely to impact on school culture, or provide continuity and progression to learners, making long-term change more difficult. On the other hand, school staff often resist the work since they feel ill equipped (Berkowitz et al, 2005) particularly in respect of dealing with disclosures of victimisation (Ellis, 2008) or perpetration (Flood et al, 2009). A collaborative arrangement utilising the strengths of both approaches might be beneficial (Lewis and Martinez, 2006; Hassel and Hanna, 2007, Ellis, 2008). Irrespective of who delivers the work, effective programmes need highly skilled, well-trained staff who receive supervision (Ellis, 2004a; Carmody et al, 2009; Flood et al, 2009; De Grace and Clarke, 2012). Skills to manage and utilise the group dynamic are crucial to create safe learning spaces where young people can discuss emotive topics and examine their own beliefs and attitudes, and to challenge and be challenged (Ellis, 2008). It is in the very relationships between people that power is enacted; skilled facilitators who are able to utilise power dynamics within a group can help children learn about power and control experientially rather than in the abstract. Learning is enhanced where staff are enabling, inclusive, direct and treat young people with respect (Wolfe et al, 1997; Thornton et al, 2002; Ellis, 2004b). In the UK, a debate is beginning about the gender of facilitators and, although there is no consensus, some boys value men facilitating the work (Bell and Stanley, 2006). Where work is co-facilitated by a woman and a man, staff can 'practice the message' of gender equity; this is also recommended good practice in perpetrator work (Respect, 2012)

Sustain

Reframing VAWG prevention

Children's rights

A framework based on children's strengths and competencies is needed for VAWG prevention, and reconceptualising the work within a children's rights discourse provides such an alternative. The UNCRC provides a legal imperative for educational initiatives to which the state can be held to account. Articles 13 and 17 concern

children's right to information, particularly Article 17 which states that children shall have 'access to information and material ... especially those aimed at the promotion of [their] social, spiritual and moral wellbeing and physical and mental health' (1989: Article 17, para 1). Article 19 stipulates that: 'State Parties shall take all appropriate legislative, administrative, social and educational measures to protect children from all forms of physical and mental violence ...' (1989: Article 19, para 1). That these measures are regarded as preventative, although categorised as protective, is suggested in paragraph 2 which states: 'Such protective measures should ... include effective procedures for the establishment of social programmes to provide necessary support for the child ... *as well as for other forms of prevention*' (1989: Article 19, para 2, emphasis added).

Deploying rights as a basis for educational work to prevent VAWG is not unproblematic since these are broad abstract statements of social justice and the process of how they are translated into practice is complex. Rights might usefully form the basis of prevention work, with a focus on promoting and attaining equality and respect for everyone, whilst acknowledging gender inequality (and other inequalities). Likewise, the values of respect, equality and social justice are foundational to feminisms. Other aspects of children's rights could be promoted too, rather than the contingent use with a focus almost exclusively on protection. Article 12 stipulates that 'States Parties shall assure to the child who is capable of forming his or her own views the right to express those views freely in all matters affecting the child, the views of the child being given due weight in accordance with the age and maturity of the child' (UNCRC, 1989: Article 12, para 1). As a procedural right, participation is not an end in itself; it is fundamental to accessing other rights. How can children be protected, educated or have their best interests met if they are unheard? Protection and participation are often opposed in discussions of children's rights; however, we should be wary of paternalistic protectionism since in disregarding children's views we discount children's strengths and competencies and the ways in which they have learned to protect themselves. Policy and practice based on young people's knowledge and experience is emerging (Carmody, 2009; EVAW, 2011) where they are not merely consulted but co-produce resources and deliver to peers, suggestive of transformative participation (White, 1996) bringing into question the adult–child

power relation by redistributing power in children's favour. Likewise, teaching methods that are participative, interactive and emotionally engaging, such as theatre, role play, DVD and small and whole group discussion, are valued by young people, are regarded as good practice in PSHE teaching (Lewis and Martinez, 2006) and are more successful (Avery-Leaf and Cascardi, 2002; Hester and Westmarland, 2005; Bell and Stanley, 2006; Ellis, 2008; Flood et al, 2009).

Feminist poststructualism

There is a substantial literature on gender and education, much of which adopts poststructuralism as an analytical tool (see for example Robinson, 2005; Ringrose, 2012; see also Chapter Four). Adopting feminist poststructuralism to theorise violence offers the potential to reframe educational work on VAWG and to position children with agency. In thinking of children and young people as carriers of discourse who constantly negotiate a gendered identity and schools as a key site in the production of gendered subjectivities, practice would aim to disrupt dominant discourses of masculinity which sanction boys'/men's violence. The work becomes 'concrete and situated engagements, namely, in this case, unpicking and dismantling relations of inequality' (Cooper, 2004: 11) where challenges and alternatives to violent masculinity can be examined and supported and gender equity promoted. A number of advantages might accrue from this thinking. Firstly, it locates the problem of violence in the social and cultural context, specifically, in this case, in schools, and not in individual children; therefore it is less likely to pathologise children or to stigmatise or alienate boys/young men, whom it is important to engage in ending VAWG (Berkowitz et al, 2005; Pease, 2008). However, this does not mean individuals cannot be held to account for violence. Secondly, it stresses the importance of a whole school approach in order to change school culture and to create an ethos where violence, including gender violence, is not tolerated. Thirdly, it offers an explanation of how violence is learnt that is consistent with feminist discourses of VAWG since it centralises power relations. Fourthly, the problem of gender violence is recognised and addressed in children's present lives – it is not 'prevented' by putting change into the future – and it is about everyday micro-practices in the classroom, corridor and playground, not abstract ideas about society. Finally,

adults are also held to account for their conduct in changing social and cultural processes and practices in schools which sanction VAWG.

Conclusion

Having looked at the current position on addressing VAWG prevention it is clear that challenging VAWG through education is complex and difficult. The task ahead appears to be to make the work more universal by moving it from the margins to a position more central to the purposes of schooling and education. If it is seen to be a 'good thing' then it should be made available to everybody, rather than languishing on the fringes. A paradigm shift in how we understand and discuss prevention might make VAWG work more acceptable and relevant to those we want to engage in it in schools. Suggesting a rights-based approach and locating the work in an already established discourse on gender and education may result in it being taken up more by schools and enable the promotion of what we want, gender equity, not prevent the undesirable, violence. The need for a cultural shift from conceptions of children as deficient in some way and as 'becomings', who are only of interest as future adults, could also be enhanced. It is important, however, to emphasise that a wider strategy to end VAWG is necessary, of which education is one part, so that the burden of social change is not placed solely on children and young people.

Notes

[1] 'Children' is used here in its legal form; to describe people under 18 years of age; this is for brevity and simplicity. It includes young people and the terms will be used interchangeably.

[2] The term 'discourse' is employed in its Foucauldian sense to define what comes to be regarded as 'truths' and to count as knowledge; that is, dominant ideas. Weedon defines discourse as 'ways of constituting knowledge, together with social practices, forms of subjectivity and power relations which inhere in such knowledges and relations between them' (1997: 105).

[3] The full title is The Office for Standards in Education, Children's Services and Skills; it regulates and inspects a range of educational provision, childcare and children's social care in England.

References

Allen, G. (2011) *Early intervention: The next steps*, London: The Stationery Office.

Allen, G. and Duncan Smith, I. (2008) *Early intervention: Good parents, great kids, better citizens*, London: Centre for Social Justice and Smith Institute.

Armstrong, D. (2004) 'A risky business? Research, policy, governmentality and youth offending', *Youth Justice*, 4(2): 100-16.

Audit Commission (1996) *Misspent youth: Young people and crime*, London: Audit Commission.

Avery-Leaf, S and Cascardi, M (2002) 'Dating violence education: Prevention and early intervention strategies' in Schewe, P (ed) *Preventing violence in relationships: Interventions across the life span*, Washington, DC: American Psychological Association.

Baggott, R. (2000) *Public health: Policy and politics*, Basingstoke: Palgrave Macmillan.

Ball, S.J. (2013) *The education debate* (2nd edn), Bristol: The Policy Press.

Bandura, A. (1977) *Social learning theory*, Englewood Cliffs, NJ: Prentice Hall.

Beck, U. (1992) *The risk society: Towards a new modernity*, London: Sage.

Bell, J. and Stanley, N. (2006) 'Learning about domestic violence: Young people's responses to a healthy relationships programme', *Sex Education*, 6(3): 237-50.

Berkowitz, A., Jaffe, P., Peacock, D., Rosenbluth, B. and Sousa, C. (2005) *Young men as allies in preventing violence and abuse: Building effective partnerships with schools*, Pennsylvania: VAWnet. Available: www.vawnet.org/Assoc_Files_VAWnet/YoungMenAllies.pdf

Bessant, J., Hil, R. and Watts, R. (2003) *'Discovering' risk: Social research and policy making*, New York: Peter Lang Publishing.

Billis, D. (1981) 'At risk of prevention', *Journal of Policy Studies*, 10(3): 367-79.

Butler, J. (1993) *Bodies that matter: On the discursive limits of 'sex'*, London: Routledge.

Caplan, G. (1964) *Principles of preventive psychiatry*, New York: Basic Books.

Carmody, M. (2009) *Sex and ethics: Young people and ethical sex*. Melbourne: Palgrave Macmillan.

Carmody, M., Evans, S., Krogh, C., Flood, M., Heenan, M. and Ovenden, G. (2009) *Framing best practice: National Standards for the primary prevention of sexual assault through education: National Sexual Assault Prevention Education Project for NASASV,* Australia: University of Western Sydney.

Castel, R. (1991) 'From dangerousness to risk' in Burchell, G., Gordon, C. and Miller, P. (eds) *The Foucault effect. Studies in governmentality*, Chicago: The University of Chicago Press.

Catalano, R. and Hawkins, D. (1996) 'The social development model: a theory of antisocial behaviour' in Hawkins, D. (ed) *Delinquency and Crime. Current Theories*, Cambridge: Cambridge University Press.

Chief Secretary to the Treasury (CST) (2003) *Every child matters*, London: The Stationery Office.

Connell, R. (1995) *Masculinities*, Cambridge: Polity Press.

Cooper, D. (2004) *Challenging diversity: Rethinking equality and the value of difference*, Cambridge: Cambridge University Press.

Dartington Social Research Unit (2004) *Refocusing children's services towards prevention: Lessons from the literature*, London: DfES.

DCSF (Department for Children, Schools and Families) (2010) *Early intervention: Securing good outcomes for all children and young people*, London: DCSF.

Dean, M. (1999) *Governmentality: Power and rule in modern society*, London: Sage.

De Grace, A. and Clarke, A. (2012) 'Promising practices in the prevention of intimate partner violence among adolescents', *Violence and Victims,* 27(6): 849-59.

DH (Department of Health) (2009) *Improving safety, reducing harm: Children, young people and domestic violence*, London: TSO.

Edwards, A. (2008) 'Activity theory and small-scale interventions in schools', *Journal of Educational Change*, 9(4): 375-78.

Ellis, J. (2004a) *Preventing violence against women and girls: A study of educational programmes for children and young people*, London: Womankind Worldwide.

Ellis, J. (2004b) *New City Women's Aid children and domestic violence project: Evaluation report,* New City: New City Children's Fund.

Ellis, J. (2008) 'Primary prevention of domestic abuse through education' in Humphreys, C., Houghton, C. and Ellis, J. (2008) *Literature review: Better outcomes for children and young people affected by domestic abuse – Directions for Good Practice,* Edinburgh: Scottish Government.

EVAW (End Violence Against Women) (2011) *A different world is possible: Promising practices to prevent violence against women and girls,* London: EVAW.

Farrington, D. and West, D. (1993) 'Criminal, penal and life histories of chronic offenders: risk and protective factors and early identification', *Criminal Behaviour and Mental Health* 3: 492-523.

Flood, M., Fergus, L. and Heenan, M. (2009) *Respectful relationships education: Violence prevention and respectful relationships education in Victorian secondary schools,* Melbourne: State of Victoria, Department of Education and Early Childhood Development.

Formby, E., Coldwell M., Stiell, B., Demack, S., Stevens, A., Shipton, L., Wolstenholme, C. and Willis, B. (2011) *Personal, Social, Health and Economic (PSHE) Education: A mapping study of the prevalent models of delivery and their effectiveness,* London: DfE.

France, A. (2008) 'Risk factor analysis and the youth question', *Journal of Youth Studies,* 11(1): 1-15.

Fraser, M. (1997) *Risk and resilience in childhood: An ecological perspective,* Washington DC: NASW Press.

Freeman, R. (1992) 'The idea of prevention: a critical review' in Scott, S., Williams G., Platt, S. and Thomas, H. (eds) *Private risks and public dangers,* Aldershot: Avebury.

Freeman, R. (1999) 'Recursive politics: prevention, modernity and social systems', *Children and Society,* 9: 232-41.

Furlong, A and Cartmel, F. (2007) *Young people and social change: New perspectives,* Maidenhead: McGraw-Hill/Open University Press.

Gewirtz, S., Ball, S. and Bowe, R. (1995) *Markets, choice and equity in education,* Buckingham: Open University Press.

Gilling, D. (1997) *Crime prevention: Theory, policy and politics,* London: UCL Press.

Gordon, R. (1987) 'An operational definition of disease prevention' in Sternberg J. and Silverman, M. (eds) *Preventing mental disorders,* Rockville, MD: U.S. Department of Health and Human Services.

Harber, C. (2004) *Schooling as violence. How schools harm pupils and societies,* London: RoutledgeFalmer.

Hardiker, P. (1999) 'Children still in need indeed: prevention across five decades' in Stevenson, O. (ed) *Child welfare in the United Kingdom 1948-1998,* Oxford: Blackwell.

Hassall, I. and Hannah, K. (2007) *School-based violence prevention programmes: A literature review.* New Zealand: Institute of Public Policy. Available: www.ipp.aut.ac.nz/__data/assets/pdf_file/0016/110473/violence-prevention-programmes.pdf

Hawkins, D. and Catalano, R. (1992) *Communities that care: Action for drug abuse prevention,* San Francisco: Jossey-Boss Publishers.

Heise, L. (1998) 'Violence against women: An integrated, ecological framework', *Violence Against Women,* 4(3): 262-90.

Hester, M. and Westmarland, N. (2005) *Tackling domestic violence: Effective interventions and approaches,* London: Home Office.

Hirschi, T. (1969) *Causes of delinquency,* Berkeley: University of California Press.

HM Government (2008) *Youth Crime Action Plan,* London: Home Office, Ministry of Justice, Cabinet Office and DCSF.

James, A., Jenks, C. and Prout, A. (1998) *Theorizing childhood,* Cambridge: Polity.

Krug, E., Dahlberg, L.L., Mercy, J., Zwi, A. and Lozano, R. (2002) *World Report on violence and health,* Geneva: World Health Organization.

Lewis E. and Martinez A. (2006) 'Addressing healthy relationships and sexual exploitation within PSHE in schools', *Forum Factsheet 37,* London: Sex Education Forum.

Little, M. and Mount, K. (1999) *Prevention and early Intervention with children in need,* Aldershot: Ashgate.

Local Government Association (2005) *Vision for services for children and young people affected by domestic violence: guidance for commissioners of children's services,* London: LGA Publications.

Lupton, D. (1999) *Risk,* London: Routledge.

Mayall, B (2002) *Towards a sociology for childhood: Thinking from children's lives.* Buckingham: Open University Press.

Mizen, P. (2004) *The changing state of youth,* Basingstoke: Palgrave.

Morris, K. and Spicer, N. (2003) *The National Evaluation of the Children's Fund: Early messages from developing practice,* Birmingham: The National Evaluation of the Children's Fund, University of Birmingham.

Moss, P., Dillon, J. and Statham, J. (2000) 'The 'child in need' and 'the rich child'; discourses, constructions and practice', *Critical Social Policy,* 20(2): 233-54.

Mulroney, J. (2003) *Australian prevention programmes for young people,* Topic Paper, Australian Domestic and Family Violence Clearinghouse. Available: www.adfvc.unsw.edu.au/PDF%20files/prevention_progs_young.pdf

Office for Standards in Education (Ofsted) (2005) *Personal, social and health education in secondary schools,* London: Ofsted.

Ofsted (2013) *Not yet good enough: personal, social, health and economic education in schools. Personal, social and health education in English schools in 2012,* London: Ofsted

O'Malley, P. (1992) 'Risk, power and crime prevention', *Economy and Society,* 21(3): 252-75.

Partnerships Against Domestic Violence (2003) *Community awareness and education to prevent, reduce and respond to domestic violence. Phase 1 Meta-evaluation report,* Canberra: Government of Australia Office for Women.

Pease, B. (2008) *Engaging men in men's violence prevention: Exploring the tensions, dilemmas and possibilities,* Issues Paper 17, Sydney: Australian Domestic & Family Violence Clearinghouse. Available: www.adfvc.unsw.edu.au/PDF%20files/Issues%20Paper_17.pdf

Qvortrup, J. (1994) 'Childhood matters: an introduction' in Qvortrup, J, Brady, M., Sgritta, G. and Wintersberger, H. (eds) *Childhood matters: Social theory, practice and politics,* Aldershot: Avebury.

Qvortrup J, Corsaro W.A. and Honig M.S. (eds) (2009) *The Palgrave handbook of childhood studies,* Basingstoke, England: MacMillan.

Radford, J., Kelly, L. and Hester, M. (1996) 'Introduction' in M. Hester, L. Kelly and J. Radford (eds) *Women, violence and male power,* Buckingham: Open University Press, pp 1-16.

Rein, M. and Schon, D. (1993) 'Reframing policy discourse' in Fischer, F. and Forester, J. (eds) *The argumentative turn in policy analysis and planning,* London: University College London Press.

Respect (2012) *The Respect Accreditation Standard,* London: Respect.

Ringrose, J. (2012) *Post-feminist education? Girls and the sexual politics of schooling,* London: Routledge.

Robinson, K. (2005) 'Reinforcing hegemonic masculinities through sexual harassment: issues of identity, power and popularity in secondary schools', *Gender and Education,* 17(1): 19-37.

Ross Epp, J. (1996) 'Schools, complicity, and sources of violence' in J. Ross Epp and A. Watkinson (eds) *Systemic violence: How schools hurt children,* London: The Falmer Press.

Scott, S., Jackson, S. and Backett-Milburn, K. (1998) 'Swings and roundabouts: risk anxiety and the everyday worlds of children', *Sociology*, 32(4): 689-705.

Stanley, N., Ellis, J. and Bell, J. (2011) 'Delivering preventive programmes in schools: Identifying gender issues' in Barter, C. and Berridge, D. (eds) *Children behaving badly? Exploring peer violence between children and young people,* London: Wiley.

Sutton, C., Utting, D. and Farrington, D. (eds) (2004) *Support from the start: Working with young children and their families to reduce the risks of crime and anti-social behaviour,* Research Report 524, London: DfES.

Thornton, T., Craft, C., Dahlberg, L., Lynch, B. and Baer, K. (2002) *Youth violence: Best practices of youth violence prevention – A sourcebook for community action,* Atlanta, GA: Centres for Disease Control and Prevention. Available www.cdc.gov/violenceprevention/pub/yv_bestpractices.html

Thiara, R.K. and Ellis, J (2005) *WDVF London-wide schools' domestic violence prevention project: An evaluation: Fiinal report,* London: Westminster Domestic Violence Forum.

Thornberry, T. P (1998) 'Membership in youth gangs and involvement in serious, violent offending', in R. Loeber and Farrington D.P. (eds.) *Serious and violent juvenile offenders: Risk factors and successful interventions* Thousand Oaks, CA: Sage Publications, pp 147-66.

Tomlinson, S. (2005) *Education in a post-welfare society* (2nd ed), Maidenhead: Open University Press.

Tonry, M. and Farrington, D. (1995) 'Strategic approaches to crime prevention' in Tonry, M. and Farrington, D. (eds) *Building a safer society: Strategic approaches to crime prevention,* London: Chicago University Press.

Tremblay, R. and Craig, W. (1997) 'Developmental juvenile delinquency prevention', *European Journal on Criminal Policy and Research*, 5(2): 33-50.

Trumble, W. (2002) ed by Siefring, J., Stevenson, A. and Brown, L., *Shorter Oxford English Dictionary,* 5th edn, Oxford: Oxford University Press.

Tutty, L. and Bradshaw, C. (2004) 'Violence against children and youth: do school-based prevention programs work?' in Ateah, C. and Mirwaldt, J. (eds) *Within our reach: Preventing abuse across the lifespan,* Fernwood Publishing

Tutty, L., Bradshaw, C., Thurston, W.E., Barlow, A., Marshall, P., Tunstall, L., et al (2005) *School-based violence prevention programs: A resource manual*, Calgary: RESOLVE Alberta, University of Calgary. Revised ed. Available: http://wcm.ucalgary.ca/resolve/files/resolve/final-school-based-resource-manual-2005.pdf

Violence Reduction Unit (2006) *Reducing violence: an alliance for a safer future*, Glasgow: Violence Reduction Unit.

Waiton, S. (2001) *Scared of the kids? Curfews, crime and the regulation of young people*, Sheffield: Sheffield Hallam University Press.

Weedon, C. (1997) *Feminist practice and poststructuralist theory*, Oxford: Blackwell (2nd edn).

West, D. (1969) *Present conduct and future delinquency*, London: Heinemann.

White, S. (1996) 'Depoliticising development: the uses and abuses of participation', *Development in Practice*, 6(1): 6-15.

Wolfe, D., Wekerle, C. and Scott, K. (1997) *Alternatives to violence: Empowering youth to develop healthy relationships*, London: Sage.

Does gender matter in violence prevention programmes?

Leslie Tutty

All children, young people and adults can be the targets of violence, the most likely perpetrators being family members, intimate partners or acquaintances. No one deserves such abuse and we must continue to explore ways to prevent all violence. Nonetheless, it is critical to acknowledge that girls and women are the primary targets of many forms of abuse, including child sexual abuse, dating violence, intimate partner violence, sexual assault, and sexual harassment (Heise et al, 2002). Such forms of violence are defined as 'gender-based', occurring in private (as in abuse in families and intimate relationships) and public spheres (school, community).

What causes gender-based violence? While several authors have adopted a multi-levelled, ecological view of the etiology of such violence (Heise et al, 2002), one significant cause within this is a power imbalance related to male authority and privilege (Morrison et al, 2007). Gender-based violence is particularly evident when societal attitudes, behaviours and institutions uphold traditional male power. The fear of violence experienced by many women and girls tends only to reinforce the gender inequality in society; reinforcing a sense of powerlessness and limiting the effective functioning of girls and young women in both private and public realms (Berman et al, 2002).

School-based violence prevention programmes are one important way to inform, address and provide strategies to intervene so that violence either does not occur or its effects are minimised. Developed in the past 30 years, a proliferation of prevention programmes address school violence, bullying, sexual abuse, dating violence,

discrimination, sexual harassment, sexual assault and the sexual exploitation of children and young people (Tutty et al, 2005).

Drawing on the Canadian experience, this chapter explores the role and importance of a gendered framework in preventing violence against women and girls. In so doing it presents sections on school-based programmes addressing the prevention of child sexual abuse, bullying, sexual harassment, dating violence and, briefly, sexual assault, examining the gendered aspects of each. Although many programmes cite such gendered violence as a core principle, the extent to which this is explicit in the programme materials varies. The chapter discusses some of the challenges of adopting a gendered approach and strategies to address this in gaining entry to the school system.

One approach to highlight the gendered nature of intimate violence is administering the programme or parts of the programme in separate gender groups. The pros and cons of having either gender-integrated or gender-segregated groups in such work are explored. An emerging question with respect to gendered prevention messages comes from young people from the lesbian, gay, bisexual, transgendered and queer (LGBTQ) communities that provide a unique perspective on this issue. Finally, do boys and girls respond differently to the programmes and, ultimately, should school-based prevention work be built on and promote a gendered analysis of violence?

Violence prevention programmes: an overview

Children and young people in schools are by far the most common audience for violence prevention programmes as they provide the best hope for the universal provision of prevention messages (Tutty et al, 2005). This chapter focuses on primary or 'universal' prevention programmes – those developed for individuals who have not yet been victimised – in contrast to secondary and tertiary prevention programmes for children or young people at particular risk or who have already experienced abuse. School-based violence prevention programmes address a number of topics, including the abuse of children (either physical, sexual or neglect), violence against dating partners or violence between child and peers (bullying), and, rarely, sexual exploitation, though this work is now developing in Canada and the UK.

The focus of school-based violence prevention programmes has shifted over time. The first programmes in the 1970s addressed peacemaking and conflict resolution; in the 1980s, child sexual abuse prevention programmes were common; in the 1990s, dating violence prevention (mostly in high schools, ages 14-19) and sexual assault programmes (mostly in universities) emerged. Finally, in the last decade or so, bullying programmes have become common. This evolution represents a shift in interest; unfortunately, these are all important issues and are not interchangeable. Further, some are inherently gender-based, while others are presented as gender neutral, an issue that will be discussed in more detail later in the chapter.

School-based violence prevention efforts for children and young people are based on the principle that education can change awareness and knowledge, and they teach skills that can change behaviour. The hope is that such knowledge will empower young people to interact in positive and prosocial ways. Another rationale is to encourage young people to disclose and seek assistance if they have been abused. Most violence prevention programmes provide information in the hope of informing or changing attitudes with respect to problem behaviours, preventing dating violence being an obvious example. Others teach positive (prosocial) skills such as good communication or problem solving skills in the hope that relationship problems, such as dating violence, do not develop in the first place.

The gendered aspects of violence prevention programmes

Gender is an important feature in violence prevention programmes in several ways. It will be highlighted in the following review of programmes based on three questions. Firstly, there has been considerable debate about whether dating violence and violence against women should be regarded as gender-based since a number of studies show that the self-reported rates of victimisation are relatively equal by gender (Straus, 2006). It is only when looking more closely at the severity and chronic nature of the violent acts and the consequences (fear, injury) that the experiences of girls and women can be seen as dramatically more serious (Ansara and Hindin, 2011).

A study by Foshee et al (2007) examined the responses of adolescents who had completed one of the 'conducting violent acts' scales typically used when such gender-neutral results are found. In

interviews, when the students were asked to explain their responses, both boys and girls dismissed or recanted many of the 'violent' acts, raising questions about the validity of this common way of assessing dating violence and the many publications that misrepresent intimate violence as ungendered. Interestingly, when the form of abuse is sexual (whether child sexual abuse, sexual harassment or sexual assault) the fact that boys and men are the most common perpetrators and girls and women most often the victims is generally accepted. So, a key question is whether programmes present the gender statistics that highlight differential victimisation in their interactions with students. Notably, it can be difficult to ascertain this information from publications about the programmes, the major source for reviews such as this.

A second issue is gender differences in learning in response to school-based programmes, discussed later in the chapter. When this does occur, one might wonder whether students' learning could be improved in separate gender groups, leading to the third question: whether separate gender presentations or at least some time spent in separate gender groups would yield better outcomes. While most school-based programmes are universal, those that use at least some separate gender work, primarily dating violence prevention, will be highlighted.

Child sexual abuse prevention programmes

Child sexual abuse entails using children for sexual purposes that may take many forms, from the least intrusive, voyeurism, to the most intrusive, vaginal or anal intercourse (Schachter et al, 2009). Child sexual abuse school-based prevention programmes flourished in the 1980s in schools primarily targeted to elementary school children (Plummer, 1999). A meta-analysis of research concluded that children learn a statistically significant number of concepts after programme participation (Davis and Gidycz, 2000). Most studies found no significant differences in the average knowledge of boys and girls after seeing programmes (Briggs and Hawkins, 1994; Dhooper and Schneider, 1995; Tutty, 1992; Tutty, 1997), although two studies (Hazzard et al, 1990; Hazzard et al, 1991) reported that girls learned and maintained more of the material.

Child sexual abuse prevention programmes are rarely presented to separate gender groups (Tutty et al, 2005), although Freda Briggs, an expert from Australia, has promoted this idea. In qualitative research with elementary school children who participated in the *Who Do You Tell* programme (Tutty, 2014), girls aged 10 to 13 in two focus groups suggested presenting the programme in separate gender groups, commenting that it was embarrassing to hear the sexual content when boys were present, and that they sometimes did not ask or respond to staff members because of this dynamic.

Bullying prevention programmes

Currently, bullying is the major focus of violence prevention programme in schools, and, if only for this reason, deserves mention. Bullying programmes (most often directed to elementary school children – ages 5-13) rarely address gender differences in either the expression of bullying or programme results. Nevertheless, in a recent Canadian study of 1852 children, Craig et al (2007) found gender differences in the types of bullying experienced by girls as compared to boys:

> Boys were significantly more likely to report being victimized by physical bullying (44 percent of boys versus 32 percent of girls, $p < 0.01$) and by harm to their property (27 percent of boys versus 21 percent of girls, $p < 0.01$) than were girls. There was a high incidence of verbal bullying, with girls reporting significantly more victimization by this form of bullying than boys (69 percent of boys versus 80 percent of girls, $p < 0.001$). Girls were also significantly more likely to report social victimization (42 percent of boys versus 63 percent of girls, $p < 0.001$) and cyber-bullying (16 percent of boys versus 22 percent of girls, $p < 0.001$) than were boys. (p 469)

Despite these important gender differences, few bullying programmes explicitly address gender, raising the question, 'why not?' Conducting a gender analysis on dating violence and sexual harassment prevention programmes is fairly standard, but few evaluations of bullying

prevention programmes compared the responses of girls to boys. Two recent meta-analyses of bullying education programmes (both of which found only a small impact of the interventions) did not assess gender (Ferguson et al, 2007; Merrell et al, 2008). To conclude, while there has been almost no discourse on the gendered aspects of bullying and the possible impact on prevention programmes, it is perhaps time to consider doing so.

Sexual harassment as a major form of bullying

Some programme developers acknowledge sexual and other forms of harassment as extensions of teasing and bullying behaviours and preludes to teen dating violence and woman abuse in adult years (Stein, 1995; Murnen and Smolak, 2000). Berman et al (2002) see sexual harassment as one of the most rampant forms of gender-based violence, one that many girls face daily. Sexual harassment intends to demean, embarrass, humiliate or control another by slurs against their gender or sexual orientation (Fineran, 1999; Stein, 2005). Examples range from derogatory comments and jokes, to physical acts such as pulling pants down or snapping bras, to the extreme of attempted sexual assault (Stein, 2005). Interestingly, in one study, secondary students were able to differentiate teasing from bullying and from sexual harassment, suggesting that it is an important but separate aspect of bullying (Land, 2003).

Most of the literature on sexual harassment has focused on women in the workplace or university students, although more recent studies have identified the issue in middle and high schools (Fineran, 1999; Chiodo et al, 2009). Several school-based prevention programmes which address sexual harassment start as early as grade 5 (ages 10-11), but the majority are offered to high school students. Programmes that primarily concentrate on bullying also include components on sexual harassment prevention such as the 'Expect Respect' model (Sanchez et al, 2001; Meraviglia et al, 2003) but most do not address this explicitly.

In terms of the efficacy of sexual harassment programmes, Taylor et al (2010) reported mixed results in their study, with neither programme affecting sexual harassment perpetration or victimisation. In contrast, Sanchez et al (2001) found that Grade 5 students (aged 10-11 years) significantly improved their knowledge of sexual

harassment and intention to intervene in a bullying situation rather than rely on an adult to do this after participating in the 'Expect Respect' programme.

Although the harassment of gay, lesbian, transgendered, bisexual and queer students is a common aspect of bullying and sexual harassment (Williams et al, 2003; Swearer et al, 2008), occurring even in elementary schools, the extent to which this is made explicit in programmes is questionable. However, several school based programmes specific to this population have been developed (Henning-Stout et al, 2000).

Dating violence prevention programmes

Violence in dating relationships is not uncommon. Teen dating violence parallels adult intimate partner abuse in that it exists on a continuum, extending from verbal and emotional abuse to sexual assault and murder. In a Canadian study by Lavoie et al (2000) dating violence included death threats, psychological abuse, denigration and insults, jealousy, excessive control, indifference, threats of separation and reprisals, damaging reputations and harassment after separation. Although both young men and women may behave abusively, the abuse of young women by men is more pervasive and usually more severe (see Chapter Three).

Price et al (2000) studied dating violence among approximately 1700 English- and French-speaking New Brunswick young people (11–20 years old). They reported significant differences between the percentages of adolescent girls and boys experiencing psychological and/or physical abuse, 22% and 12% respectively, and sexual abuse, 19% and 4% respectively. Overall, 29% of adolescent girls and 13% of boys in the sample reported some abuse in their dating relationships.

Most dating violence/healthy relationship programmes are offered to students in middle and high schools (ages 13–18) (Tutty et al, 2005). Interestingly, while colleges and universities have taken the lead in sexual assault prevention and education programmes, few dating violence programmes are offered, an exception being Warthe et al (2013), who modelled their 'Stepping Up' programme after the 'Making Waves/Vague par Vague' programme for high school students (Tutty, 2009).

Dating violence prevention research has taken a leadership role in examining the impact of programming on the sexes, although the one published meta-analysis (13 programmes), which concluded that the programmes were effective compared to control groups, did not comment on gender (Ting, 2009). When gender analyses have been conducted on the impact of various violence prevention programmes, the evidence often shows differential effects on girls and boys. In some instances, the initial scores of the young women are already high, leaving very little room for improvement at post-test (called a ceiling effect). In several evaluations of dating violence prevention programmes, boys and young men had worse attitudes after the prevention programme than before (Jaffe et al, 1992). This 'backlash effect' may result from young men feeling blamed by descriptions of gender-based abuse.

In an early evaluation of the 'Fourth R', a well-researched Canadian teen violence prevention programme, Wolfe et al (2005) noted some gender differences: girls' post-programme attitudes towards violence did not vary between programme and control groups, but, in contrast, boys in the programme showed much better awareness of a range of forms of relational violence, comparable to the girls. Boys in the programme schools were *less likely* to self-report use of relational aggression strategies or the intention of engaging in sexual intercourse over the coming year compared to boys in the control schools. Similarly, in their later randomised cluster clinical trial (Wolfe et al, 2009b), in comparison to the control condition, boys in the programme were less likely to engage in dating violence and more likely to use condoms.

Artz et al (2000) reported that girls and young woman scored higher in desirable knowledge and attitudes in topics such as dating violence both before and after prevention programmes than did boys in the same classes. This suggests that antiviolence programmes for girls may need a different focus, as young women already know much of the information. Young women and girls may also need different approaches at different developmental stages than do boys. In their longitudinal analysis of students in the 'Safe Dates' programmes, Foshee et al (2001) also suggested that girls and boys could benefit from different approaches (such as focusing on activities to counter the peer acceptance of violence for young women), although a gender analysis seems not to be a major feature of the curriculum.

Representatives from the 'Fourth R' programme describe their way of addressing some of the difficulties in presenting gendered violence to adolescents as being 'gender-strategic' (Crooks et al, 2008):

> Because they lack the gendered understanding of important differences in the nature of this violence, both boys and girls will be hypersensitive to messages that they hear as 'boy bashing' (Tutty et al, 2002). The challenge is to understand this reality, yet increase awareness of adolescents' understanding of gender and societal constructs of gender. In the Fourth R, we target gender awareness through media deconstruction activities, discussions about different expectations and standards for boys and girls, and sometimes using different activities for boys and girls. Opportunities to discuss these issues in single sex groupings provide increased comfort while debating sensitive issues. (p 118)

'Making Waves/Vague par Vague', another Canadian programme described in Tutty (2009), utilises special separate gendered segments of the workshop, entitled 'He Said, She Said', to allow young men and women to discuss what they have always wanted to know about the other sex. Often what emerges is related to dating and sexual issues. Importantly, the groups are then brought together and each gender answers questions posed anonymously that arose from their separate gender discussions. The resultant discussion is humorous and friendly, with the common theme that both genders tend to worry about much the same issues with respect to the others, primarily what makes a good partner and how to get along.

A programme from Salt Spring Islands of British Columbia, 'Respectful Relationships', uses an explicit gender analysis in its programme information, offering 12 sessions a year for four years to students in grades 7–11 (ages 13–17) using a combination of adult and peer educators (Buote and Berglund, 2010). In a follow-up study with students from the programme (Tutty, 2009), a minority of males mentioned the focus on violence against women and girls as a negative. For the majority, it was simply not an issue.

Sexual assault prevention programmes

Sexual assault is non-consensual sexual touching or intercourse achieved through physical force, threat, intimidation and/or coercion. It takes many forms: flashing, voyeurism, or forced sexual touching, fondling, oral sex, vaginal or anal penetration and, according to Stein (2005), is rampant in schools in North America.

While sexual assault technically includes child sexual abuse, sexual harassment and dating violence, as well as assault by a stranger, prevention programming in this area often focuses on sexual assault as a discrete entity. The audiences have traditionally been young adults over age 18 who are students in colleges and universities, with a paucity of programmes for middle and high school students. Some are now recognising that sexual assault prevention should include students as young as Grade 5 or 6 (ages 11–13). Sexual assault prevention is sometimes incorporated into dating violence and/or sexual harassment programmes (Foshee et al, 2004; Wolfe et al, 2009) or can be dealt with as a separate programming topic.

College sexual assault prevention programmes are often gender-specific, having been designed for young women-only or young men-only. Some programmes for mixed-group audiences have been developed, for example, new programmes that focus on the bystanders of sexual assaults (Banyard et al, 2007) or are explicit that acquaintances are the most likely perpetrators of sexual assaults (Klaw et al, 2005). No stand-alone sexual assault programmes for middle or high school students were identified for this review. However, the separate gender nature of these college programmes may be an interesting model for other violence programming. As sexual assault is a key component of dating violence, it should be discussed in dating violence prevention programmes, despite its sensitive nature.

Discussion

One difficulty apparent in examining the array of programmes is how the 'problem' is conceptualised, which affects whether it is seen as gender-based violence or not. For example, much bullying behaviour constitutes sexual harassment or even sexual assault, which is not often acknowledged (Stein, 2005). The term 'bullying' in no way captures the seriousness of sexism or homophobia. Additionally,

sexual assaults and harassment are key aspects of dating violence but may not be highlighted because of the sensitive nature of presenting any topics related to sexuality in schools.

Furthermore, the connections between the various forms of gender-based violence are rarely made explicit (Hébert et al, 2008; Wolfe et al, 2009b), especially as the literatures tend to be fairly separate. Thurston et al (1999) argued for more comprehensive programming that highlights violence across the school years rather than segregating them into various groups: child sexual abuse for elementary, dating violence for middle and high school, for example. The effects of child sexual abuse extend throughout the life span, and some young children are starting to date (Josephson and Proulx, 2008) and are likely to be affected by pressure to engage in unwanted sexual activities.

This suggests the need for a more omnibus-style prevention programme starting in elementary school (age 5–13) and extending to at least the end of high school (age 18), if not into university. This would have the flexibility to address a number of violent experiences, with the mandate to provide information on the primarily gendered nature of these forms of abuse. 'The Second Step', a well-evaluated programme from Seattle's Committee for Children and one of the earliest prevention programmes (Bergsgaard, 1997; Grossman et al, 1997), is a teacher-offered curriculum that extends throughout elementary to middle schools, addressing child sexual abuse, bullying and conflict resolution. While not explicitly gender-based as currently presented, the programme could develop an additional high school component with a gender-based analysis of dating violence, sexual assault and harassment. Other existing gender-based programmes could consider extending their programmes to students in younger or older age groups in a similar manner.

As can be seen from the programmes reviewed previously, many school-based prevention programmes do not explicitly identify that girls and young women are the most likely victims of many forms of violence (Thurston et al, 1999). Many simply do not discuss gender differences or they focus instead on healthy relationship skills, which can easily bypass a discussion of the nature of abuse in intimate relationships. With respect to whether programmes incorporate a gendered analysis of dating violence, as mentioned previously, it is often difficult to tell. In publications describing the programmes,

in a number of instances the literature with respect to the problem did not use a gendered lens (Avery-Leaf et al, 1997), a clue that the programme materials may be gender-neutral as well.

Even with a gendered understanding of violence against women and girls, the concept of being 'gender strategic' (Crooks et al, 2008) implies not highlighting any gender differences so as not to create negative reactions in male students or teachers. In the case of external programmes, not underscoring the gendered nature of the programme may be necessary to gain entry into the school system (Tutty, 2009). Even programmes developed from feminist organisations, such as shelters and sexual assault centres, use materials and exercises (such as those on media violence or discussing gender roles) that imply a gendered analysis but do not explicitly present the arguments, although the statistics regarding the gender differences can be presented if the opportunity arises.

Nonetheless, sidestepping a gender-analysis is not necessary, especially when programmes such as 'Respectful Relationships' provide a template for how to respond should boys or young men respond negatively to gendered statistics. Presenters should avoid blaming men in general or stereotyping either men as perpetrators or women as victims. It is important to acknowledge that boys and men can also be victims of abuse and suffer similar negative consequences as girls and women.

Presenters can also stress the impact of socialisation in our culture in which the overwhelming messages about being male or female set the stage for violence. Traditional sex-role beliefs that women should be subservient to men and that women and children are essentially the property of the partner/father are examples of such messages. Providing young people with an understanding of the gender socialisation in our culture could increase both girls' and boys' awareness of these detrimental messages. It could also help them understand how such attitudes can lead to violence. In the author's view, all violence prevention and conflict resolution programmes with young people should incorporate information about gender-role stereotyping and gender expectations.

As mentioned previously, several recent evaluations of dating violence programmes have suggested that boys and young men have a different reaction (typically poorer attitudes, less knowledge) than girls or young women after participating in the same programme.

One suggestion to address this is providing separate gender groups, either programme-wide, or in special sessions (Cameron, 2002). However, although separate gender groups provide a venue to speak about gender-related issues in a 'safer' environment, as a strategy they do not guarantee a gender analysis; programmes could still avoid discussing these issues.

An issue not yet discussed in the literature is the impact of being asked to move into separate male-female groups on young people who are gay, lesbian, bisexual, transgendered or queer. At a conference with a strong youth presence in Toronto in 2012, sponsored by the Canadian Women's Foundation, we discussed gender and dating violence programmes, some of us promoting separate groups as a strategy to better address violence against women and girls. A group of young delegates described their own difficulties in responding to such exercises. Several lesbian and transgendered young people spoke of not knowing which gendered group to join and how emotionally difficult this process proved to be. At the conference, these young people wished to move the discourse to a different level entirely, focusing more on homophobia and other ways in which they had been harassed and marginalised. This suggests that a gendered analysis must not simply deal with male–female issues but, now that LGBTQ young people are becoming more visible, must incorporate their perspectives into violence prevention programming.

Nonetheless, we must not abandon the quest to address male–female differences in perpetration and victimisation of intimate and family violence; rather, we must broaden our gender lens so as not to exclude LGBTQ young people. Being more explicit about LGBTQ issues in programmes on bullying and sexual harassment will also address these concerns. This will likely not be an easy process, but is clearly important.

In conclusion, from the author's perspective, when describing the different forms of violence, it is essential to clarify the gender differences in victim–victimiser rates, especially for older students. A concerted effort must be made to better engage boys and young men in preventing violence against girls and young women that alleviates a perception of being blamed for all violence, without shifting to a gender neutral presentation. A number of authors have written about ways to do so (Crooks et al, 2007; Flood, 2011). Programmes such as 'Respectful Relationships' have persevered in their efforts

to maintain a strong feminist perspective and the response has been very favourable (Tutty, 2009). This and other programmes that have remained steadfast in providing a gendered analysis of violence should be commended and supported.

References

Ansara, D. L. and Hindin, M. J. (2011) 'Psychosocial consequences of intimate partner violence for women and men in Canada', *Journal of Interpersonal Violence,* 26(8): 1628-45.

Artz, S., Riecken, T., MacIntyre, B., Lam, E. and Maczewski, M. (2000) 'Theorizing gender differences in receptivity to violence prevention programming in schools', *The B.C. Counsellor,* 22(1): 2-30.

Avery-Leaf, S., Cascardi, M., O'Leary, K. D. and Cano, A. (1997) 'Efficacy of a dating violence prevention program on attitudes justifying aggression', *Journal of Adolescent Health,* 21: 11-17.

Banyard, V.L., Moynihan, M.M., and Plante, E. G. (2007) 'Sexual violence prevention through bystander education: An experimental evaluation', *Journal of Community Psychology,* 35(4): 463-81.

Bergsgaard, M. (1997) 'Gender issues in the implementation and evaluation of a violence-prevention curriculum', *Canadian Journal of Education,* 22(1): 33-45.

Berman, H., Straatman, A., Hunt, K., Izumi, J., and MacQuarrie, B. (2002) 'Sexual harassment: The unacknowledged face of violence in the lives of girls', in H. Berman and Y. Jiwani (eds), *In the best interests of the girl child* London, ON: The Alliance of Five Research Centres on Violence, pp 15-44. Online at: www.phac-aspc.gc.ca/ncfv-cnivf/familyviolence/nfntsnegl_e.html

Briggs, F. and Hawkins, R. (1994) 'Follow-up data on the effectiveness of New Zealand's national school based child protection program', *Child Abuse and Neglect,* 18: 635-43.

Buote, D. and Berglund, P. (2010) 'Promoting social justice through building healthy relationships: Evaluation of SWOVA's 'Respectful Relationships' program', *Education, Citizenship and Social Justice,* 5(3): 207-30.

Cameron, C. A. and the Creating Peaceful Learning Environments Schools' Team (2002) 'Worlds apart ... coming together: Gender segragated and integrated primary prevention implementations for Adolescents in Atlantic rural communities', in H. Berman, and Jiwani, Y. (eds) *In the best interests of the girl child: Phase II report* London, ON: Alliance of Five Research Centres on Violence, pp 143-69. Online at: www.phac-aspc.gc.ca/ncfv-cnivf/familyviolence/nfntsnegl_e.html

Chiodo, D., Wolfe, D.A., Crooks, C., Hughes, R., and Jaffe, P. (2009) 'Impact of sexual harassment victimization by peers on subsequent adolescent victimization and adjustment: A longitudinal study', *Journal of Adolescent Health,* 45: 246-52.

Craig, W., Pepler, D., and Blais, J. (2007) 'Responding to bullying: What works?' *School Psychology International,* 28(4): 465-77.

Crooks, C.V., Goodall, G.R., Hughes, R., Jaffe, P.G., and Baker, L. L. (2007) 'Engaging men and boys in preventing violence against women: Applying a cognitive-behavioral model', *Violence Against Women,* 13: 217-39.

Crooks, C.V., Wolfe, D.A., Hughes, R., Jaffe, P.G., and Chiodo, D. (2008) 'Development, evaluation and national implementation of a school-based program to reduce violence and related risk behaviours: Lessons from the Fourth R', *Institute for the Prevention of Crime Review,* 2:109-35.

Davis, M.K. and Gidycz, C.A. (2000) 'Child sexual abuse prevention programs: A meta-analysis', *Journal of Clinical Child Psychology,* 29(2): 257-65.

Dhooper, S., and Schneider, P. (1995) 'Evaluation of a school-based child abuse prevention program', *Research on Social Work Practice,* 5(1): 36-46.

Ferguson, C.J., San Miguel, C., Kilburn, J.C. and Sanchez, P. (2007) 'The effectiveness of school-based anti-bullying programs: A meta-analytic review', *Criminal Justice Review,* 32(4): 401-14.

Fineran, S. and Bennett, L. (1999) 'Gender and power issues of peer sexual harassment among teenagers', *Journal of Interpersonal Violence,* 14: 626-41.

Flood, M. (2011) 'Involving men in efforts to end violence against women', *Men and Masculinities,* 14(3): 358-77.

Foshee, V.A., Bauman, K.E., Ennett, S.T., Linder, F., Benefield, T. and Suchindran, C. (2004) 'Assessing the long term effects of the Safe Dates program and a booster in preventing and reducing adolescent dating violence victimization and perpetration', *American Journal of Public Health,* 94(4): 619-24.

Foshee, V.A., Bauman, K.E., Linder, F., Rice, J. and Wilcher, R. (2007) 'Typologies of adolescent dating violence: Identifying typologies of adolescent dating violence perpetration', *Journal of Interpersonal Violence,* 22(5): 498-519.

Foshee, V.A., Linder, F., MacDougall, J.E., and Bangdiwala, S. (2001) 'Gender differences in the longitudinal predictors of adolescent dating violence', *Preventive Medicine,* 32: 128-41.

Grossman, D.C., Neckerman, H.J., Koepsell, T.D., Liu, P.Y., Asher, K.N., Beland, K., Frey, K. and Rivara, F. P. (1997) 'Effectiveness of a violence prevention curriculum among children in elementary school: A randomized controlled trial', *Journal of the American Medical Association,* 277: 1605-11.

Hazzard, A. P., Kleemeier, C. P., and Webb, C. (1990) 'Teacher versus expert presentations of sexual abuse prevention programs', *Journal of Interpersonal Violence,* 5(1): 23-36.

Hazzard, A., Webb, C., Kleemeier, C., Angert, L. and Pohl, J. (1991) 'Child sexual abuse prevention: Evaluation and one-year follow-up', *Child Abuse and Neglect,* 15: 123-38.

Hébert, M., Lavoie, F., Vitaro, F., McDuff, P. and Tremblay, R. E. (2008) 'Association of child sexual abuse and dating victimization with mental health disorder in a sample of adolescent girls', *Journal of Traumatic Stress,* 21(2): 181-89.

Heise, L., Ellsberg, M., and Gottmoeller, M. (2002) 'A global overview of gender-based violence', *International Journal of Gynecology and Obstetrics,* 78 Suppl, 1: S5-S14.

Henning-Stout, M., James, S. and Macintosh, S. (2000) 'Reducing harassment of lesbian, gay, bisexual, transgender, and questioning youth in schools', *School Psychology Review,* 29(2): 180-91.

Jaffe, P., Sudermann, M., Reitzel, D. and Killip, S.M. (1992) 'An evaluation of a secondary school primary prevention program in intimate relationships', *Violence and Victims,* 7(2): 129-46.

Josephson, W. L. and Proulx, J. B. (2008) 'Violence in young adolescents' relationships: A path model', *Journal of Interpersonal Violence,* 23(2) 189-208.

Klaw, E.L., Lonsway, K. A., Berg, D. R., Waldo, C. R., Kothari, C., Mazurek, C.J., and Hegeman, K. E. (2005) 'Challenging rape culture: Awareness, emotion and action through campus acquaintance rape education', *Women and Therapy,* 28(2): 47-63.

Land, D. (2003) 'Teasing apart secondary students' conceptualizations of peer teasing, bullying and sexual harassment', *School Psychology International,* 24(2): 147-65.

Lavoie, F., Robitaille, L. and Hébert, M. (2000) 'Teen dating relationships and aggression: An exploratory study', *Violence Against Women,* 6(1): 6-36.

Meraviglia, M.G., Becker, H., Rosenbluth, B., Sanchez, E., and Robertson, T. (2003) 'The Expect Respect project: Creating a positive elementary school climate', *Journal of Interpersonal Violence,* 18(11): 1347-60.

Merrell, K.W., Gueldner, B.A., Ross, S.W. and Isava, D.M. (2008) 'How effective are school bullying intervention programs? A meta-analysis of intervention research', *School Psychology Quarterly,* 23: 26-42.

Morrison, A., Ellsberg, M. and Bott, S. (2007) 'Addressing gender-based violence: A critical review of interventions', *The World Bank Research Observer,* 22(1): 25-51.

Murnen, S.K. and Smolak, L. (2000) 'The experience of sexual harassment among grade-school students: Early socialization of female subordination?', *Sex Roles,* 43(1/2): pp 1-17.

Plummer, C.A. (1999) 'The history of child sexual abuse prevention: A practitioner's perspective', *Journal of Child Sexual Abuse,* 7(4): 77-95.

Price, E.L., Byers, E.S., Sears, H.A., Whelan, J., and Saint-Pierre, M. (2000) *Dating violence amongst New Brunswick adolescents: A summary of two studies,* Research Papers Series: Number 2. Fredericton, New Brunswick: Muriel McQueen Fergusson Centre for Family Violence Research.

Sanchez, E., Robertson, T.R., Lewis, C.M., Rosenbluth, B., Bohman, T., and Casey, D.M. (2001) 'Preventing bullying and sexual harassment in elementary schools: The Expect Respect Model', *Journal of Emotional Abuse,* 2(2/3): pp157-80.

Schachter, C.L., Stalker, C.A., Teram, E., Lasiuk, G.C. and Danilkewich, A. (2009) *Handbook on sensitive practice for health care practitioner: Lessons from adult survivors of childhood sexual abuse,* Ottawa, ON: Public Health Agency of Canada.

Stein, N. (1995) 'Sexual harassment in school: The public performance of gendered violence', *Harvard Educational Review,* 65(2): 145-62.

Stein, N. (2005) 'A rising pandemic of sexual violence in elementary and secondary schools: Locating a secret problem', *Duke Journal of Gender Law and Policy,* 12: 33-52.

Straus, M.A. (2006) 'Future research on gender symmetry in physical assaults on partners', *Violence Against Women,* 12(11): 1086-97.

Swearer, S.M., Turner, R.K., Givens, E. and Pollack, W.S. (2008) '"You're so gay!": Do different forms of bullying matter for adolescent males?' *School Psychology Review,* 37(2): 160-73.

Taylor, B., Stein, N. and Burden, F. (2010) 'The effects of gender violence/harassment prevention programming in middle schools: A randomized experimental evaluation', *Violence and Victims,* 25(2): 202-23.

Thurston, W.E., Meadows, L., Tutty, L.M. and Bradshaw, C. (1999) *A violence reduction health promotion model. Report to Prairie Partners Community Foundation,* Calgary, AB: University of Calgary.

Ting, S.R. (2009) 'Meta-analysis on dating violence prevention among middle and high schools', *School Violence,* 8(4): 328-37.

Tutty, L.M. (1992) 'The ability of elementary school aged children to learn child sexual abuse prevention concepts', *Child Abuse and Neglect,* 16(3): 369-84.

Tutty, L.M. (1997) 'Child sexual abuse prevention programs: Evaluating "Who Do You Tell"', *Child Abuse and Neglect,* 21(9): 869-81.

Tutty, L.M. (2009) '*Do dating violence and healthy relationship programs make a difference?,* Final report for the Canadian Women's Foundation. Online at: www.canadianwomen.org/sites/canadianwomen.org/files/PDF%20-%20VP%20Resources%20-%20CWF%20Healthy%20Relationships%20-%20FULL%20REPORT%20-%20April%2029%202011.pdf

Tutty, L.M. (2014). 'Listen to the children: Kid's impressions of Who Do You Tell™', *Journal of Child Sexual Abuse,* 23(1): 17-37.

Tutty, L. and Bradshaw, C., Thurston, W.E., Barlow, A., Marshall, P., Tunstall, L. and Nixon, K. (2005) *School based violence prevention programs: Preventing violence against children and Youth (Revised Ed.).* Calgary: AB: RESOLVE Alberta. Online at www.ucalgary.ca/resolve/violenceprevention/

Warthe, D.G., Kostouros, P., Carter-Snell, C. and Tutty, L. M. (2013) 'Stepping Up: A peer to peer dating violence project on a post-secondary campus', *International Journal of Child, Youth and Family Studies,* 4(1): 100-18.

Williams, T., Connolly, J., Pepler, D, and Craig, W. (2003) 'Questioning and sexual minority adolescents: High school experiences of bullying, sexual harassment and physical abuse', *Canadian Journal of Community Mental Health,* 22(2): 47-58.

Wolfe, D.A., Crooks, C., Chiodo, D., Hughes, R. and Jaffe, P. (2005) *The Fourth R interim evaluation report: Impact of a comprehensive school-based prevention program,* London, ON: CAMH Centre for Prevention Science.

Wolfe, D.A., Crooks, C., Chiodo, D. and Jaffe, P. (2009a) 'Child maltreatment, bullying, gender-based harassment, and adolescent dating violence: Making the connections', *Psychology of Women Quarterly,* 33: 21-4.

Wolfe, D.A., Crooks, C., Jaffe, P., Chiodo, D., Hughes, R., Ellis, W., Stitt, L. and Donner, A. (2009b) 'A school-based program to prevent adolescent dating violence: A cluster randomized trial', *Archives of Pediatric Adolescent Medicine,* 163(8): 692-99.

Responding to sexual violence in girls' intimate relationships: the role of schools

Christine Barter

The primary focus of this chapter is to explore girls' experiences of sexual victimisation in their intimate relationships and to provide messages for school-based responses. By concentrating on female victimisation, we do not wish to imply that boys' experiences of intimate violence are any less worthy of attention. However, research using self-reports on the effects of violence (both physical and emotional) indicate that boys report fewer, less serious impacts to their welfare than girls do (Barter et al, 2009). This is especially true in relation to sexual violence. In addition, studies indicate that violence carried out by girls; is often a direct response to their own victimisation (Cook and Swan, 2006; Allen et al, 2009). If a large proportion of violence carried out by girls is a response to their partners' initial aggression, by reducing violence carried out by boys we will inevitably also reduce girls' use of retaliatory violence.

So how significant a problem is intimate sexual violence against girls? Previous national and international findings on intimate sexual violence provide contrasting results although all testify to its significance. Estimates of sexual coercion and violence range from 4% to as high as 80% although most studies consistently show that girls are most likely to be victims and males perpetrators (Lane and Gwartney-Gibbs, 1985; Muehlenhard and Linton, 1987; Gamache, 1991; Silverman et al, 2001, Ackard et al, 2003). Muehlenhard and Linton (1987) report that 15% of their sample had been rape victims and that nearly 80% had experienced some form of unwanted sexual

activity from their boyfriends, mostly forced kissing and touching. A Scottish survey of 14 to 18 year-olds found that 10% of girls and 8% of boys said their partners had tried to force them to have sex. However, Ackard (2003) found that 4% of adolescent girls reported being physically forced into sexual contact by an intimate partner. This wide variation reflects in part a definitional problem of what encompasses sexually aggressive acts as well as sampling issues, primarily the diverse, and therefore incompatible, age groups under investigation. Our research sought to overcome this methodological dilemma by including a range of survey questions on specific aspects of sexual violence and analysing responses both by individual acts and also by a combined category of sexual violence.

Research studies

This chapter is based on two related research projects. The first study used a multi-method approach (Barter et al, 2009). A confidential survey was completed by 1,353 young people, roughly equal numbers of girls and boys, aged between 13 and 17 years old, from eight schools in England, Scotland and Wales. We selected schools from urban and rural locations and from affluent and less affluent areas. Alongside the survey, a total of 91 in-depth interviews were undertaken with 62 girls and 29 boys between the ages of 14 and 17 years. The interviews were semi-structured enabling participants to have control over the format and context of the discussions. It was recognised that a school-based study would exclude the experiences of young people not in full-time education. To bridge this gap, a complementary project was undertaken with young people who were 'disadvantaged' due to not being in full-time education, or through being in care, including teenage mothers, pupils who had been permanently excluded and young men in a young offenders institution (Wood et al, 2011). In this study, 82 young people were interviewed, this time slightly more boys (n=44) than girls (n=38). We had two advisory groups, one for young people and another for professionals, who worked alongside us throughout the two research studies.

In the following section, our findings on physical and emotional forms of intimate violence are outlined. These findings provide a wider context in which sexual violence was often perpetrated. The survey and interviews found that, in most cases, girls who experienced

sexual violence also experienced physical and controlling behaviours from their partners. Consequently, experiences of sexual violence need to be contextualised within wider relationship dynamics.

Physical and emotional violence

In this section, both girls' and boys' responses will be used to illustrate the importance of ensuring that both incidence and impact are measured when exploring intimate violence. From the sample, 25% of girls and 18% of boys who reported a relationship experienced some form of physical violence, such as being pushed, hit or slapped. Moreover, approximately 11% of girls (but only 4% of boys) reported *severe* physical violence, such as being punched, strangled or hit with an object. We asked young people to report the subjective impact of the violence they experienced and separated their responses into 'no impact' or 'negative impact'. The analysis showed that 76% of girls, compared with 14% of boys, stated that the physical violence had negatively impacted on their welfare. Girls more often stated that the violence made them feel scared, frightened, upset or unhappy.

However, boys' perceptions of the impact of physical violence from their partners, both in the survey and interviews, were fundamentally different. In all sources of data, boys' responses showed that, generally, girls' use of violence against them was seen as amusing, sometimes annoying, but few reported a negative emotional effect. Consequently, what was fundamentally distinct in boys' accounts compared to girls' accounts, both in the survey and interviews, was a lack of fear.

In relation to emotional violence, nearly 75% of girls and 50% of boys reported some form of emotional violence from a partner, including verbal abuse, being screamed or shouted at, threats, and, most commonly, controlling behaviour. Control usually centred on two distinct areas: the wish to restrict and determine a partner's movement; and the desire to disrupt, or in some cases sever, friendship networks. A principal component of this control involved continual surveillance. A central mechanism to enhance the level of surveillance was through the use of mobile phones and, specifically, the use of text messages. Violent partners often used their own peer networks as a means to keep partners under observation and to extend their control over them. A few also attempted to coerce their girlfriend's own friends into reporting her movements and interactions. Nonetheless,

control did not have to be underpinned by physical violence or intimidation to impact negatively on girls' lives. Again, more girls than boys stated a negative impact, although proportionally fewer participants (31% of girls and 6% of boys) reported this compared with other forms of violence. More girls than boys reported multiple (more than three) forms of emotional abuse. Having briefly outlined the incidence and impact of physical and emotional aspects of relationship violence, the rest of this chapter specifically addresses girls' experiences of sexual violence from their partners.

Sexual violence

The survey contained four questions to gauge the incidence of sexual violence in young people's relationships. The questions were designed to reflect the role that both 'pressure' or coercive control and physical force can play in perpetrating sexual violence. In addition, two levels of sexual violence were investigated. Firstly, a wide definition of sexual violence was utilised which involved asking if respondents had ever been 'pressured' or physically forced 'to do something sexual, such as kissing, touching or something else'. This was followed by a more restricted definition being used which focused on if respondents had ever being pressured or forced into 'having sexual intercourse'.

Girls were significantly more likely than boys to experience sexual violence. Combining all reported incidents, 31% (n=185) of girls, compared to 16% (n=93) of boys, experienced sexual violence from their partner. However, important caveats regarding the accuracy of some of the boys' data have been identified. Incident rates for boys' sexual victimisation varied between 9% and 22% in seven of the eight schools. However, one school showed a markedly higher rate of 37%. This was mostly attributed to a group of similar aged boys. Our fieldwork notes showed that in this school a number of male participants laughed and talked together while the survey was being administered. We therefore need to question the validity of this aspect of the data. Nevertheless, even with these responses included in the analysis being female still constitutes a significant associated factor for sexual victimisation

Overall, 31% of girls aged between 13 and 17 had experienced sexual violence. Breaking this down into the specific questions asked, coercive control or 'pressure' was used much more frequently

by partners than physical force. Just over a quarter of girls (27%, n=162), stated that they felt pressured into doing something sexual against their wishes. For the majority this had happened only once or a few times. For a small minority (1.5%, n=9) this had been a regular occurrence. More than one girl in eight (13%) had been physically forced into doing something sexual; for most girls this was an isolated incident. However, for a minority (5%, n= 31) the victimisation was occurring on a more systematic basis. In relation to sexual intercourse, 16% (n=93) of girls reported that they had been pressured into intercourse and 6% (n=35) stated they had been physically forced. Again, although for many this was an isolated experience, 6% had regularly been pressured into sexual intercourse and five girls reported that physical force had been repeatedly used.

The vast majority of girls (70%) who were sexually victimised emphasised that this had a negative impact on their welfare. Overall, half of the girls interviewed for both studies reported some form of sexual violence. All subsequent quotes are from Barter et al (2009) or Wood et al (2011) and have been anonymised.

> Louise: "Um … well yeah, he was pressuring me a lot.
> But there'd be a few times where he was like really trying
> to force me … it was a few times he did yeah."

While a few girls were able to talk in-depth about the sexual violence they had experienced, others, such as Louise, found it very hard to describe what they had been through except to state, very briefly, that it had occurred. The difficulties that girls faced in defining their experiences often surrounded their attempts to reconcile their boyfriends' violent behaviour with their own wish to maintain the relationship despite that behaviour. Many of these girls endeavoured to do so through limiting the significance and impact of the abuse.

> Jasleen: "But when it happens it just kind of happens and
> then afterwards you think oh my god … but the weirdest
> thing is you still go back, we still go back to them, we
> still see them again because we have feelings for them
> obviously, but we shouldn't have went back to them …"

> Interviewer: "You still have feelings for them?"

Jasleen: "They didn't force you 'cause they can't. Well they did kind of yeah."

Jasleen sought to minimise her partner's actions by initially stating that she had not been physically forced into sex, although she then acknowledges that he "did kind of". Some of the incidents described to us by female participants in the two studies constitute statutory rape. Nevertheless, girls struggled with classifying their experience of sexual violence in this way. More girls spoke to us about their experiences of sexual violence based on pressure or coercive control.

Rebecca: "He tried making ... he kept trying to make me have sex with him and I was like, and first of all I was like 'no no no' and then he was like trying, kissing my neck and stuff like that to try and make me do it ... I was like "no no no" because I hadn't done it before; he was like 'go on, go on, go on' and I was like 'no' and then I finally like give in to him and we went off to go and do it. But obviously like I was like 'I don't want to do it'."

Interviewer: "Did he keep trying?"

Rebecca: "Yeah and I was like 'no I can't I can't' and he, oh my god, and he made me suck his dick and it was horrible, and then he never made me but he kept telling me to do it and I was like 'no', because I'd never done anything like that before and I was like 'no, no, no' and then I done it and it was proper horrible and I'm never doing it again but it was horrible and I can't believe I done it. Then like afterwards, where I'd been seeing him for so long... once he done that he didn't really speak to me again [*nervous laughing*] and I was so young as well, I didn't know what I was doing."

The extensive coercive pressure placed on girls, and its persistent nature, should not be underestimated. As Rebecca showed in her recollection, although the actual physical act was traumatic, this was also accompanied by overwhelming feelings of guilt due to 'allowing' herself to comply. Indeed, three years after the incident it was still

the fact that she 'gave in' to his demands which caused her most distress. Through analysing young people's accounts five coercive strategies were identified: loss of partner; allusion to love; accusations of immaturity; manipulation of saying "no"; and fear tactics.

Loss of partner

Possibly one of the most powerful forms of sexual coercion that boys used was through insinuating, or introducing the threat, that they might leave the relationship if their partner did not comply.

> Jordynn: "I said I didn't want to go any further but they persistently asked and asked and if they don't get their own way they put on like a strop. Like [name of boyfriend] storms out and then you feel like well you can feel like 'yeah ok then whatever makes you happy' sort of thing …"

> Interviewer: "And how have you felt about that afterwards?"

> Jordynn: "I felt, because obviously he felt happy, like maybe I was insecure in the relationship that the fact that he might leave me if not."

> Sarah: "… boys put pressure on the lassies to go further than they want too."

> Interviewer: "What type of pressure?"

> Sarah: "Like saying that they are not going to stay with them and they will go and get somebody else that will do it."

The above extracts show how girls can routinely defer their own wishes to their partner's wish for sexual gratification, including having sexual intercourse. It is also important to acknowledge male partners' awareness of their own actions in these situations. In these cases, female partners were clearly demonstrating they do not wish

to continue, as evidenced by the way in which Jordynn's boyfriend "storms" out of the room. Therefore, it is not that male partners are getting 'carried away' or that they are failing to read the signs of female non-consent. Many of the girls who experienced this felt that the fear of losing a partner was too great a risk to take.

Allusion to love

Often allusions to love were linked to the fear of losing a partner: specifically, if they loved them they would do what they asked. Donovan and Hester (2010) have identified that 'love' represents a neglected, and powerful, factor in understanding and responding to domestic violence. This form of pressure was often less overt than the one discussed above. A more subtle form of pressure was exercised to instil a sense of obligation.

> Louise: "They manipulate you into thinking that's what you had to do. Like if you really respect (love) them … they try and do that … That was quite hard, I remember that. Because you know I was like young so … then like the next day I'd be like 'God, can't believe that happened', you know."

Accusations of immaturity

Girls spoke about their older partners using the age difference to emphasise their lack of sexual maturity. Inherent to this form of sexual pressure was the fear that they may be replaced by an older, more sexually active, girlfriend.

Manipulation of saying "No"

For many, saying "no" to their partner's demands was extremely difficult. Previous work has shown that perceptions of nonconsent in relationships are gender specific. Hird (2000) shows how girls generally view verbal expression of non-consent as sufficient, whilst boys demand physical as well as verbal signs, such as pushing them away, removing hands or walking away. Many girls perceived that boys' use of sexual pressure was not simply due to misreading signs

of non-consent (Hird, 2000), but was more premeditated. Some girls felt that male partners used their reluctance to overtly refuse sexual demands to their own advantage.

> Laura: "To say 'no' is really kind of big; like got to say no because you really don't want to do this, and usually in my head it's like I'm going to count down from ten and then I'm going to say no."

Fear tactics

In some instances, the sexual coercion experienced by the girls interviewed was also underpinned by threats of intimidation and violence. Many of these girls were too scared of their partner's reaction to refuse their demands. Most relationships initially contained some consensual sexual experiences. However, as some of these relationships progressed the consensual aspect often declined. For some, this meant that towards the end of the relationships the majority of their sexual experiences were negative. The difficulty for girls of experiencing consensual (and enjoyable) sexual experiences alongside sexual violence could be very confusing. Indeed, some girls were already struggling with very complex issues regarding how to determine if their partner's behaviour constituted sexual coercion.

> Jasleen: "But how do you know if someone's using you or not? How can you tell if someone's using you for sex, how would you tell ... because you don't know if they're genuine or not?"

Resistance

Some girls had developed protection strategies such as ending any relationship where they felt uncomfortable with their partner's behaviour. This strategy seemed to be mostly applied in situations which did not involve a serious long-term partner. However, many, and especially disadvantaged young women, felt they had little choice but to endure it. Many normalised the presence of sexual coercion, and in some cases physical force, as a common, although unwelcome aspect of relationships. A common theme to emerge was that active

defiance of sexual coercion was often too risky a strategy to employ, due to the fear of making their partner angry, and consequently many girls resorted to 'passive resistance'.

> Interviewer: "So how did you deal with that when he was trying to force you?"
>
> Tasminder: "I didn't, I just went with the flow really. I was just crying, I was just crying and crying and crying."

In the majority of interviews, severe physical violence was initially experienced due to a refusal, or more often reluctance, to undertake a particular sexual act, most often sexual intercourse (Kaestle and Halpern, 2005). Moreover, once physical violence was used its presence often became routine.

> Amy: "Sometimes I just really didn't want to do anything, I'd rather just sit there, it was kind of weird, he just wouldn't want that. So then I thought if I don't he'll just get mad with me and I don't want that, so I just let him get on with it."

Having explored female participants' experiences of sexual violence, we will now move on to examine some of the wider dynamics and associated factors before addressing boys' use of sexual violence.

Sexual violence dynamics

Three quarters (75%, n=146) of girls stated that the sexual violence only occurred in one relationship. However, for a quarter (25%, n=43) the violence had happened in a few relationships. Nearly half of girls (46%, n=89) reported that the violence stopped, over a third (39%, n=70) said it remained the same and a minority (15%, n=28) reported an escalation in sexual violence within their relationships. However, we do not know if the violence itself stopped or if the relationship ended.

Help-seeking

Reflecting our findings on physical and emotional forms of violence, peers were the only substantial area of support used by young people who were experiencing sexual violence in their relationships. Nearly half of girls (48%, n=92) informed a friend about their sexual victimisation. Siblings were used by 8% of girls and only a very small minority of young people told an adult, something to which we will return.

Associated factors

Age was not significantly associated with sexual violence for either gender, and younger girls were as likely to report sexual violence as older participants. Given the impact on girls, this must be viewed as a very worrying finding and one that has important safeguarding implications. However, more girls in the oldest age group (16 years old and over) reported being physically forced into sexual intercourse than any other age range. It may be that as girls get older they are more able to resist sexual pressure and, therefore, some boys resort to physical force.

A significant association was found between the age of a partner and sexual violence for girls; this association was also mirrored in physical and emotional forms of violence. Three quarters (76%) of *all* incidents of sexual violence for girls occurred with an *older* partner. In interviews, girls identified an older partner as being at least two years older.

As with physical and emotional partner violence, a significant association was found between experiencing family violence and sexual victimisation by a partner. Nearly half (45%) of girls who reported family violence (which was defined as domestic violence or familial child abuse) also experienced sexual victimisation in their relationships compared to a quarter of girls (25%) who had not experienced family violence. This reflects previous research (Barter 2009) and constitutes a major area of concern.

Instigation of sexual violence

Responses to the survey showed that 12% of boys and 3% of girls reported using some form of sexual violence against a partner, with nearly all such cases involving sexual pressure. Half of the boys stated that the sexual violence was due to a negative reason, acknowledging their responsibility, whilst one third said they had been messing around.

No female interviewees stated they had used any form of sexual violence. Some male participants did reveal sexually coercive tactics, often emphasising that this was a normalised and routine aspect of relationships. These boys reported that everyone behaved this way and that it was commonplace for boys to try and persuade girls to engage in sexual activities even if they "seemed" reluctant. Many justified their behaviour as "messing around". However, it was also evident from the interviews that some boys were unsure if their behaviour constituted sexual coercion or pressure. Some were unclear if they had actually gained 'active' consent for their partners or simply assumed it had been given. Most stated they had not asked their partners how they felt about their behaviour.

> Marcus: "I do it sometimes like. Girls are pushing my hands away and that. They're just shy … girls are like that."

Some male participants also showed pride in their ability to control their partners, including sexually. These male participants often lacked any other areas in their lives where they could feel in control and acquire a feeling of self worth. In these instances, girls were often objectified as primarily sexual objects. Sometimes this controlling behaviour was supported in wider peer group interactions where male control of partners was viewed by male peers as a sign of status. This was demonstrated in a male group interview where participants revealed mutual admiration for each other's sexually coercive tactics. In addition, many of the male participants who reporting using violence, including sexual violence, often held very traditional notions of gender role expectations (McCarry, 2010). International research has shown that adolescents with more traditional ideas about gender roles were more often instigators of sexual violence, as were

those who could less easily accept other people's sexual boundaries (de Bruijn et al, 2006). These are fundamental issues which require addressing at a societal and institutional level. Having explored the main research findings on girls' experiences of sexual violence, we will now address the implications for schools.

Implications for school-based prevention and intervention

The level of violence in young people's relationships testifies to the need to develop school-based responses that are aimed at safeguarding children's and young people's welfare. This research provides a firmer evidence base on which to develop more effective and accessible prevention and intervention services for children and young people. Young people have repeatedly stated that the relationship element of Sex and Relationship Education (SRE) is neglected. A survey of over 1,700 young people found that 92% had learnt about the 'biology of sex and reproduction' but only 21% had learnt 'skills for coping with relationships' (Sex Education Forum, 2008). This is an obvious area where work in schools needs to be targeted if we are to prevent sexual violence in young people's relationships.

How do schools effectively respond to boys' and young men's sexual violence against girls? De Bruijn et al, in their Dutch study of sexual aggression, conclude that it '… is not possible to contrast sharply adolescents who are in need of therapeutic interventions, either as a victim or perpetrator of unwanted sexual behaviour, from those who just "make a mistake" in sexually experimenting' (2006: 94). However, our findings suggest that male instigators of violence in adolescent relationships, including sexual violence, do not necessarily represent a homogenous group. It may be that a more nuanced approach is required. Consequently, distinct prevention or intervention approaches may be needed in schools. Not all boys were necessarily aware, or were 'certain', that their behaviour constituted sexual pressure or coercion. Some also seemed oblivious to the negative impact that their behaviour may have had on their partners. Similarly, in girls' accounts, some participants were unsure if their partners recognised the negative consequences of their behaviour. Indeed, we found little evidence of open and reflective communication between young people about the sexual aspect of

their relationships. However, our research also clearly showed that for some male partners this was a more overt and knowing use of control and violence. Our discussions with girls with much older partners (at least two years) were particularly concerning, as such relationships were characterised by inequality and control. In these instances, any trace of sexual negotiation was largely missing. It is unclear if these behaviours represent different positions on the same continuum or distinct instigation trajectories.

Intervention programmes need to ensure that all young people recognise that consent to sexual activity has to be given freely without duress or pressure and that it can be withdrawn at any point. Given our research findings, this may be difficult for some young people to acknowledge, indicating that an exploration with young people about their understanding of consent to sexual activity is crucial in schools work. How is consent negotiated in young people's relationships and how widely do young people understand the need to gain active consent rather than 'passive' compliance? Our findings also indicate that interventions need to explore with young people how gender expectations impact on the gaining and withdrawal of consent and how these understandings, or misunderstandings, can contribute to unacceptable sexual behaviour.

However, our research also showed that some instigators knowingly used sexual violence and justified their actions as being a standard, and acceptable, aspect of traditional gender relations. In some cases, violence was viewed as a normal part of their lives, including family violence and association with violent peer networks. The control and violence they exercised over their female partners was viewed as a continuum of these experiences. The work of Gadd and Jefferson (2007) on psychosocial criminology provides an insight into how more intensive work may be required to address some forms of sexual violence instigation. They seek to explore the subjectivities of violent offenders by linking their inner and outer worlds and thereby develop a deeper understanding of the links between emotions, morality and culture. They argue that violence can often be viewed as emerging from disordered social relationships. To understand why young people use violence, and subsequently how to intervene in this process, we need to explore the emotional worlds of those individuals to understand how morality, crime and violence stem from feelings of anger, shame and guilt that develop in relation to others. These

feelings can then compound entrenched notions of gender roles and traditional masculinities to increase the use of interpersonal violence. Central to this process is a lack of empathy for the feelings of others.

Schools will often already be working with many of these young men due to their wider use of violence: for example, through bullying programmes or due to offending in the community. Interventions to challenge sexual violence need to be more directly linked to this work. It should, however, be acknowledged that although schools can play a major part in transforming attitudes, some entrenched behaviours, as described above, will require additional professional therapeutic services.

Prevention programmes need to address the diversity in young people's use of interpersonal violence. Different forms of interventions, whether primary or secondary, may be best tailored to different instigation profiles. Extrapolating findings on sexual violence from the survey and in-depth interviews reveals a more complex picture of young people's use of sexual violence. Figure 3.1 illustrates how emerging patterns associated with a range of factors indicate how effective 'universal' prevention programmes, based on changing attitudes, will be compared with interventions based on changing deep-rooted behaviour. Moving across the figure each factor identified increases the likelihood that behaviours become entrenched, more justified (including reference to traditional gender roles) and resistant to change. At the same time we would need to also include positive or resilience factors in these young men's lives, which can be built on whilst also challenging their use of violence.

Unfortunately, due to lack of research, and especially longitudinal studies, we are not yet at this level of complexity. It seems reasonable to presume that time-limited prevention programmes, as most schools have, may be more aligned to reduce less entrenched, less 'knowing' forms of intimate violence. However, where intimate violence has become more severe, patterned and perpetuated through wider peer interactions and family violence a more intensive multiagency intervention may be necessary. Long-term evaluations on the effectiveness of different prevention and intervention programmes are required. Due to a lack of longitudinal research it is not yet known what factors support positive change in young people's attitudes and

Figure 3.1: Instigation typology

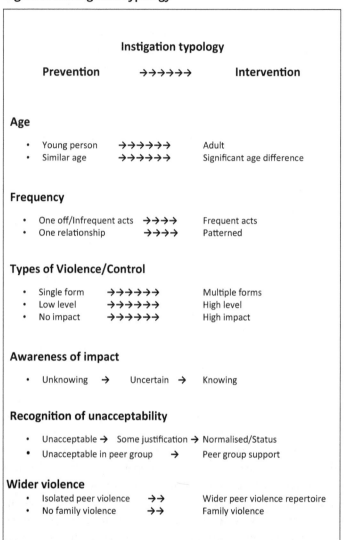

behaviours into adulthood. Given the costs of adult domestic violence any reduction would be both socially and financially beneficial.

This chapter has so far concentrated on school responses to boys' use of sexual violence. However, irrespective of how successful a prevention or intervention programme is, some girls will still experience violence and require support. Our research contained

a number of messages for schools regarding how best to support young victims of intimate violence, including sexual victimisation. Worryingly, very few girls who had experienced violence told an adult. In the school-based interviews, some young people identified learning mentors as a source of appropriate support and advice. Learning mentors, a strand of the Excellence in Cities (EiC) initiative, work largely with children and young people in primary and secondary education settings. Learning mentors are not teachers, but members of the local community whose remit is to provide additional support to pupils to help them address barriers to learning. Thus, their work bridges academic and pastoral support roles. In the interview sample, some girls spoke very positively about the support that the mentors provided generally, as well as specifically in relation to the girls' experiences of partner violence. In these circumstances, learning mentors were perceived as being distinct from the educational aspect of school, and as they were recruited from the local community young people felt the mentors could understand the issues they were facing in their lives. They also felt that the mentors took their problems seriously and included them in the decision making process. The service was not viewed as stigmatising by young people due to its remit of learning support rather than child welfare. This provides an important example of an accessible and appropriate school-based service for young victims of intimate violence.

Nevertheless, the research clearly identified that young people's main avenue for support and advice was through peers. School-based interventions need to build on young people's existing help-seeking behaviour through peer counselling or mentoring schemes. Although generally perceived as a response to bullying, they could be extended as a potential source of support for young victims of intimate violence once additional training has been received by peer counsellors. Research on bullying has shown that a whole school response to stop bullying is essential (Cowie, 2011). This awareness and intolerance now needs to extend to violence in young people's relationships.

The research findings provide clear evidence that some teenage girls, especially those with a history of family violence or with an older or much older boyfriend, are at serious risk of harm due to their partner's violence. These young people require a multi-agency response which recognises their vulnerability and works with them

to acknowledge the risks they are experiencing. However, the status of having a boyfriend, and particularly an older boyfriend, in girls' perceptions also requires attention. Schools need to support girls to improve self-confidence and self-esteem and to build resilience in order to decrease their dependence on relationships to gain social status.

In conclusion, we shall return to the question posed at the beginning of this chapter. How significant a problem is intimate sexual violence against girls? Our findings have highlighted that physical, emotional and sexual violence in young people's intimate relationships represents a substantial threat to girls' welfare. This threat is now more widely recognised within policy and practice. A range of school-based interventions are now in place and we await evaluations of their impact with interest. However, it is clear that schools have a central and crucial role to play in safeguarding young people's wellbeing through challenging the normalisation of violence in young people's relationships, building resilience, addressing instigation and supporting victims.

References

Ackard, D.M., Neumark-Sztainer, D. and Hannan, P. (2003) 'Dating violence among a nationally representative sample of adolescent girls and boys: Associations with behavioral and mental health', *Journal of Gender Specific Medicine*, 6(3): 39-48.

Allen, C., Swan, S. and Raghavan, C. (2009) 'Gender symmetry, sexism, and intimate partner violence', *Journal of Interpersonal Violence*, 24(11): 1816-34.

Barter, C., McCarry, M., Berridge, D. and Evans, K. (2009) *Partner exploitation and violence in teenage intimate relationships*, NSPCC/ University of Bristol. Available www.nspcc.org.uk/inform/research/ findings/partner_exploitation_and_violence_report_wdf70129.pdf.

Cook, S. and Swan, C. (2006) 'Guest editor's introduction to the special issue on gender symmetry', *Violence Against Women*, 12: 995-96.

Cowie, J. (2011) 'Understanding why children and young people engage in bullying at school' in Barter, C. and Berridge, D. (eds) (2011) *Children behaving badly: Violence between children and young people*, Chichester: Wiley.

de Bruijn, P., Burrie, I. and van Wel, F. (2006) 'A risky boundary: Unwanted sexual behaviour among youth', *Journal of Sexual Aggression*, 12(2): 81-96.

Donovan, C. and Hester, M. (2010) '"I hate the word 'victim'"': An exploration of recognition of domestic violence in same sex relationships', *Social Policy and Society*, 9(2): 279-89.

Gadd, D. and Jefferson, T. (2007) *Psychosocial criminology: An introduction*, London: Sage.

Gamache, D. (1991) 'Domination and control; The social context of dating violence', in Levy, B. (ed), *Dating Violence: Young Women in Danger*, Seattle: Seal Press.

Hird, M.J. (2000) 'An empirical study of adolescent dating aggression', *Journal of Adolescence*, 23: 69-78.

Kaestle C.E., and Halpern C. T. (2005) 'Sexual intercourse precedes partner violence in adolescent romantic relationships', *Journal of Adolescent Health*, 36(5): 386-92.

Lane, K.E. and Gwartney-Gibbs, P.A. (1985) 'Violence in the context of dating and sex', *Journal of Family Issues*, 6(1): 45-59.

McCarry, M. (2010) 'Becoming a 'proper man': Young people's attitudes about interpersonal violence and perceptions of gender', *Gender and Education,* 22(1): 17-30.

Muehlenhard, C. and Linton, M. (1987) 'Date rape and sexual aggression in dating situations: Incidence and risk factors', *Journal of Counselling Psychology*, 34(2): 186-96.

Sex Education Forum (2008) *Key findings: Young people's survey on sex and relationships education (Briefing paper),* London: National Children's Bureau and Sex Education Forum. Available www.ncb.org.uk/media/333301/young_peoples_survey_on_sex___relationships_education.pdf

Silverman, J.G., Raj, A., Mucci, L.A. and Hathaway, J.E. (2001) 'Dating violence against adolescent girls and associated substance use, unhealthy weight control, sexual risk behaviour, pregnancy, and suicidality', *Journal of the American Medical Association*, 286(5): 572-9.

Wood, M., Barter, C. and Berridge, D. (2011) '"Standing on my own two feet": disadvantaged teenagers, intimate partner violence and coercive control', London: NSPCC. Available www.nspcc.org.uk/Inform/research/findings/standing_own_two_feet_wda84543.html

FOUR

'Pandora's Box': preventing violence against black and minority ethnic women and girls

Hannana Siddiqui and Anita Bhardwaj

Introduction

In September 2010, Southall Black Sisters (SBS)[1] embarked on a two-year pilot project to test the whole school approach in preventing violence against black and minority ethnic (BME) women and girls. The aim was to establish if our intervention could successfully challenge and change attitudes and behaviour at all levels, amongst pupils, teachers, governors, parents and support staff. We also endeavoured to embed the issue in the teaching of curricular and non-curricular subjects and, indeed, to change the whole ethos of a school so that its policies and procedures on equalities, safeguarding and school bullying reflected an understanding of, and measures to tackle, violence against BME women and girls (BME VAWG).

The SBS project was part of a wider evaluation of the whole school approach to preventing violence against women and girls (VAWG) pioneered by Womankind Worldwide,[2] funded by Comic Relief[3]. The project built on decades of work by SBS in schools and colleges with young people in raising awareness of and challenging attitudes to BME VAWG. The work of the project concentrated on Year Nine and 10 pupils aged between 13 and 15, but in total we worked with about 2300 pupils/students, teachers, governors and parents in two schools from September 2010 to August 2012. In order to assess the impact of the project, a range of tools were used, including pre- and post-surveys, focus groups with pupils, 'learning journals' for pupils

85

in classroom sessions, questionnaires for teacher training provided in the project and interviews with senior and lead teachers.

In the words of one lead teacher, there was a particular fear that the SBS project would open a 'Pandora's Box'. Both schools were concerned about religious and cultural sensitivity, and about challenging some BME pupils, especially boys, holding ingrained conservative attitudes on gender equality. The fear of being accused of racism, intolerance of minority cultures and, in particular, of being Islamaphobic or anti-faith by BME parents and the community were unique issues which hampered progress on addressing BME VAWG. This chapter focuses on how SBS attempted to overcome these barriers, and the extent to which we successfully increased levels of awareness and understanding among pupils and teachers, changed attitudes and behaviour among pupils, and improved the policies, ethos and environment of the whole school in relation to BME VAWG.

Background

As a grassroots expert, SBS focused on BME VAWG issues in two co-education comprehensive high schools, which we will call School A and School B, selected because of their location in an area with a high BME population in West London. Both schools have a high percentage of children from Somali, Afghani and South Asian backgrounds, the latter forming the majority of the school population. A high number of these children had English as an additional language, were recent arrivals in the UK and were from a low socioeconomic background. The teachers were from white or minority, mainly Asian, backgrounds, with a higher number being female in both schools. At senior levels, there were about equal numbers of white male and female teachers. In 2007, School A had an 'outstanding' rating from the school's inspectorate body, Ofsted, while, in 2010, School B was classified as 'satisfactory'.

School A was conventional in how and what it taught, but also organised and efficient. For example, it worked with us to develop the lesson plans and introduced the idea of a 'learning journal' to help pupils record their progress and capture changes in their level of awareness. The school designated an experienced senior member of staff to work with the project, and, in the second year, an enthusiastic

teacher also led on delivery. However, the school insisted that our teaching materials and evaluation questionnaires excluded some controversial issues, such as female genital mutilation (FGM), because it was too similar to sex education or because the subject had upset pupils in the past. At the same time, they recognised the need to push boundaries to confront difficult issues such as harmful practices and to address VAWG more generally. Despite this view, School A later wanted to monitor and control what pupils said in a DVD on forced marriage that SBS planned with the drama department. This led to SBS withdrawing from the DVD project as it did not want pupils to be censored and prevented from giving their honest views.

School B was more flexible in its approach, but also less organised and more 'politicised' in its outlook. Indeed, our project experienced some delays in year one when sessions were suspended because teachers and pupils went out on strike in support of a teacher facing disciplinary action, which also drew support from the local BME community. This situation continued until the pupils themselves demanded that the sessions be reinstated, but a junior member of staff was allocated for the work which highlighted the low priority the project had in the school.

In year one, nervous about the 'sensitive' nature of the project, School A wanted to test out the project by limiting it to Personal, Social and Health Education (PSHE) classes for Year Nine, while School B 'piloted' it on 30 pupils, also from Year Nine, in their Personal Development Curriculum (PDC) sessions. These were repeated in year two of the project, but extended to the whole of the school in School B. By the second year, we also undertook more workshops and whole school events in both schools. In School A, SBS also developed a VAWG 'Peer Ambassadors Programme'. These ambassadors organised a whole school event on the International Day to End Violence against Women in 2011, campaigned on the issues of forced marriage and 'honour-based' violence (HBV), and helped to deliver classroom sessions to Year Nine.

The issues discussed in the activities included: gender equality and gender stereotypes; VAWG myths, realities and definitions; healthy and respectful relationships; consent; sexual bullying; the effects of violence; why men are violent; immigration and racism; BME VAWG; honour and forced marriage; religion and culture; suicide and self-harm; intersectional discrimination, particularly that based

on race and gender; black feminism; risks, early warning signs; and where to seek help.

Both schools had very little school time for teacher training and restricted this to short sessions with teachers delivering the classroom sessions. In addition, in School B, we undertook two workshops with parents, and advice sessions with pupils.

School 'sensitivities'

While both schools had policies on safeguarding and equal opportunities, none existed on gender equality or VAWG. The outlook of both schools was focused more on race equality and they did little work on BME women, who stand at the intersection of race and gender. Indeed, we convinced the governors to undertake the project by comparing the need to address domestic violence on the same basis as racial violence.

Prior to this project, individual teachers in both schools interested in addressing BME VAWG would occasionally invite SBS to carry out workshops with pupils, and in some years, we undertook some short-term structured programmes. This work had not included working with the whole school, mainly because some BME parent governors had objected to our involvement in the school. They were concerned that SBS would 'corrupt' their daughters and encourage them to leave home or challenge their parent's authority. This time, a governor in School B implied that the project was not needed as domestic violence in Asian communities had 'already been addressed', and the project could 'stigmatise' boys from Afghani and Somali communities as they appeared to hold some of the most conservative views. In School A, a governor questioned whether parents had given permission, and suggested that abusive parents would not allow their children to participate.

Despite these concerns, however, the governing bodies agreed to allow SBS to undertake the project, with strong support from head teachers and department leads in both schools. Although School A had done some work on domestic violence, both schools had undertaken limited or no work on VAWG or women's rights, and even less on BME women and girls. However, they wanted to develop this work to improve educational performance and safeguarding, and to influence change in future generations:

"... more importantly the future of the young people at this school and how they live their lives, and how young people live their lives; it's about breaking the cycle and improving the world, you know, there's a lot of young people come through a school and they go everywhere so each one of those people have got the power to make a difference to their lives, you know, their own lives and the people they interact with, so I think each child can be an agent of change for the future so it's very important." (Acting Head, School B)

Teachers in both schools lacked confidence in their level of understanding of VAWG, and were nervous about handling BME VAWG issues. They were concerned about challenging violence justified in the name of culture, and particularly religion, for fear of being accused of insensitivity or ignorance.

Only School B allowed us to work with parents, but again this was not sustained beyond two sessions. Some parents expressed concern that SBS was working in the school as they did not want their daughters to learn about the subject, while most Somali parents were reluctant to discuss FGM, although it was admitted that the problem existed in the community. Indeed, the adverts for the workshops had to be toned down after they were defaced, from advertising discussions on FGM or BME VAWG to those on healthy relationships. The parents' workshops did not continue due to the supposed need by the school to address 'other priorities', particularly after a teacher organising these events left the school.

Schools' experience

In the pre-intervention interviews, the senior teachers in both schools displayed a good understanding of VAWG and recognised the complexities of gendered violence in extended family networks in Asian communities. In School B, the teacher said that reporting rates were lower in Somali communities, and that sexual abuse was not reported so much as a 'regular stream' of physical violence. The school also knew that Asian girls did not have as much freedom as boys or children from white backgrounds. The teacher said Asian girls did not engage in school activities as much, and they used the

school as a space to 'explore their sexuality' by 'dressing provocatively' as they were not allowed to socialise or wear makeup or skirts at home. Surprisingly, the school had not dealt with any cases of forced marriage, and teenage intimate partner violence was rare because dating and romantic relationships were not approved of, and so it is likely that the problem remained more hidden. The school had dealt with a number of cases of HBV, one of which was the local high profile case of Samira Nazir, an 'honour' killing:

> "She had a Chinese boyfriend, anyway a boyfriend of a different faith; she was butchered, it was horrendous, and what was also quite distressing, it was one of our pupils that murdered her, he joined in the murder; so he went with the brother, he was her cousin and he'd only been here a short time, he'd come from abroad, from Pakistan." (Head Teacher)

Pupil awareness and attitudes

Prior to the SBS intervention, most pupils in both schools showed a good understanding of what constitutes a respectful and healthy relationship and of gender equality. However, many demonstrated a low level of, and sometimes an extremely poor, awareness or understanding of VAWG and BME VAWG, particularly in School B. However, the pupils, particularly girls, were very confident about defining and very knowledgeable about forced marriage. It was the only issue on which pupils disclosed having direct knowledge of victims.

Pupils in School A displayed a good understanding of HBV and the fact that women were most affected, particularly in the context of so-called 'honour' killings as there were some well known cases. By comparison, pupils in School B did not have as great an understanding of the term HBV and had to be prompted with the words 'izzat' (honour) and 'sharam' (shame), with which they were more familiar as they are terms used in Asian languages. However, they still did not understand it as gendered violence. The boys had a slightly better understanding as it was linked with notions of honour and pride. They described it as 'sticking up' for what they believed in, and they linked it to disrespect and 'fighting for a purpose'.

Girls in School B were particularly reluctant to discuss BME VAWG and said people were silent on abuse in the community. Boys were generally careful about revealing sexist attitudes. For example, when one Afghani boy let slip that he thought it was acceptable to hit a woman, another Afghani boy attempted to divert attention away from the conversation.

Impact on pupils

Generally, the post intervention data shows increased levels of awareness and understanding and positive changes in attitudes amongst pupils in both schools. Behaviour was also changed in relation to increased rates of disclosure, more demand for work on BME VAWG within the school and a desire to help victims more. For example, in the survey, by year two, pupils became clearer in defining issues such as forced marriage and HBV, with increased rates of disclosure of themselves or others being victims. There was also strong disagreement with statements like 'families have the right to arrange your marriage; they know what is best for you, even if you think otherwise'. In School B, for instance, in year one, 12% of pupils agreed, 47% disagreed and 39% were not sure of this statement. In year two, 15% agreed, 65% disagreed and 16% were not sure. There had been an 18% increase in those who disagreed. More pupils not only disagreed with the statement but had also become clearer about their views. However, there were some key differences between boys and girls. Girls showed higher rates of awareness and condemnation of the practice, while boys knew of more female victims.

In the focus groups, while pupils were able to define forced marriage clearly pre-intervention, by year two they displayed an in-depth understanding of it and its link with family honour. There was also a greater understanding of HBV and its links to the use of male power to control women. The pupils were surprised by the high number of cases, and by how increased knowledge meant they knew what to do. Some pupils felt that there was a greater rate of VAWG within BME communities, mainly because they did not know many people from white communities, while some said this was racial stereotyping. Others also said that some BME communities were "less developed" on gender equality as violence against women occurred because minority cultures and religions were more entrenched.

'Scary' attitudes

One of the common attitudes amongst the boys before the SBS intervention is typified by the following comment:

> Somali boy: "I'm a king and I rule the land outside, she's my wife and so would be my queen; she can rule inside the home."

> Facilitator: "And what would happen if she didn't want to rule inside the home but outside?"

> Somali boy: "I'd get another wife!"

The post-intervention data shows that there was a small group of boys who held onto rigid views and, in a few cases, even reinforced them, particularly in relation to issues concerning 'honour,' interreligious marriage by girls and provocation to violence by women and girls who flirt or openly express their sexuality. For example, in School B, with regard to the statement 'women and girls need to obey their parents and families to respect their religion and culture, such as "honour" or "izzat"', pupils who agreed with the statement increased by 5% in year two, particularly boys. More girls disagreed and fewer of them were 'not sure'. While these figures show that, overall, similar entrenched views continued to be held by year two, it appears that the girl's views became more clearer and challenging, while some boys became more conservative.

A similar pattern emerged with regard to the statement: 'If a Muslim girl wanted to marry a Sikh boy it would be acceptable for the family to put a stop to this, even if it meant using force.' In School B, 3% more boys agreed and 13% fewer girls disagreed by year two; 17% more pupils were unsure. This data suggests that pupils became more conservative or unsure about their views on this statement. This may be due to the controversial nature of religion and marriage; possibly the increased uncertainty was created by the challenging debates generated in the SBS project.

Indeed, it was around this issue, which was the most hotly contested in the classroom sessions, that a few Somali and Afghani boys showed some very rigid opinions on women, particularly in a male-only

session where they were more open about their views. For example, in School A, a boy, when asked what he and his peers would do if their daughters from a specific religious background were to bring home someone from outside of that religion to marry, his answer, alongside a group of his peers, was that they would kill the boyfriend. A direct challenge of such an action was made within the class, not just by the facilitator, but also by his peers and the lead teacher. Shockingly for the teachers, a number of boys were unwilling to shift in their position on the need to "kill the boyfriend".

For the school, there was a clear understanding of the uphill struggle in working with some BME boys who held rigid attitudes, which one lead teacher called "scary". In School A, the lead teacher was unsure if this was an accurate reflection of their own opinions or something they had heard at home. The lead teacher in School B said this was going to be difficult for the school to address.

The Acting Head in School B felt that there was a fine balance to challenging BME boys on violence against BME women without them becoming defensive as they consider it an attack on their culture, and worse, an attack on their religion. Changing such attitudes was harder to achieve if they were not being challenged within the home and wider community. The Acting Head felt the impact of the SBS project had been greatest on boys but was surprised that some boys held rigid views as it was assumed that these values systems would have "petered out" with the new generation.

Many pupils in both schools also thought these attitudes would have disappeared, particularly when some had expressed the view in focus groups that there was a "culture clash" between the younger and older generations; that they held more liberal views than their own parents. The pupils also recognised problems with the school's ability to change these attitudes. They felt that teachers needed to be more comfortable and candid about BME VAWG, with "hard-hitting" stories and victims/survivors talking about it directly, as well as experts like SBS. They liked interactive methods of teaching. The most effective tools were the use of a 'body map' and the SBS DVD *My Second Name is Honour* produced by survivors. The 'body map' used different parts of the body to raise issues relevant to an honour killing, such as 'eyes' which witnessed abuse and 'legs' which could have helped the victim escape;. Feedback from teachers also

demonstrated that some found the subject matter uncomfortable and wanted more training and support to handle it.

Changing attitudes and behaviour

Despite difficulties in shifting the rigid attitudes amongst some boys, the Acting Head in School B believed the project became a catalyst, for many boys, for raising their awareness of the prevalence and injustice of VAWG within the BME community: "... boys who have become very interested ...; they see it in the community and they know that it's wrong." An example of this was that some male pupils, of their own volition, created a PowerPoint presentation on the issue of honour killings as a follow up to the PDC sessions which was then used by teachers throughout the school.

In the focus groups, boys in both schools acknowledged that there had been a general change in male pupil's attitudes and behaviour as a result of the SBS intervention. In School A, they reported that boys were more likely to mix with girls in the playground with less "play-fighting" or sexual bullying. One boy said:

> "I think after the programme we just realised that the girls and boys are equal and that they shouldn't hate each other because they are of a different sex." (Boy, School A)

Another boy also said the project helped them to be more challenging and respectful of girls:

> "Yeah, umm, like, outside of school yeah. If my friends see a girl that they find attractive, they run after them like, la, la, la. But then, if the girl is uncomfortable, I tell them to stop because she feels uncomfortable, leave her alone." (Boy, School A)

By contrast, however, in School B, some members of the girl's focus group felt that although there had been some change among the majority, some boys still treated sexual bullying as a "joke", and more work on gender equality was still required directly with the boys with more of a focus on changing male behaviour.

Some pupils also talked about how the SBS project had helped them to raise debates within their own extended families, and to realise that domestic violence had occurred within them. Others were also more aware of the problem in the community but felt helpless in doing anything about it. Many pupils, however, indicated they were more willing than previously to talk to a teacher or mentor, and to worry less about being a "snitch". They were also more aware of services provided by SBS. Many of the pupils said they would advise a friend in trouble to obtain help, and make them consider the seriousness of the matter, or report the abuse on their behalf. Some suggested talking to the abuser, if he was a friend, to try and stop their behaviour:

> "If it was my friend in an abusive relationship, first of all, I would tell them to stop, because it's wrong. Then I would talk to the person he was being abusive to and tell them to go to Southall Black Sisters. Then I would try to persuade [him] myself to stop and make him think about, if it was his little sister, how would he feel? And try to make him think about it." (Boy, School B)

Others talked about how learning about VAWG created wider change:

> "I think this is a global issue. So more people need to learn about it, the more the better, and [figure] out that it's wrong. If more people find out about it, hopefully it will stop. We're all depending on that." (Girl, School A)

There was an acknowledgement by senior and lead teachers that pupils in both schools had become more vocal and confident about challenging BME VAWG in the schools. The most effective and empowering workshop for BME girls in the project was considered to be the VAWG 'Peer Ambassadors Programme' (School A) in which 64 expressed an interest, which is an indicator of success in itself. The campaign around the International Day to End Violence against Women created long-lasting effects. Indeed, the lead teachers said that some pupils wore their white ribbons, given out on the day, for some time afterwards. They also donated their takings from

selling cakes to the SBS survivor support group (and, later on, a pupil also donated from her prize money for a school award). The project resulted in increased levels of confidence in reporting and tackling abuse more generally:

> "I now know how I can help someone who is suffering from abuse. I would be confident enough to report anything to SBS, even if I was being abused." (Girl, School A)

The success of the programme was also recognised by the Deputy Head:

> "I would like to extend my thanks to [the project worker and lead teacher] as an interesting purposeful and inspiring piece of student-voice work. Some of the girls have never spoken publicly before. As a piece of prevention and awareness work it is exemplary." (Deputy Head, School A)

The Deputy Head also said the programme helped to influence change: "for every one of the ambassadors, 10 pupils will be affected". She found that girls were more confident in expressing themselves, and the programme will be embedded in the school and maybe even extended to boys. In School B, a group of BME girls had also become more vocal on sexual bullying. This had an impact on the school environment, as stated by the Acting Head of School B:

> "I didn't observe lessons; I walked through areas and stopped to listen. I wasn't part of the official observation. But that wouldn't necessarily have had a big impact on me if it wasn't for the fact that even the dining room, the day after I think, I listened to a conversation between some boys and some girls about the session ... One girl calling one boy to account for something he said." (Acting Head, School B)

Changing school policy and ethos

In School A, the Deputy Head was reluctant to acknowledge that the project had changed their policies or ethos. She said that the school was starting from a position of strength, and that it was not so much about successfully changing attitudes or behaviour but more about "refocusing" onto VAWG. The Deputy Head argued that safeguarding policies had always been strictly applied, but they are reviewing their PSHE programme so that domestic violence, which was embedded some time ago, remains. While some pupils felt that the school had improved after the SBS intervention, others said that teachers had always taken violence seriously but it was the pupils who have come to realise its seriousness. The lead teacher in this school strongly felt that, unlike before, the school now took VAWG more seriously.

In School B, the Acting Head said VAWG had "more prominence" after the SBS intervention and more teachers were expressing concerns about pupils, some of which were founded. The Acting Head acknowledged that VAWG was now a central focus of their questioning and concern. Early warning signs, such as bruises that may have been overlooked or that they had concluded to have been the result of a fight in the playground, were now acted upon promptly. This was dovetailed by a growing culture within the school of ensuring that teachers asked the right questions and acted upon them. VAWG is now also embedded in the PDC and the arts and humanities curriculum. The Acting Head discussed a preference of a "drip feed" approach to awareness-raising and prevention work. This entailed a small but regular focus on the issue of VAWG and BME VAWG rather than big one-off events that were resource intensive but may not necessarily have a longer lasting effect.

The lead teacher in School B felt that the SBS project had a major impact at all levels within the school and BME VAWG was mentioned in articles in the school magazine, assemblies and on displays board for 'thoughts of the week.' Governors had become more interested, particularly after the local authority published some statistics on domestic violence, and there was some support from parents. The pupils agreed that while more was being done by the school there was a lot more to do. One pupil said the school ensures that referrals are made to SBS, but another pupil felt that they did not have a dialogue with pupils; some boys felt there was more dialogue with

girls than boys. Sexual bullying, such as 'bum smacking', was still a problem in the school but not to the same extent.

Although the teachers' levels of understanding of VAWG increased, their levels of awareness about BME VAWG seem to show an even greater increase after the SBS intervention, particularly in School A. Teachers said that the training gave them unprecedented insight into the nature and scale of the problem. Although some teachers felt nervous about sensitive issues involving BME VAWG, they felt that the training helped to show them how to deliver to BME pupils while being part of the white community.

Conclusion

Overall, the project showed some significant positive changes in the level of awareness and understanding, and in changes in attitudes and behaviour, in relation to VAWG and BME VAWG in both schools, particularly amongst pupils and teachers, but also in the general school policies, ethos and environment. While the schools did not introduce new formal policies on gender equality or VAWG, they indicated that they would be willing to do so in the future with more input from SBS. The schools were monitoring bullying more, teachers were more vigilant about signs of abuse and pupils were more willing to disclose or report abuse. The project helped to embed VAWG and BME VAWG in some subjects, particularly PSHE/PCD and whole school events and programmes, such as the VAWG 'Peer Ambassadors Programme'. There was more literature and posters about VAWG visible in the schools. However, there was insufficient time or willingness by the school to undertake work with parents, governors and support staff.

Both schools stated that expert SBS intervention should continue. SBS will be producing an education pack to enable teachers to continue delivery and to replicate the work in other schools[4]. However, it is critical to increase the schools' teacher training and classroom sessions, and the involvement of the whole school, to maximise impact. It is also clear that for the programme to be successful it needs champions and support at the most senior levels within the school.

While some girls showed very traditional attitudes – "women should learn to cook, to look after and keep a man" – most showed

increased levels of understanding and concern about BME VAWG, especially about issues like forced marriage and HBV, resulting in increased rates of disclosure and willingness to report abuse against themselves and others. The project also saw similar changes among many boys. One boy talked about how he was more challenging of male friends, who noted that he had "changed from before": "You're different, but it's a good way." Another boy said it helped him to respect girls more: "Yes, especially because I have sisters, it helps me know how to respect them." However, a small cohort of boys, particularly those from Somali and Afghani backgrounds, continued to display conservative, even 'scary' views. It appears that some rigid attitudes are hard to shift in short-term interventions. Although SBS lack the resources to do this, sustained work on BME VAWG in a school is therefore recommended.

The senior teachers, particularly in School A, were too worried to allow workshops on FGM to take place, as were parents in School B, or to allow pupils to talk about forced marriage on film in case they were too open. Both schools were also reluctant to disclose the number of child protection and bullying cases on the grounds of 'confidentiality', although we only wanted anonymised data. In addition to funding pressures and turnover of staff, which they share with many other comprehensive schools, these issues are particularly challenging in a school or area with a high BME population. Teachers and governors are often nervous about accusations of 'cultural insensitivity', and in particular, 'religious insensitivity', from parents and the wider community. Indeed, in their feedback, some teachers wanted to know how to deal with a backlash from the community. These fears, responses and attitudes show the need for more intensive, challenging and long-term specialist interventions in schools on BME VAWG.

More generally, both pupils and teachers said the SBS project was effective but required longer-term intervention, extending to the whole school, allowing for wider and deep-rooted change and mainstreaming. In particular, pupils and teachers recommended that VAWG and BME VAWG be taught as part of the national curriculum due to its "lifelong impact." Contrary to the Government's current policy,[5] they said PSHE should become statutory.[6] When asked what they would say in a letter to the Prime Minister, one boy said:

"I would say if you don't have any money, the number of money you spend on getting police officers and putting people in jail this year, that can be spent on PSHE lessons. The amount of crime for that case will go down so you'll get your money back eventually."

The importance of the SBS project was acknowledged,[7] and more investment in such work was called for by pupils and teachers. One boy said "thanks for telling us how we should treat girls". Another boy highlighted the importance of services: "No woman should have to go through this without the support of SBS." Prevention work using the whole school's approach was considered vital; as one pupil said: "Future generations need to know, otherwise history will repeat itself over and over again."

Notes

[1] SBS is a leading BME women's organisation, founded in 1979, tackling violence against BME women and girls. It provides holistic information, advice, advocacy, counselling and support services for victims. It also undertakes local and national campaigning and policy, educational and developmental work to challenge social, cultural and religious attitudes and practices, as well as influence social policy reform and best practice around tackling domestic violence and harmful practices within BME communities.

[2] See: Womankind Worldwide (2010) *Freedom to Achieve. Preventing violence, promoting equality: a whole-school approach*, London: Womankind Worldwide. www.womankind.org.uk/wp-content/uploads/2011/02/WKREPORT_web-24-NOV-2010.pdf.

[3] Five other 'grassroots' organisations were also conducting pilots in different locations in the country and/or with a different focus. All of these projects were subject to an independent evaluation by Against Violence and Abuse (AVA) for Comic Relief. SBS was also part funded by the joint Home Office and Foreign Office Forced Marriage Unit (FMU) for the first year of the project.

[4] In April 2013, SBS began a pan-London prevention project in schools led by Tender and funded by London Councils (via the London VAWG Consortium), which uses this material.

[5] See: www.education.gov.uk/schools/teachingandlearning/curriculum/b00223087/pshe

[6] This view is supported by the United Nations Committee on the Convention for the Elimination for All Forms of Discrimination against Women (CEDAW), which expressed concern that PSHE and education on sexual relationship was not compulsory in all schools in the UK. It was also concerned about bullying, expressions of racist sentiments and harassment of girls in schools. See: CEDAW

(2013) Concluding observations on the seventh periodic report of the United Kingdom of Great Britain and Northern Ireland', CEDAW/C/GBR/CO/7: 26 July 2013. Available: www2.ohchr.org/english/bodies/cedaw/docs/55/CEDAW-C-GBR-Q-7.pdf

[7] The SBS project was also recognised as an example of best practice by the End Violence against Women (EVAW) coalition. See: EVAW (2011) *End Violence against Women and Girls: A Different World is Possible: Promising practices to prevent violence against women and girls*, London: EVAW, www.endviolenceagainstwomen.org.uk/data/files/resources/20/promising_practices_report_.pdf.

Preventing violence against women and girls: a whole school approach

Claire Maxwell and Peter Aggleton

Activists, agencies and practitioners in the field of violence against women and girls (VAWG) understand VAWG to be both the consequence and continued cause of unequal relations between men and women. For instance, as an organisation, UN Women states that it works on several fronts to end VAWG, including tackling 'its main root: gender inequality'[1]. Yodanis (2004) calls this the 'feminist theory' (p 656) position on VAWG, and goes on to suggest that 'the educational and occupational status of women in a country is related to the prevalence of sexual violence against women' (p 655). Other writers emphasise that VAWG is legitimated by and contributes to the production and reproduction of a wider set of gender and sexual inequalities (Messerschmidt, 2000; Phipps, 2009; Powell, 2010).

While much research on gender-related violence and its effects has taken place in Southern countries (Garcia-Moreno et al, 2006; WHO/LSHTM, 2010; Parkes and Heslop, 2011), this chapter is concerned with the prevention of VAWG in English and Welsh schools. It questions the extent to which current programmes take as their starting assumption the argument made by many feminists that tackling gender inequality lies at the heart of reducing VAWG. It then discusses the notion of a 'whole school approach' and emphasises its importance for VAWG prevention. Drawing on Pierre Bourdieu's concepts of habitus and field, the chapter explores ways in which the school space (or at least spaces within the school) can be used to challenge and change (if not transform) those power relations which facilitate VAWG in all its forms. By drawing on examples of actions

developed in schools we have worked in in England and Wales, to prevent VAWG,[2] we argue for the usefulness of Bourdieu's theoretical framework for developing a whole school approach.

VAWG prevention programmes – the question of gender

Over the last 20 years, many school programmes in this area of work have sought to raise awareness of the issue of 'dating violence' (a common focus of programmes in North America – see, for example, the 'Safe Dates Program' in North Carolina[3]), domestic violence (such as the London-based Westminster Domestic Violence Forum's *Domestic Violence Prevention Pack for Schools*[4]), and respectful and/or healthy relationships between young people (such as SafePlace's 'Expect Respect Program' in Austin, Texas[5] or Women's Aid England 'Expect Respect' Education Toolkit[6]). Increasingly, however, there is an interest in developing a broader 'VAWG' approach to prevention work in schools, which seeks to address a much wider range of forms of violence, including forced marriage, sexual exploitation, 'honour-based' violence and female genital mutilation[7].

The outcomes of many existing programmes have only been weakly evaluated (Whitaker et al, 2006; Campbell, 2009; Maxwell et al, 2010), but where evaluations exist they generally point to changes in knowledge and attitudes rather than behaviours (Sanchez et al, 2001; Stevenson, 2001; Campbell, 2009). Not untypically, Meyer and Stein's (2001) review of evaluated 'school-based dating violence prevention curricula/programs' (p 2) concluded that the most significant impact reported by evaluation studies are increases in 'knowing' about dating violence.

Most school-based initiatives recognise that gender is a key concept which students, staff and the wider community need to engage with to raise awareness about, and challenge, sexist and violent attitudes which condone and justify VAWG. Thus, most programmes at some level explore gender stereotypes (see for instance Womankind's *Challenging Violence, Changing Lives* pack for UK secondary schools[8]). But to what extent does a programmatic engagement with gender move beyond discussing sexual double-standards or stereotypical assumptions about what it is to be a girl/boy, man/woman? And how theoretically informed and positioned is this kind of work in schools?

Debbie Ollis's work over the past 20 years in Australia has, from the beginning, been closely informed by a feminist poststructuralist understanding of gender. The 1995 *No Fear* resource[9] set out to 'explore the structural inequalities of gender, power and violence inherent in the policies and practices of institutions such as the school, law, language, marriage' (Ollis, 2011: 20). It sought to provide students with the opportunity to engage with the concept of 'multiple gendered 'subject positions'… [whereby people can take up] a range of ways to be male or female … [and discuss notions of] power in gender relationships … [and discuss] the role of language in bringing about change' (p 20). But is a theoretically-informed programme of work around the concept of gender enough for it to be 'successful', or have an impact?

In particular, as Meyer and Stein (2001) ask, how can programmes move beyond raising awareness of the issues and the severity of VAWG to actually changing behaviours of perpetration and/or victimisation, and encouraging young people to challenge their peers and others with regard to particular attitudes and/or behaviours? Maxwell et al (2010) and Meyer and Stein (2001) argue that programmes which are of longer duration, in terms of number of sessions and periods of time, are more likely to demonstrate changes in young people's behaviours. Foshee's (2004)[10] evaluation of the 'Safe Dates Programme', for instance, found that compared to young people in the control group, students receiving a one-year intervention (consisting of a peer-performed theatre piece, a ten-session curriculum input and a poster contest), reported significantly lower levels of physical and sexual violence perpetration and victimisation in their intimate relationships four years after the programme.

Significantly, however, some argue that it is a 'whole school approach' to challenging VAWG that is key to developing a successful programme of work (Dusenbury et al, 1997; Hester and Westmarland, 2005; Ellis, 2008; Ollis, 2011). A whole school approach is valuable, because it is not only students whose understanding of gender and gender inequality needs scrutiny but also those of the staff, the wider school community and even educational policy itself (Skelton and Francis, 2009). As one teacher in our recent work on school-based gender violence explained:

"There are one hundred more negative lessons being taught in the corridor, lunch queues etc., compared to what they are learning in a lesson! Gender issues are being reinforced during break and lunch times - we might be focusing on lessons and learning [in our VAWG programme], but we are failing [our students] outside. Many young people are just having to learn to cope with this place [the school]!" (Maxwell et al, 2010)

A whole school approach is, therefore, called for if we are to tackle the multiple determinants of VAWG. Crucially, at the heart of any whole school initiative should be a commitment to promoting gender equality in its broadest sense. While this may seem obvious, many programmes, partly because they are given so little time to deliver the work in school settings (Meyer and Stein, 2001), seek to equip young people with skills to resist violence without attempting to engage in a process of 'unsettling' structurally embedded attitudes, understandings and 'conscious and unconscious courses of action' (Ollis and Tomaszewski, 1993: 37) around gender and VAWG.

Understanding a whole school approach

In recent work, we have reviewed a number of whole school frameworks developed by English policy-makers or academics in relation to VAWG prevention, healthy schools initiatives or raising boys' underachievement (Maxwell et al, 2010). This literature, along with the attempts by five schools (who took part in a programme across England and Wales led by a England-based international civil society organisation – Womankind Worldwide) to develop a whole school approach to tackling VAWG, led us to identify three key arenas for intervention if this work is to be successful: (i) action at institutional and policy levels; (ii) work involving school staff; and (iii) programmes of support for young people.

Without attention at the first of these three levels, schools, staff, students and the wider community will find it difficult to know what to expect from a programme. Subsequent work with staff and students should include a mix of awareness raising, skills development and support. The development of a school culture that promotes equality

and challenges violence derives from combined efforts across each of these three levels.

However, just as we would argue that many previous and current VAWG prevention programmes have not been informed by an adequately sophisticated understanding of gender and power relations, a whole school approach requires careful thought about flows of power within the institutional space of the school and reflection on how social change can be facilitated. A number of education theorists have argued that education 'oppresses students because its central sense and purpose is domination and subjection' (De Lissovoy, 2010: 205; also Biesta, 2010) and much research has emphasised how schools are sites intimately involved in the reproduction of different forms of privilege linked to generation, gender, sexuality, race, and social class (Kehily, 2002; Reay et al, 2007; Allan, 2009; Maxwell and Aggleton, 2010b). However, schools can also provide opportunities for the emergence of new forms of politics (Giroux, 2003) and the development of new social realities. Horvat and Davis (2011), for instance, concluded 'that educational programs could become sites of transformation rather than reproducers of social inequality' (p 142) – in this case, the gender and sexual inequality which facilitates violence against women and girls.

In order to be successful, VAWG prevention in schools should, therefore, draw on a theoretical framework that can support both the conceptualisation of how gender relations operate and how change can legitimately occur within a school environment. This way, we can work towards developing a programme that aims to create a space (the school), or at least spaces within the school, that promote or embed greater gender equality, thereby offering the potential to challenge VAWG.

A feminist poststructuralist framework for understanding VAWG prevention work in schools

Many feminists in the field of education work within a poststructuralist framework. There is no easy or unified definition of poststructuralism, but at the heart of this approach is an attempt to expose the ways in which power flows through language and other 'structures' that shape how we come to understand and interact with others (people, institutions) around us. Poststructuralist analysis aims to 'deconstruct'

power relations and 'truths' about the world and, by so doing, offers new ways of conceptualising possible relations between people or institutions. Judith Butler is one of the key thinkers and writers within work on feminist poststructuralism.[11]

Butler (1990) argues that we constantly 'perform' ways of being different kinds of subjects – a woman or a man, someone who belongs to a particular cultural or social group and so forth. Rather than these positions being 'real' or 'stable', they are cultural constructs recreated and often reinforced every time we perform them. Habitually, when we 'do' girl/woman or boy/man, our performances reproduce the norms that characterise particular sociocultural societies – especially norms of heterosexuality and ideas about 'appropriate' femininities or masculinities. However, as Butler (1997) argues, 'performative utterances can go wrong, be misapplied or misinvoked' (p 151). This can have the effect of 'unsettling' normative ideas of who we are and who we can be. Such misfirings open up the possibility for a 'politics of performative resignification' (Hey, 2006: 439). Through such a politics, ideas about femininity and masculinity and the relations between them, can potentially be recast (Beavis and Charles, 2007). If we accept the argument that in order to prevent VAWG we need to challenge unequal gender relations and interactions, then re-imagining how femininities and masculinities might be embodied and performed, and therefore how they relate to one other, is central to attempts to prevent VAWG.

How might ideas about performative resignification work out in practice? Work that has taken place in schools around gender justice or challenging homophobia has revealed, for instance, how some teachers 'trouble – and proliferate alternatives to [more traditional understandings of gender] ... decentr[ing] such knowledges through a blurring and destablising ... of gender differentiation' (Keddie, 2008: 346). These 'progressive spaces' (Keddie, 2010: 364), in which dominant paradigms are de-grounded and unsettled (Atkinson and DePalma, 2009: 23), rely on teachers' critical reflexivity and capacity (Nayler and Keddie, 2007) to provoke 'conversations' (Keddie, 2010: 363) that raise awareness of how 'localised narratives contribute to gender inequities in a particular context' (p 363). Such a 'politics of resistance' (Giroux, 2003: 5) requires, according to Keddie (2010), a 'strong feminist agenda and [a] deep and critical knowledge about issues of gender construction' (p 364).

Many of the schools we have worked in over the past few years have developed some form of peer mentoring related to challenging gender stereotyping and/or sexual bullying. Although the role of peer mentors has developed in different ways in different schools (through existing peer mentors receiving additional training on issues of gender and sexual bullying; via a new group of young women being recruited to act as peer mentors to other young women in order to challenge sexual harassment or bullying; or by means of a mixed-sex group of young people being recruited to act as 'anti-sexual bullying' peer mentors) the principle behind their roles is similar. Through the training they receive, young people are supported to critically reflect on gender and gender relations so as to challenge discriminatory attitudes and behaviours of their peers – thereby engaging in a politics of performative resignification.

In one school in our recent study – Northridge (a pseudonym) – 20 students were recruited on an annual basis to form the 'anti-sexual bullying peer mentoring team'. Each member of the team received basic training, was issued with a badge identifying them as a peer mentor, and was then involved in assembly and classroom sessions on sexual bullying, as well as mediating between pupils when an incident occurred. For example, on one occasion peer mentors were called to intervene when a young man called two female peers in his class 'lesbos' (lesbians). Two mentors subsequently held a session with him discussing appropriate and inappropriate language. However, opportunities to engage in the more active subversion of norms appeared rare for these mentors. Few incidents of violence (physical or otherwise) were reported to them, and they themselves did not appear to challenge the attitudes and behaviour they witnessed frequently. One way of understanding this may be that young people lacked the critical awareness and support to promote 'multiple ways of being masculine and feminine … [which could] problematise and transform, rather than re-inscribe, the gendered ways of being' (Keddie, 2005: 88).

While the peer mentors at Northridge had received only rather minimal training, delivered by non-experts on VAWG (two teachers coordinating the group) the girls-only peer mentoring group at Buzwell Academy (a pseudonym for another school in England) participated in an eight-hour training programme led by an expert in VAWG. The young women later participating in the girls-only

mentoring group appeared to develop a heightened awareness about gender inequality and their need to challenge this; during a group discussion, two of its members explained "boys don't see the effect they have on women – and how they can make you feel" and "girls need to stand up for themselves" (Maxwell et al, 2010: 57). Yet group members were similarly unsuccessful in challenging or mediating incidents within the school so it would appear that the responsiveness of the school environment is crucial in enabling a peer-mentoring approach to have an 'impact'.

Overall, few incidents of VAWG were reported to peer mentors in both schools and fellow pupils expressed ambivalence and even active resistance to the need for action. And yet in Northridge School, the young peer mentors delivered sessions on sexual bullying as part of Personal, Social, Health and Economic Education to positive reviews by fellow pupils. Arguably, the critical mass created by an annual programme of recruiting and training 20 young people for this role might potentially lead to the creation of spaces in which dominant norms could be questioned and some 'unsettling of knowledges' may occur. Perhaps, therefore, such an approach, arguably informed by Butler's politics of performative resignification, might in the longer term be able to support the promotion of gender equality – if peer mentors receive the kind of on-going support to provide them with the understanding and confidence to challenge the reproduction of dominant gender relations, thereby opening up spaces for new forms of masculinity and femininity to emerge. However, it would seem crucial that adult members of the school community support this process: firstly, by affirming the importance of peer mentorship, and secondly, by reinforcing this work through their own subversive reiterations.

The need for students and staff within a school community to work in complementary ways arguably points to the need for a more systemic approach to the promotion of gender equality within a particular setting. Poststructuralist approaches, by their very nature, are less directional and 'systematic' in this respect and do not, therefore, in our opinion offer a very clear roadmap as to how fleeting and momentary challenges to dominant norms and expectations can in the longer-term be sustained (Maxwell and Aggleton, 2010a).

Pierre Bourdieu – dynamic between the habitus and field

Pierre Bourdieu's work has been extensively utilised in education. His notion of field, here understood to represent the space of the school, locates social agents – people – within a particular set of power relations. Social agents within a particular field share a habitus or 'an open system of dispositions that is constantly subjected to experiences, and therefore constantly affected by them in a way that reinforces or modifies its structures' (Bourdieu, 1992: 133). Several writers have used Bourdieu's concepts to discuss different experiences of education. Thomson (2000), for example, showed how schools located in two very different socio-economic communities promoted very different attitudes to femininity and masculinity and how the culture of the school interacted with the habitus of students to reinforce different 'logics of practice' (p 407).

In Bourdieu's framework, there exists a dynamic relationship between field and habitus in that the field structures the habitus, and the habitus helps constitute the field. Reay (2004) has concluded that 'when the habitus encounters a field with which it is not familiar, the resulting disjunctures can generate change and transformation' (p 436). Building upon such an understanding, changes within the broader school system may lead to a change in habitus, which in turn may reaffirm, sustain and move yet further the changes instigated at the field level.

We would therefore like to explore efforts to promote gender equality and the prevention of VAWG through the suggestion that a particular field (in this case, the school) can seek to influence what Bourdieu (1990) has called 'the feel for the game' (p 66) and potentially begin the process of shifting the habitus of the field's social agents. Ash's (2011) work offers a useful starting point for putting the institution (the 'field') at the heart of an examination of how gender equality might be promoted and is practised. Using Bourdieusian terminology, she conceptualises educational settings as having three main dimensions:

1. The 'rules of the game' (positional dimension) which constitute the normative logic of institutional roles and requirements. Thus, to begin to bring about change in power relations (around gender in this example) school policies and priorities should be reviewed and altered.

2. The 'feel for the game' (the dispositional dimension) conveys how members within the field (in this case, the school community) engage with the rules, policies, priorities of this space at an affective level, thereby altering the dispositional approach to power inequalities within the school.

3. The 'actual game played' (the interactive-situational dimension) whereby the affective approaches and understandings of school policies must also be practised during interactions if the rules and feel of 'a new game' (gender equal relations) are to be taken up and reproduced.

What might adopting such an approach to promoting gender equality, and preventing VAWG look like in practice? In our work we have not yet encountered any school which could be described as a gender-equal space, but the first author did spend some time in one school which was developing its work to challenge VAWG in ways that can usefully be examined using a Bourdieusian framework and offered as an example of developing a whole school approach.

> "Children must learn about respect and self-respect from a very early age. The promotion of equality and challenging violence should be a natural and imperative part of the school curriculum ... I want the whole school to adopt better self-respect." (Deputy Headteacher: Maxwell et al, 2010: 78)

At All Saints School (a pseudonym) 'respectful relationships' were identified as central to what the school wanted to achieve across the community of students and teachers (in other words, the kinds of power relations that should be structuring the field). This was formalised in a specific policy framework and in the school's development plan (thereby to some extent ensuring this core presumption was foregrounded in all subsequent work). Thus, 'the rules of the game' (see Ash's 2011 positional dimension above) were established. This was the first step towards the development of a whole school approach at All Saints. The head teacher explained that although facilitating respectful relationships was 'more to do with the feel [or] ethos of the school', the 'framework' they had constructed around the concept of respect 'makes it more structural'.[12]

Subsequently, a series of initiatives was developed to percolate understandings of what respect meant throughout the school, and to model respectful relationships across staff and students.

These programmes of work included: a school policy on 'Respect', which specifically mentioned gender; a Gender Equality Scheme; a girls group for young women with low aspirations and for those who were disengaged from school; a resource pack for teachers which aimed to outline creative teaching and learning strategies for engaging young women; an already existing peer mentoring team who received additional training on challenging sexual and homophobic bullying; a girls' group whose members became campaigners against VAWG; mediation sessions focused on raising awareness and developing skills around respectful relationships; and a focus on VAWG in the Personal, Social, Health and Economic Education curriculum. These initiatives together offer examples of the universal and targeted programmes Maxwell et al (2010) identified as central to developing a whole school approach to VAWG prevention work.

The respect agenda was led from "the front ... [by] some very passionate people" (Headteacher), who arguably modelled the new 'feel for the game' as espoused by the 'rules of the game' (the policy priority). But to what extent did the 'actual game played' within All Saints start to change?

Eleven months after the policy had been put in place (and the point at which the research project informing this chapter was drawing to a close), most teaching staff appeared to be utilising the word 'respect' when discussing the school culture and respect was also reflected in students' articulations of their attitudes to others, their schooling and themselves. Thus, arguably, the power relations set up by the 'Respect Policy' were to some extent being evidenced by a change in staff and pupil habitus.

One specific example of this lay in the changes in attitudes of, and towards, the young women who were recruited to be part of a girls-only group for those likely to under-achieve or those who were becoming increasingly disengaged from the school and their education. Young women from this group made the following comments when asked what impact being in the group had had on them:

> "It [has] made us closer and we are more like a little community."

"It makes you closer to the teachers as well, and you learn a lot more than you did before."

"It [has] made me feel more confident and I feel more mature and it makes you really think about what you want to do." (Maxwell et al, 2010: 47)

As part of their involvement in the group, young women began to represent the school at various external events and became more actively involved in school life: in lessons, during student consultation exercises, by raising money for local VAWG charities. Furthermore, the improved relationships noted between these students who were previously seen as being on the margins and their more mainstream, achieving peers, as well as between these students and their teachers, led to a call both from groups of young men and from teachers, for such an initiative to be replicated for those boys who, too, were disengaged or low-achieving. In these ways, changes in the habitus of some students (evidenced in their increased engagement in, and pride about, their school and increased sense of their own potentiality) and the teachers (through more nuanced and positive attitudes to previously challenging female students) appeared to reaffirm the deliberate changes made at the institutional level which sought to create respectful relationships across the whole school community. It is therefore possible to see how changes at the level of the field can start to influence the habitus of members of the school community through a process which, in turn, becomes mutually reinforcing. Given the openness to the feel for such a 'new' game, further programmes of work could be developed to continue challenging inequality in gender relations and outcomes for young men and women.

Could these be the first steps towards promoting gender equality (and ultimately challenging VAWG) if this is defined as respecting others? At the time of our study, the various elements of work at All Saints appeared to be beginning to reinforce one another and therefore potentially tackling the issue mentioned by a teacher at another school (quoted earlier) who felt that the impact of lessons on VAWG was lost the moment students left the classroom space and re-entered the heteronormative culture which pervaded other parts of the school. Of course, this same argument holds true at All Saints – what happens once students and teachers exit the school gate and return home? To some extent, All Saints was trying to engage the

broader community, through involving other schools in local events and raising money for local VAWG charities, but what is especially important about All Saints' work, in our view, was that they were attempting to develop a whole school approach.

Conclusion

This chapter has argued that VAWG prevention programmes in schools must place the promotion of gender equality at the heart of their endeavour if they are to succeed, as gender inequality is both a cause and a consequence of VAWG. Not only does the research evidence base for VAWG prevention work in schools argue that in-depth, extended programmes of work are likely to have a greater impact in changing behaviours that facilitate, justify and perpetrate VAWG, but critical to this work also is the need to develop a whole school approach in the promotion of gender equality (and therefore challenging VAWG). Gender relations shape interactions between members of the school community, affect the behaviour of pupils, and influence attainment. For this reason, raising awareness of the concept of gender and how it shapes relationships within (and beyond) the school requires the adoption of a whole school approach. Furthermore, research on whole school approaches to health and educational engagement suggests that this approach can promote a form of 'school connectedness' (Rowe et al, 2007; Rowe and Stewart, 2009) which is closely linked to engagement in learning (Younger et al 2005; Thurston, 2006) and the development of an inclusive, more respectful ethos (Rowe et al, 2007).

In this chapter, we have argued that not only do programme developers and practitioners need to have a theoretically-informed and consistent understanding of gender, but that this same theoretical position should highlight how change within a school space can be brought about through programme development and implementation. In support of this, we have suggested that Bourdieu's conceptual toolkit could usefully be drawn on to conceptualise gender relations (as evidenced within habitus) and how gender equality might be promoted via a more systematic, whole school approach. Thus, through the development of new 'rules of the game', a shift for the 'feel for the game' begins which in turn starts to unsettle

and facilitate a new/different 'actual game played' between members occupying the different spaces within the school.

While feminist poststructuralist approaches can help inform an understanding of unequal gender relations and how these might be unsettled, they do not, in our view, offer a sufficiently strong approach to understanding how change can occur at a whole school-level so as to inform policy and practice. Bourdieu's work on habitus and field, on the other hand, offers an explanation of how power relations (the field) determine how people position themselves within the space of the school, and how these positions in turn inform the practices (together forming the habitus) of those within the institution. Drawing on Bourdieu's concepts facilitates an understanding of how it may be possible to effect change in (one part of) the system which can unsettle power dynamics across the system, thereby making it possible for different and more equitable relationships to be formed, with this potentially becoming a mutually reinforcing process. What is especially powerful about Bourdieu's framework (and unlike feminist post-structuralism) is that it makes the case for how change can occur when it commences at the field level (via establishing 'new rules of the game'), which then works to influence the overall school ethos or habitus ('altering the feel for the game') and eventually the 'actual game played'.

Notes

[1] www.unifem.org/gender_issues/violence_against_women/

[2] Some of the examples in this chapter are taken from our two-year study following the experiences of five schools developing a 'whole school approach' to promoting gender equality and challenging VAWG between 2008 and 2010, commissioned by Womankind International: www.womankind.org.uk/wp-content/uploads/2011/02/WKREPORT_web-24-NOV-2010.pdf.

[3] www.violencepreventionworks.org/public/safe_dates.page

[4] http://webfronter.com/hounslow/learningtorespect/menu0/Learning_To_Respect/London_Wide_Evalution/images/WDVF_London_wide_Schools_DV_Prevent_Evaluation_report_2005.doc.

[5] www.safeplace.org/page.aspx?pid=376.

[6] www.womensaid.org.uk/page.asp?section=0001000100280001§ionTitle=Education+Toolkit].

[7] Although to date, we do not know of any programmes that attempt to cover all these forms of violence in a comprehensive way through a schools-based education programme.

[8] www.womankind.org.uk/what-we-do/our-impact/legacy/.

[9] Department of Employment Education and Training (1995) *No Fear: A Whole School Approach, Facilitators Guide* [Canberra: Australian Government Publishing Service]. See also Ollis (2011) and http://trove.nla.gov.au/work/13835654? q=subject%3A%22School+violence+-+Australia.%22&c=music#versions .

[10] http://ajph.aphapublications.org/doi/abs/10.2105/AJPH.94.4.619

[11] Amanda Keddie's writing on the facilitation of gender justice work in schools (2008; 2010; 2007) and work of The 'No Outsiders' action research project, which sought to challenge heteronormativity in primary schools (Atkinson and DePalma 2009; DePalma and Atkinson 2009), both utilise Judith Butler's ideas.

[12] All Saints (pseudonym) was one of the schools who took part in the research which informed the research report by Maxwell et al (2010).

References

Allan, A. (2009) 'The importance of being a 'lady': Hyper-femininity and heterosexuality in the private, single-sex primary school', *Gender and Education*, 21(2): 145-58.

Ash, M. (2011) *Double bind of female academics: Equality policy caught between the 'rock' of academic culture and the 'hard place' of hrm?*, Paper presented at the 8th International Gender and Education Conference, 27 April 2011, Exeter University.

Atkinson, E. and DePalma, R. (2009) 'Unbelieving the matrix: Queering consensual heteronormativity', *Gender and Education*, 21(1): 17-29.

Beavis, C. and Charles, C. (2007) 'Would the 'real' girl gamer please stand up? Gender, LAN cafés and the reformulation of the 'girl' gamer', *Gender and Education*, 19(6): 691-705.

Biesta, G. (2010) 'A new logic of emancipation: The methodology of Jacques Rancière', *Educational Theory*, 60(1) 39-59.

Bourdieu, P. (1990) *The logic of practice*, Cambridge: Polity Press.

Bourdieu, P. (1992) *An invitation to reflexive sociology*, Cambridge: Polity Press.

Butler, J. (1990) *Gender trouble: Feminism and the subversion of identity*. London: Routledge.

Butler, J. (1997) *Excitable speech: A politics of the performative*, London: Routledge.

Campbell, T. (2009) *Violence against women and girls. Rapid research literature review: Evidence on school-based interventions.* London: Department for Children, Schools and Families: Schools Analysis and Research Division.

De Lissovoy, N. (2010) 'Rethinking education and emancipation: Being, teaching, and power', *Harvard Educational Review*, 80(2): 203-21.

DePalma, R. and Atkinson, E. (2009) "No outsiders': Moving beyond a discourse of tolerance to challenge heteronormativity in primary schools', *British Educational Research Journal*, 35(6): 837-56.

Dusenbury, L., Falco, M., Lake, A., Brannigan, R. and Bosworth, K. (1997) 'Nine critical elements of promising violence prevention programs', *Journal of School Health*, 67(10): 409-14.

Ellis, J. (2008) 'Primary prevention of domestic abuse through education' in Humphreys, C., Houghton, C. and Ellis, J. *Literature review: Better outcomes for children and young people affected by domestic abuse - directions for good practice*, Edinburgh: The Scottish Government.

Foshee, V.A., Bauman, K.E., Ennett, S.T., Linder, G.F., Benefield T. and Suchindran. C. (2004) 'Assessing the long-term effects of the safe dates program and a booster in preventing and reducing adolescent dating violence victimization and perpetration', *American Journal of Public Health*, 94(4) 619-24.

Garcia-Moreno, C., Jansen, H.A., Ellsberg, M., Heise L. and Watts. C.H. (2006) 'Prevalence of intimate partner violence: Findings from the WHO multi-country study on women's health and domestic violence', *Lancet*, 368: 1260–69.

Giroux, H.A. (2003) 'Public pedagogy and the politics of resistance: Notes on a critical theory of educational struggle', *Educational Philosophy and Theory*, 35(1): 5-16.

Hester, M. and Westmarland, N. (2005) *Tackling domestic violence: Effective interventions and approaches*, London: Home Office.

Hey, V. (2006) 'The politics of performative resignification: Translating Judith Butler's theoretical discourse and its potential for a sociology of education', *British Journal of Sociology of Education*, 27(): 439-58.

Horvat, E.M. and Davis, J.E. (2011) 'Schools as sites for transformation: Exploring the contribution of habitus', *Youth & Society*, 43(1): 142-70.

Keddie, A. (2005) 'A framework for gender justice: Evaluating the transformative capacities of three key australian schooling initiatives', *The Australian Educational Researcher*, 32(3): 83-102.

Keddie, A. (2008) 'Teacher stories of collusion and transformation: A feminist pedagogical framework and meta-language for cultural gender justice', *Journal of Education Policy*, 23(4): 343-57.

Keddie, A. (2010) 'Feminist struggles to mobilise progressive spaces within the 'boy-turn' in gender equity and schooling reform', *Gender and Education*, 22(4): 353-68.

Kehily, M.J. (2002) *Sexuality, gender and schooling: Shifting agendas in social learning*, London: Routledge Falmer.

Maxwell, C. and Aggleton, P. (2010a) 'Agency in action – young women and their sexual relationships in a private school', *Gender and Education*, 22(3): 327-43.

Maxwell, C. and Aggleton, P. (2010b) 'The bubble of privilege: Young, privately educated women talk about social class', *British Journal of Sociology of Education*, 31(1): 3-15.

Maxwell, C., Chase, E., Warwick, I., Aggleton, P. and Wharf, W.H. (2010) *Freedom to achieve. Preventing violence, promoting equality: A whole school approach*, London: Womenkind Worldwide.

Messerschmidt, J.W. (2000) 'Becoming "real men": Adolescent masculinity challenges and sexual violence', *Men and Masculinities*, 2(3): 286-307.

Meyer, H. and Stein, N. (2001) *Relationship violence prevention education in schools: What's working, what's getting in the way, and what might be some future directions*. Paper presented at the 7th International Family Violence Research Conference, in Portsmouth, NH, USA.

Nayler, J.M. and Keddie, A. (2007) 'Focusing the gaze: Teacher interrogation of practice', *International Journal of Inclusive Education*, 11(2): 199-214.

Ollis, D. (2011) 'A 'respectful relationships' approach: Could it be the answer to preventing gender-based violence?' *Redress*, 20(1): 19-26.

Ollis, D. and Tomaszewski, I. (1993) *Gender and violence position paper*, Canberra: Commonwealth Department of Education, Australia.

Parkes, J. and Heslop, J. (2011) *Stop violence against girls in school: A cross-country analysis of baseline research from Ghana, Kenya and Mozambique*, Johannesburg: ActionAid International.

Phipps, A. (2009) 'Rape and respectability: Ideas about sexual violence and social class', *Sociology*, 43(3): 667-83.

Powell, A. (2010) *Sex, power and consent: Youth culture and the unwritten rules*, Melbourne: Cambridge University Press.

Reay, D. (2004) "It's all becoming a habitus': Beyond the habitual use of habitus in educational research', *British Journal of Sociology of Education*, 25(4): 431-44.

Reay, D., Hollingworth, S., Williams, K., Crozier, G., Jamieson, F., James, D. and Beedell, P. (2007) '"A darker shade of pale?" Whiteness, the middle classes and multi-ethnic inner city schooling', *Sociology*, 41(6): 1041-60.

Rowe, F. and Stewart, D. (2009) 'Promoting connectedness through whole-school approaches: A qualitative study', *Health Education*, 109(5): 396-413.

Rowe, F., Stewart, D. and Patterson, C. (2007) 'Promoting school connectedness through whole-school approaches', *Health Education*, 107(6): 524-42.

Sanchez, E., Robertson, T.R., Lewis, C.M., Rosenbluth, B., Bohman ,T. and Casey, D.M. (2001) 'Preventing bullying and sexual harassment in elementary schools: The Expect Respect model', *Journal of Emotional Abuse*, 2(2/3): 157-80.

Skelton, C. and Francis, B. (2009) *Feminism and 'the schooling scandal'*, Abingdon: Routledge.

Stevenson, J. (2001) *Women and violence: Education is prevention: Saltspring women opposed to violence and abuse (SWOVA): Interim project findings*, Saltspring Island, B.C.: SWOVA.

Thomson, R. (2000) 'Dream on: The logic of sexual practice', *Journal of Youth Studies*, 3(4): 407-27.

Thurston, M. (2006) *The National Healthy Schools Programme: A vehicle for school improvement? Case studies from Cheshire*, Chester: University of Chester.

Whitaker, D.J., Morrison, S., Lindquist, C., Hawkins, S.R., O'Neil, J.A., Nesius, A.M., Mathew A. and Reese. L. (2006) 'A critical review of interventions for the primary prevention of perpetration of partner violence', *Aggression and Violent Behavior*, 11(2): 151-66.

WHO/LSHTM (World Health Organization/London School of Hygiene and Tropical Medicine) (2010) *Preventing intimate partner and sexual violence against women: Taking action and generating evidence*, Geneva, World Health Organization, 2010.

Yodanis, C.L. (2004) 'Gender inequality, violence against women, and fear: A cross-national test of the feminist theory of violence against women', *Journal of Interpersonal Violence*, 19(6): 655-75.

Younger, M., Warrington, M., Gray, J., Rudduck, J., Mclellan, R., Bearne, E., Kershner, R. and Bricheno, P. (2005) *Raising boys' achievement*. Nottingham: DfES.

What did you learn at school today? Education for prevention

Pattie Friend

"I have learnt that no one should make you do anything you don't want to and that you should only be with someone if they treat you well." (Primary school pupil, 2007*)*

Introduction

Schools have the opportunity to change pupils' attitudes or to be the playgrounds, both literal and metaphorical, in which damaging and negative gender relations are rehearsed and internalised for future reference. The prevalence of domestic violence, coupled with schools' responsibility for the social and moral development of their pupils, presented a space within which to introduce the initiative discussed here. This chapter considers the important role that schools can play in addressing the many gender inequalities, stereotypes and negative images of women that persist in mainstream and popular culture. Such inequalities, which can engender low self-esteem in girls and a sense of entitlement in boys, may contribute to the types of behaviour that lead to domestic violence.

Evidence of the need for a school-based domestic violence prevention initiative in the borough was initially identified with reference to the London Domestic Violence Strategy (GLA, 2001). Several years after the introduction of the Learning to Respect (LTR) programme discussed in this chapter, the need for domestic violence prevention in the school curriculum was affirmed by the former government's VAWG strategy. The new 2013 cross-government definition of domestic violence, extended to include 16 and 17 year olds, amplifies this need (Home Office, 2013).

Funding was secured and the author was appointed, in 2004, for a fixed-term part-time consultancy to establish a pilot scheme which became known as the 'Learning to Respect: Domestic Violence Education Programme' (the LTR programme). This chapter considers the many opportunities and barriers presented during the development, delivery and evaluation of the LTR programme in Hounslow, a large diversely populated west London borough. Other issues explored include the practicalities of delivery, the evolution of the post, its location within an education context, concomitant funding issues, the formation of a multiagency team to deliver training and the relationship of all of these factors to the sustainability of the programme. The chapter illustrates the methods by which the programme gained some purchase in schools through the creation of a distinct identity and by collaborating with colleagues involved in supporting schools to meet statutory requirements related to areas such as curriculum development and child protection.

The aims of the LTR programme were identified with reference to the original *Westminster Domestic Violence Prevention Pack for Schools* (Debbonaire, 2002) and in consultation with the local Domestic Violence Network. The long-term aim, to create safer communities by reducing the incidence of domestic violence, was supported by short-term aims with a focus on the development of healthy, nonabusive relationships amongst young people. These aims included issues such as conflict resolution, negotiation skills, self-esteem and confidence building and as such constituted a positive behaviour model consistent with other school approaches.

These aims were made explicit to schools in order to provide clarity and boundaries, and to ensure senior managers understood that the focus was not 'solving' individual cases of domestic violence. However, making referrals to appropriate support was considered an integral part of the programme and is discussed in greater depth later. Since pupils' access to the curriculum, and therefore access to the LTR programme, was influenced by many factors, a presumption was made at the outset that schools would consider how factors such as race, culture, class, gender and disability could impact on inclusion and how resources could be developed and allocated to address this.

National context

During the eight years the programme has been in operation, a number of legislative and policy changes have occurred that have both helped and hindered the potential to retain a local domestic violence programme in schools and other settings. The LTR launch year saw the introduction of the most significant domestic violence legislation in 30 years: the Domestic Violence Crime and Victims Act 2004. The Act provided a framework within which local domestic violence fora could develop action plans and priorities. The area of 'prevention' provided the context for domestic violence work with children and young people in schools.

Other developments such as the *Every Child Matters* (ECM) agenda and the introduction of the *Common Assessment Framework* (CAF) provided a greater space for the growth of domestic violence prevention education. With the formation of the coalition government in 2010, previous plans to make Personal Social and Health Education (PSHE) compulsory in schools were retracted. This seriously undermined recommendations in both governments' Violence Against Women and Girls (VAWG) strategies to incorporate healthy relationships education (including issues such as forced marriage and domestic violence) into the PSHE curriculum. This, coupled with the ineluctable steer towards Academy status[1] for schools, could result in a preference for curriculum development designed to enhance the league table status of schools. The diminishing role of the local authority relationship with Academy schools will also reduce its influence on curriculum content.

Pan-London and Hounslow context

As already noted, the first *London Domestic Violence Strategy* provided a framework for pan-London developments in this area of work. To further some of the strategy's objectives the former Association of London Governments funded Westminster Domestic Violence Forum to develop and roll out training, using their domestic violence prevention pack for schools, to all interested London boroughs. At the same time, the London Borough of Hounslow's local Domestic Violence Network, responding to recommendations in the London strategy, identified domestic violence prevention work in schools as

a priority. Both external and internal funding was secured[2] for an independent consultant to develop and implement a pilot scheme in the year 2004–05. Other boroughs were also developing their own approaches to this work but a dedicated post for the sole purpose of domestic violence prevention work in schools was unique at that time.

The post of programme coordinator, accountable to the former Teaching Support Service (TSS) and the Community Safety Partnership, was located within the education section of the former Lifelong Learning Leisure and Cultural Services. The placement of the programme within an education setting, and the TSS in particular, has been an influential factor in the success of the initiative. Within this context, the programme coordinator was able to take advantage of the robust longstanding links already forged with schools. The programme coordinator's previous career as teacher, refuge worker and Domestic Violence Coordinator further aided the development of the ongoing relationship with schools. The depth of knowledge about the areas of both domestic violence and education ensured that realistic expectations were placed upon those involved. Coupled with an understanding of, and planning for, potential difficulties, this helped to establish the credibility of the programme with fellow professionals who became integral to the implementation of the programme.

A strategic approach

The programme coordinator quickly established partnership working with school improvement services and the PSHE Advisor became a key member of the training team. LTR became an established part of PSHE plans and recommendations for schools, and an integral feature of consultations on issues such as 'Healthy Schools', anti-bullying, sexual bullying and 'Social and Emotional Aspects of Learning' (SEAL).[3] Identifying further strategic opportunities, the programme coordinator negotiated representation on working groups set up to respond to ECM, including the 'Stay Safe' and 'Be Healthy' groups, thus ensuring a place for domestic violence prevention targets within the borough's Children and Young People's Plan (CYPP).[4] LTR was then, as it is now, a feature in the Community Safety Strategy, the Anti-Bullying Policy, the Domestic Violence Action Plan, Business Development Plan and most recently, the local VAWG Strategy. The

inclusion of LTR in all of these interlinking strategic plans has helped to ensure the retention of domestic violence prevention education in Hounslow.

In 2009, the move to locality-based multiagency Early Intervention Teams marked the beginning of a new level of awareness about the issue of domestic violence in general. As the Early Intervention Service (EIS) in the borough became more established and the Safeguarding agenda expanded, domestic violence awareness appeared to rise significantly. It was addressed more fully in the statutory child protection and CAF training, and links between domestic violence and the wellbeing of children and young people were emphasised, thus making the issue more visible to schools. The programme coordinator had the opportunity to reiterate these links when co-facilitating delivery of child protection training to newly qualified teachers in the borough.

Insecure funding created challenges for ensuring a long-term strategic approach to the development of LTR. However, as the programme become more embedded within local authority policy and within schools, as part of their development plans, funding provision reflected a greater sense of permanence. From its origin as a fixed-term consultancy, financed largely through external funds, the role became permanent in 2006, on teachers' pay and conditions. This constituted a significant local authority commitment to domestic violence prevention work in schools.

The multiagency team

The most significant factor in the longevity of LTR has been the formation of a multiagency team to deliver the training to school staff. Procuring a means of training provision beyond the limited resources of the programme coordinator as well as making schools responsible for the delivery of a prevention programme to their pupils has enabled a borough-wide approach and ensured sustainability. Schools have responded very positively to the principle that teachers, and not outside agencies, should be delivering the programme to young people. This helped to embed the programme within the curriculum and ensure commitment to LTR for the long term. The importance of long-term prevention work delivered by teachers has been emphasised by Ellis (2008) who observes that 'external staff are

less likely to impact on school culture, or provide continuity and progression to learners making long-term change more difficult' (not numbered).

Creating a multiagency team brought a wealth of experience and expertise to the programme and provided great depth and variety to the content and style of the training programme. The inclusion of support agencies within the team, such as representatives from Hounslow Domestic Violence Outreach Service, Refuge and Victim Support, was particularly helpful when preparing responses to any potential disclosures by school staff during training sessions. In order to avoid overburdening team members, all of whom give their time in addition to their respective work duties, it was important to establish clear boundaries and responsibilities. The trainers' sole function was to deliver the training to schools. All other aspects of the programme, such as initial meetings with head teachers, follow up development work with PSHE coordinators, preparation of training materials and resources, and evaluation of the training and programme delivery, were the responsibility of the programme coordinator.

The composition of the team has changed frequently over the years as people either moved on from the borough or reassessed involvement due to changes in their primary area of work.[5] Despite this, the size of the team, between 10 and 15 people, has remained fairly constant, though the ethnic and gender make-up has fluctuated. Deliberate attempts to reflect the vast cultural diversity of the borough within the team were not practicable. Recruitment has been based on a commitment to the area of domestic violence and some experience in the delivery of training. It was important, however, that there was varied ethnic representation, ensuring that domestic violence education was not perceived by schools as a concern for one particular community. The increase in male trainers helped to ameliorate any potential defensiveness amongst the male staff, who are in the minority, and to demonstrate to schools the positive role men can play in prevention education and in modelling nonviolent masculinity.

The enthusiasm, professionalism and commitment of team members have been key factors in the successful continuation of the LTR programme. Team members not only committed to delivering the training sessions in schools but also to attendance at team meetings, and at training sessions for their own professional

development related to their role within LTR. Training needs were identified by the team and the programme coordinator, and they encompassed both skills and knowledge with areas covered, including forced marriage, sexual exploitation of young people, teenage relationship abuse, voice care, presentation skills and use of puppets. These sessions have been viewed as mutually beneficial, as observed by one team member.

> "Since being part of the LTR team, my development has been huge … I am much more confident now … Being part of the team has given me the knowledge to be able to deliver DV awareness programmes in my centre." (LTR team member, 2012)

Annual team training and development days provide further opportunity to hone skills and explore any issues related to the training. Conversely, it is also an opportunity to celebrate what has been effective. The reflections of team members and the great breadth and depth of knowledge shared have greatly enhanced the development of the programme and informed decisions regarding direction and purpose. Staying abreast of changing school needs and responding appropriately has been facilitated by the nature of the multiagency team. A further benefit of a multiagency approach to training is the clear message it conveys to school staff that a variety of agencies in the borough consider domestic violence to be an important issue to which they are prepared to commit their time, some over many years.

Engaging schools

Cultivating a positive relationship with schools is central to the advancement of a domestic violence prevention initiative in any context. It was important from the start to ensure that the initial approach and engagement with schools proved beneficial for them as well as securing a pilot year for the programme. This was achieved by persuading head teachers and their senior managers of the benefits to the whole school community, emphasising the clear links between the aims of LTR and other education initiatives such as 'SEAL', 'Project Achieve', 'Rights Respecting Schools' and the 'National Healthy

Schools Programme'[6]. In particular, the way in which participating in LTR would provide evidence for meeting some of the Healthy Schools Standards was underlined.

In the early period, time was spent ascertaining the roles and influence of key personnel in the borough and securing their approval for the principles of the programme and support for delivery in schools. This was achieved across a variety of departments and agencies. Initial meetings with pilot schools focused on identifying their unique needs in relation to time afforded for training, appropriate delivery time within the school year and the development of teaching resources. This significant learning from the pilot, coupled with an understanding of the multiple pressures on schools associated with, for instance, Office for Standards in Education (Ofsted), the requirements of the National Curriculum, Standard Assessment Tests (SATs) and safeguarding, helped to inform all subsequent contact with schools. Most notably, it still remains important to demonstrate to senior managers that flexibility, and a largely nonprescriptive approach, are key elements of LTR which help to ensure participation.

From the second year on, schools were identified in consultation with the PSHE Advisor for the borough, also a member of the programme team, whose detailed knowledge of schools and their PSHE programmes helped in targeting those that were in a position to incorporate LTR. This judgement was often based on identifying schools with an ethos sympathetic to the aims of LTR or schools already engaged in activities aimed at improving relationships and behaviour. Ensuring the inclusion of the Pupil Referral Service[7] and special schools was also a priority throughout, so that pupils with specific educational needs were not excluded from the programme. As it became more established in the borough and schools perceived the benefits of participation, the issue of engagement of new schools became notably easier. Earlier cohorts began to re-engage, requesting repeat training, support, and information on new resources.

Training provision

For the efficient delivery of the curriculum, schools are, by necessity, highly structured and organised institutions. To ensure the success of the programme, it has been essential to respect this orthodoxy. Nowhere has the flexibility of the programme been more crucial

than in the provision of school staff training, both in terms of dates and times, but also duration. In the early days, a basic menu for training was offered, funded by the local authority, which was adapted to meet the changing requirements of individual schools. Schools have multiple and competing priorities for staff development and relatively few days in the school calendar to discharge their duties in this respect. Offering schools a whole day, half a day or two after school sessions seemed to strike a balance between the limited time available to schools and the minimum amount of time required to impart essential information. A commitment to whole day training sessions was a rarity, but LTR was sometimes combined with other training needs as part of a whole Inset day (continuing professional development). This had considerable advantages, emphasising the links between domestic violence and, for instance, Child Protection or the Healthy Schools agenda. This adaptation was made possible by the knowledge and experience of particular members of the team whose primary work roles were in these fields.

The content of training reflected the original Westminster model and consisted of basic domestic violence awareness and a session modelling age-appropriate classroom activities for children and young people. In primary schools, all staff were encouraged to attend, including office staff (who are the gatekeepers of communication between parents, children and other school staff), teaching assistants, governors and site management staff. However, in the main, it was teaching staff and teaching assistants who undertook the training, as involving everyone had implications for funding and the fulfilment of primary work duties. Involving all staff in secondary schools has, unsurprisingly, been extremely rare due to the greater numbers involved, the varying arrangements for staff training, and the focus on individual subject disciplines.

Evaluations from the pilot indicated that training delivered by the team was well prepared and of a high standard and this helped to establish the professional credibility of the trainers and therefore the programme. In addition to training specific to LTR, the programme coordinator collaborated with the PSHE Advisory Team in the planning and delivery of other associated training for school staff, such as circle time,[8] Healthy Schools and gender issues, and this was crucial in developing the identity of the LTR programme.

Resources for domestic violence prevention work

Throughout this initiative's lifespan there has been a proliferation of resources for prevention education, including schemes of work produced by participating schools. The identification of age-appropriate resources has been a key factor in eliciting a positive response from schools. Responding to feedback from teachers about the scarcity of early years resources, the programme commissioned the production of an Early Years Emotional Literacy resource (Moffat, 2006) which proved immensely popular with infant, nursery and primary schools. One teacher observed: "Gorgeous books, with huge teaching potential – I particularly picked up on books that could be used to cover literacy objectives" (Infant and nursery teacher, 2006).

The resource bank of school schemes of work has expanded as more schools have participated, enhancing and enriching what is available for subsequent cohorts, obviating the need to spend time developing original programmes. Other resources provided have included a LTR DVD, posters and leaflets on forced marriage, the *Expect Respect Education Toolkit* (Women's Aid, 2008, 2010) and the government's Teenage Relationship Abuse Campaign materials (Home Office, 2011, 2012). All schools are regularly sent information on relevant websites, resources, government and other reports pertinent to the area of domestic violence or VAWG generally.

The LTR programme is not prescriptive and the content of a scheme of work for prevention education is for the school to decide, with the support and guidance of the programme coordinator. However, core themes are emphasised such as respect in personal relationships, gender and equality, and all forms of bullying, including sexual bullying. At the heart of all the activities are the programme aims outlined in the introduction to this chapter. In addition to these aims, all the activities involve a variety of teaching and learning styles, are likely to increase emotional literacy and encourage an awareness of the effects of certain behaviours on others. Many of the exercises do not involve writing, are often drama-based and frequently consist of whole class or group work. This has contributed to the popularity of LTR with pupils, as one stated: "The most interesting part of the project was the 'Learning to Respect' posters because they were fun to make" (Primary school pupil, 2010).

Supporting the whole school community

Recognising the potential impact that domestic violence education might have on children affected by the issue, as well as the needs of any parents or school staff experiencing domestic violence, has been an important ethical consideration for the programme team and schools. To this end, a group was established to explore these ideas with representatives of support agencies in the borough. The most significant outcome of these considerations was the decision to request that a senior staff member should provide a résumé of the school's child protection procedures at all future training sessions. This was predicated on the belief that the best way to support children (other than providing help for the nonabusing parent) was to ensure staff were confident about what to do in the event of a disclosure. Signposting pupils to relevant websites, support agencies and literature, including a leaflet designed by focus group participants in the pilot schools, was another important aspect of this support.

Supporting adult survivors themselves has been a more complex affair and there have been various attempts to meet this need appropriately over the last eight years. All schools were provided with leaflets, posters and cards advertising local and national support agencies and these were displayed in prominent places in schools during the delivery of the programme. In the early days, domestic violence outreach sessions were timetabled and advertised for both pilot schools, as well as support agencies being available to provide telephone support, thus providing an offsite 'one stop shop' for survivors. A leaflet was produced and the sessions were advertised in both schools' newsletters. This service was rarely used, however, probably for all the reasons that we know about survivors' hesitation in presenting to helping agencies, such as fear of the perpetrator, anxiety about being believed or worries about being perceived as a bad parent.

Some schools currently offer parent information sessions on the LTR programme in the curriculum, rather than domestic violence outreach sessions. The sessions, provided by members of the LTR team, offer some insights into the purpose and nature of the programme in school, but the primary focus is the dissemination of information about local support agencies for survivors of domestic violence. Both the team and senior managers in school have been sensitive to the likelihood of some staff being affected by domestic

violence. Staff in such circumstances had the option not to attend whole staff training but instead have one to one training and support from the programme coordinator, as well as relevant signposting to support agencies in the borough. This proved necessary on two occasions.

Schools respond

"Schools are the environment in which future relationships are built." (Secondary school teacher, 2009)

The response from schools has, in the main, been overwhelmingly positive with classroom teachers and senior managers demonstrating great commitment, creativity and a genuine concern to address the issue of domestic violence. There have been challenges for some staff, faced for the first time with shocking statistics on the prevalence of domestic violence and the potential effects on children. Many teachers already feel the pressures of the responsibility to safeguard children for whom they are 'in loco parentis'. In training, it was made explicit that the role of teachers is 'healthy relationships education' and not one of 'social care.' Senior managers were informed that the programme was not primarily about identifying pupils at risk but was a universal prevention programme for all pupils. However, the majority of teachers responded with a desire to know how to help and support young people and how to deal with disclosures effectively because "children living with domestic violence need all the help they can get" (Primary school teacher, 2007). Since the pilot, staff anxiety about pupil disclosure has always been evident both at training sessions and on post-training evaluations and therefore an increasing amount of support literature for teachers has been included in training packs.

LTR has been introduced to 96 per cent of schools in the borough across the entire age range and including the Pupil Referral Service and special schools. In eight years this amounts to over 2,000 teachers and16,000 thousand pupils, especially as many schools deliver the programme on an annual basis and it appears in school development plans as part of their PSHE programmes of study. It has also been delivered to young people leaving care, students at the local further education college, staff at a respite centre for children with profound

and multiple learning disabilities, Connexions Advisors, youth workers, Children's Centres and nursery settings, in an attempt to be as inclusive as possible and to maximise the potential for prevention education across the board. However, it may be the case that some of the most vulnerable young people are often not in school, especially those who absent themselves in order to offer some protection to the non-abusing parent.

Secondary schools (ages 11 and over)

Almost exclusively, secondary schools have delivered the programme to one year group through PSHE or Citizenship, apart from three schools, one of which delivered to all pupils other than Year 11, the second delivered it through the English curriculum, and the third delivered it through Sociology and Drama. As the programme has developed, some secondary schools now deliver in Year 7 or 8 (11–12 year olds) and then revisit, using advanced resources with older pupils. The wider curriculum offers many opportunities to deliver domestic violence education (Maxwell et al, 2010). If PSHE becomes marginalised, it may become crucial to the continuation of domestic violence prevention work to emphasise these opportunities to schools.

Nursery, infant, junior and primary schools (ages 3–11)

Schools with pupils aged 3–11 often delivered LTR as a themed week with cross-curricular activities, exploiting the potential for a unique and creative approach to the programme. The focus for younger pupils was usually respect for self and others, good friendships, and/or bullying and self-esteem, with many schools approaching the issue of domestic violence overtly around Years 5 or 6 (ages 9–11). Some staff felt comfortable addressing the issue with younger pupils and this may be as a consequence of a wider and increasing culture of safeguarding. Whole school assemblies have been a regular feature as a celebration of achievements and a way of helping pupils to see that issues of respect, bullying and domestic violence are taken seriously by other teachers and pupils in the school. This approach, with at least some suspension of the normal school timetable, shows considerable commitment given the pressure on schools to meet

statutory requirements, and many staff appreciated the creative space this provided, not only for the pupils but for themselves also.

> "'Learning to Respect' week has been a huge success. The children have been highly motivated and our lessons have ended up being over an hour each!" (Primary school teacher, 2009)

> "I would like to have two weeks of 'Learning to Respect' week, have more acting, more writing activities and stuff like that." (Primary school pupil, 2010)

Some primary schools incorporated LTR into the wider theme of respect for others, the environment, animals and so on. Although it is a creative way of embedding this work, the disadvantage to this approach is that the issue of domestic violence is less visible and explicit. This may indicate some reservation about the inclusion of domestic violence in the curriculum and this has been expressed on some occasions at the initial meetings with schools. Such anxiety may relate to parental responses or the risk of 'offending' the local community where some assumptions, erroneous or otherwise, may have been made about the existence of domestic violence in that area. Any fears have been easily allayed by reassuring schools that domestic violence affects all communities. However, the opportunity for any discourse regarding the more subtle aspects of the interplay between domestic violence and culture (Thiara and Gill, 2010) has not been possible in the limited time available to promote the programme in schools.

Evaluating the programme

> Research on primary prevention in education settings indicates that violence prevention programmes may change attitudes. (Hague et al, cited in Hester et al, 2007: 210)

> What is less well known is whether there is a link between raised awareness and any long-term impact on violence reduction. (Hester et al, 2007: 210)

Creating an evidence base to support and justify the continuation of the programme raised some challenges. The stated long-term aim 'to reduce the incidence of domestic violence' was not predicated upon the notion that this could be realistically measured. The short-term aims, such as building self-esteem, although seemingly more amenable to measurement, are also affected by myriad influences in the various environments that young people inhabit, including school, home, friendships and cyberspace. It has been important, therefore, to measure as effectively as possible, those aspects of the programme that lend themselves more readily to this process, ensuring that the voices of everyone involved, particularly young people, are represented. The evaluation forms completed by pupils indicate their level of enjoyment of the activities but also give them the opportunity to say which activities they liked the least, providing useful information for both the programme coordinator and teachers.

Pupils completed evaluation forms following delivery of the programme, varying according to age, and some schools have chosen methods other than written formats to elicit information, ensuring maximum inclusion. These have included a class show of hands, 'smiley faces' and interviews with the School Council representatives. In addition to an evaluation form, secondary school pupils were asked to complete a 'before and after' attitude survey, although it has proved difficult to ensure completion of these as many staff found it too time-consuming to administer this in addition to evaluation forms. However, it is likely that this process will be greatly facilitated by emerging technologies, in particular the use of online surveys.

In general, key stage 1 and 2 (ages 5–11) pupil evaluations indicated that children had understood the nature of good friendships and relationships and the importance of mutual respect. At key stages 3, 4 and 5 (ages 11–18) pupil evaluations indicated an understanding of the nature of domestic violence and about where to seek help. The great majority of pupils indicated that they enjoyed the LTR activities, for example:

> "… week after week we had productive lessons where we learnt a lot of useful facts. There were times where we had class discussions or group discussions which enabled us to see things from a different perspective."
> (Year 8 pupil, 2012)

This was also evidenced in some schools by pupils' willingness to participate in extra-curricular activities leading up to inter-school pupil showcases and competitions, more of which is discussed later. Across the age range, pupils have demonstrated imagination and empathy in their submissions to school and borough-wide competitions, demonstrating their enthusiasm for the work. However, a very small number of pupils have indicated a level of discomfort with programme content: "It's good to learn this kind of stuff but I do sometimes feel uncomfortable talking about things like this" (Year 8 pupil, 2012). One can only speculate about the reasons for this unease; it may indicate embarrassment or the presence of domestic violence in that young person's experience, or simply that talking about difficult issues in a public setting is not comfortable for some young people. In one infant and nursery school, evaluations revealed that the vast majority of pupils said they would respond differently to their peers following delivery of the programme. In some other schools, staff observed that not only did pupil relationships improve but those between staff and pupils had also benefitted: "I noticed that other children were showing respect to others ... the teachers would pay more attention to you than usual" (Primary school pupil, 2006).

Training evaluation forms were completed by all staff following training, and the responses were collated and tabled by the programme coordinator and presented back to the school to inform the LTR/school partnership of any issues that needed to be addressed. Some PSHE coordinators in schools have also designed their own forms for eliciting feedback from staff. Following delivery in schools, meetings took place between the head teacher, programme coordinator and PSHE coordinator to discuss all aspects of the programme in order to identify successes and areas for development. These discussions have provided valuable information for adaptations to the programme, with schools proffering insights that have informed approaches to further school cohorts. As 'pupil voice' has become more integral to education (Short, 2010), pupils have become familiar with the evaluation process and some returned forms have provided great insight into pupils' experience of the LTR programme.

Despite these attempts at effective evaluation, it still remains the most problematic aspect of this initiative. It has been the qualitative aspects of this process that have been the most informative, such as the spontaneous conversations that have taken place with numerous

staff and pupils participating in the programme. This communication has taken place during frequent school visits, at LTR events in the borough and at other events and training sessions attended by teachers. These informal conversations, though unrecorded, have informed the coordinator's understanding of the direction the programme has taken in individual schools and the support that may be needed to maintain a commitment to this area. These interactions have also highlighted the importance of the consistent and ongoing relationship between the coordinator and school staff, emphasising the need for a discrete post to develop this work.

Maintaining a profile

Since its inception, LTR has developed and maintained a unique identity in the borough. This has been achieved by organising and participating in a variety of events aimed at raising the profile of the programme as well as providing pupils, staff and other partners with both informative and enjoyable experiences. The very first of these was a launch event in 2004, attended by over 90 local authority personnel, school staff and pupils. This provided a forum for the pilot schools to talk about their experiences of programme delivery. This was followed by a domestic violence prevention day the next year. Held at the Civic Centre, this event involved groups of pupils and staff from six schools in a variety of interactive sessions with Domestic Violence Responses (DVR) and the National Youth Theatre (NYT). Pupils participated in drama, discussion and written activities as well as an interactive performance by members of the NYT.

Over the years there have been a number of pupil showcases. These events have involved several schools in presentation and performance pieces to a multiagency audience, on the topic of respect and domestic violence. These events have been supported by prominent personnel in the borough and some of these showcases have also involved collaborations with DVR and the NYT, and also Tender, an organisation working in schools and other settings to develop positive attitudes to relationships. The quality of work has been impressive with pupils demonstrating not only skills but a depth of knowledge and an awareness of domestic violence and related issues that was testament to the work taking place in schools. These occasions have been evidence of substantial commitment on

the part of participating schools and the LTR team, with much time and effort afforded to the preparation. The showcases, providing staff and pupils with the opportunity to witness the way in which other schools have creatively interpreted the LTR programme, have been covered by local press and corporate communications.

Other ways of ensuring agencies and organisations are aware of LTR have included displays in a variety of locations, presentations at both national and local conferences, borough events and training sessions, and participation in events to mark International Day Against Violence Against Women. The programme coordinator has also, in conjunction with the Community Safety Partnership, provided training for numerous agencies in the borough. Communication with these agencies has ensured continued interest in LTR and has provided ample opportunity to recruit new members to the LTR training team.

Conclusion

The implementation of LTR has taken place within the context of frequent shifts and changes in policy and practice, both nationally and locally. However, more recent national developments which could have created ample opportunity to embed VAWG in the curriculum as a requirement have been reduced to recommendations (HM Government, 2013). This represents a further departure from earlier discourses around the importance of gender in education and its implications, not only for academic success but for equality of opportunity generally (Stanworth, 1983; Arnot and Weiner, 1987; Skelton et al, 2006). The change in government, in 2010, and the consequent changes in education policy have resulted in the acceleration in transition to Academy status for many schools. No longer required to implement local policy in relation to delivery of the curriculum, the subordination of PSHE and Sex and Relationships Education (SRE) to more 'academic' subjects may well occur in the future. It is within PSHE and SRE particularly that inequality has been addressed and challenged.

Domestic violence prevention initiatives can take advantage of new Ofsted judgements around bullying and safety. However, given the harsher judgements implicit in the new framework, what does this presage for initiatives which sit outside of statutory provision and

require a degree of flexibility and creativity in the delivery? The LTR programme has flourished within an atmosphere of collaboration, with schools willing to share schemes of work, ideas and resources. How well this culture of co-operation will survive the inherent competition of the education marketplace remains to be seen.

The need for this work, however, remains the same. For example, a 2010 focus group with 14-17 year olds in the borough 'suggests that gendered roles are becoming ever more restrictive not less' (James-Hanman, 2010: 1). The issue of domestic violence and VAWG generally is not a finite area; needs have changed even within the lifespan of LTR, with new technologies creating myriad opportunities for bullying and the exposure of young people to abuse. It is imperative that schools continue to incorporate VAWG into PSHE (where PSHE remains in the curriculum) and into anti-bullying initiatives as a discrete subject area. The potential demise of PSHE as an integral part of the curriculum indicates the need for a more cross-curricular approach to domestic violence prevention education. Locally there is much evidence of commitment to this work, with many policymakers, agencies and the vast majority of schools continuing to afford the programme considerable time and energy. In particular, the significant effort of members of the multiagency team has ensured the programme's success. LTR has been introduced to nearly all schools in the borough and the programme has begun the next phase, expanding its reach to encompass Children's Centres and nursery settings across the borough. This is a very positive development, indicating a clear recognition that domestic violence prevention needs to start with the very young, as one teacher stated: "Unless we start addressing these issues from an early age we will not bring about change" (Primary school teacher, 2009).

Notes

[1] The establishment of Academy schools began under the previous Labour government, and the original intention was to improve failing schools. Responsibility for the school and related budgets is delegated to the governing body and away from the local authority, giving schools considerable 'freedom'. Under the current coalition government, greater financial incentives have encouraged schools to opt for Academy status.

[2] Initial funding was from Government Office for London and the Teaching Support Service (TSS). In addition to this, the programme coordinator has accessed a number of smaller funding streams to support specific initiatives

pertaining to the programme from various bodies, including Metropolitan Police Special Projects, Extended Schools, Youth Offending.

[3] Social and Emotional Aspects of Learning (SEAL) is a programme for schools, designed to improve the emotional literacy of pupils primarily, but staff and parents also.

[4] Every local authority used to be required to develop a Children and Young People's Plan (CYPP) to set targets and priorities for the welfare of children and young people in that area. The CYPP is based on the five areas in Every Child Matters (ECM).

[5] The following agencies have been represented in the LTR Team: the Behaviour Education Support Team (BEST), the TSS, Police, Children's Social Care, Housing, Sure Start, Youth Offending Team, Education Psychology Service, Refuge, Youth Service, Community Safety Team, Education Advisory Service, Child and Adolescent Mental Health Service, Victim Support, Targeted Youth Support, Local Safeguarding Children's Board, Domestic Violence Outreach Service, Probation Service and a serving teacher.

[6] All of these initiatives share broadly similar aims such as improving relationships, recognition of personal rights and responsibilities, and the healthy social and emotional development of children and young people.

[7] A Pupil Referral Service exists to support pupils temporarily excluded from mainstream schools due to behavioural and/or educational difficulties.

[8] Circle time brings pupils into a circle to participate in group activities, the aim of which is to nurture their emotional wellbeing.

References

Arnot, M. and Weiner, G. (eds) (1987) *Gender and the politics of schooling,* London: Hutchinson Education.

Debbonaire, T. (2002) *Domestic violence prevention pack for schools: Promoting healthy relationships and creating safer communities,* London: Westminster Domestic Violence Forum.

Ellis, J. (2008) 'Primary prevention of domestic abuse through education' in Humphreys, C., Houghton, C. and Ellis, J. *Literature review: Better outcomes for children and young people affected by domestic abuse – Directions for good practice,* Edinburgh: Scottish Government. Available www.scotland.gov.uk/Resource/Doc/234221/0064116.pdf

GLA (Greater London Authority) (2001) *London Domestic Violence Strategy,* London: GLA.

Hester, M., Pearson, C. and Harwin, N. with Abrahams, H. (2007) *Making an impact: Children and domestic violence: A reader* (2nd ed), London: JKP.

Home Office (2011, 2012) *Teenage relationship abuse campaign resources* [online] Available: www.homeoffice.gov.uk

Home Office (2013) *Information for local areas on the change to the definition of domestic violence and abuse*, London: Home Office, produced in partnership with AVA.

HM Government (2013) *A call to end violence against women and girls: Action plan* London: Home Office.

James-Hanman, D. (2010) *Uncomfortable truths: Sexual survivors speak out*, London: AVA (unpublished report).

Maxwell, C., Chase, E., Warwick, I. and Aggleton, P. with Wharf, H. (2010) *Freedom to achieve: Preventing violence, promoting equality: A whole school approach*, London: Womankind Worldwide.

Moffat, A. (2006) *Emotional health and well-being: An early years resource to promote healthy relationships: A resource for the Learning to Respect Programme* (unpublished).

Short, N. (2010) 'Exploring pupil voice in primary schools', *Primary Headship*, October, Optimus Education [online] Available: www.teachingexpertise.com/articles/exploring-pupil-voice-primary-schools-10116

Skelton, C., Frances, B. and Smulyan, L. (eds) (2006) *The Sage handbook of gender and education*, London: Sage.

Stanworth, M. (1983) *Gender and schooling: A study of sexual divisions in the classroom*, London: Hutchinson and Co.

Thiara, R.K. and Gill, A.K. (2010) 'Understanding violence against South Asian Women: what it means for practice', in Thiara, R.K. and Gill, A.K. (eds.) *Violence against women in south asian communities: Issues for policy and practice*, London: Jessica Kingsley Publishers.

Womankind Worldwide (2007) *Challenging violence, changing lives: Gender on the UK education agenda. Findings and recommendations 2004–7*, London: Womankind Worldwide.

Women's Aid (2008) *Expect Respect education toolkit*, [online] Available at: www.womensaid.org.uk

Women's Aid (2010) *Expect Respect: A toolkit for addressing teenage relationship abuse*, [online] Available at: www.womensaid.org.uk

SEVEN

No silent witnesses: Strategies in schools to empower and support disclosure

Chris Greenwood

Introduction

Imagine …

Being a child in say … the leafy lanes of Cheshire.

Lying awake, night after night, listening to loud arguments and the scary silence that follows.

Being anxious about what might happen to your brothers and sisters if you leave them to go to school.

Being eight years old and running naked down a street at 11.00pm trying to get someone to call the police to help your mum.

Not wanting to go home after school because you fear what might be there or who might not.

Living on the streets because you're too frightened to live at home.

Believing that the treatment family members endure is all your fault.

Thinking you will turn out to be a violent adult too.

All this but not being able to tell anyone.

These are the consequences of domestic abuse (DA), a key safeguarding issue, as these examples illustrate, for a significant number of children in Cheshire. Many children attending UK schools do not need their imagination to engage with such scenes; for many these images are their reality, their childhood memories and will most certainly impact on their ability to access both teaching and learning and, ultimately, their life chances. It is clear that educationalists have an important role in ensuring that children exposed to DA are identified, protected

and supported. Children spend a large proportion of their time in school and their class teacher can be a very significant figure in their lives, especially in primary education. A teacher can be a consistent person who listens in a non-judgmental way, who can effectively signpost them to sources of information and support, and who can alter the course of their lives and of their families.

Cheshire County Council undertook to raise awareness of DA amongst a broad range of professionals and the general public, including young people. A range of services were also provided to meet the identified needs of those affected, with the aim of keeping them safe and, as far as possible, mitigating against harm. Cheshire Education Services embedded DA in its Child Protection training, and they also developed and led a range of personal, health, social, and citizenship education (PHSCE) initiatives, focusing on healthy relationships, in schools. In collaboration with the Cheshire Domestic Abuse Partnership (CDAP), it commissioned programmes to challenge attitudes to violence in the hope of changing abusive patterns of behaviour in the personal relationships of children and young people. The Safeguarding Children in Education and Settings (SCIES) Team enjoyed success over a ten-year period, largely due to the dedication and passion of the SCIES team members; its work was implemented in 82 per cent of Cheshire's schools and accessed by over 52,000 young people. This work was nationally acclaimed and nominated for awards. In 2000, new and innovative work was introduced. At that time, there were few, if any, other local authorities attempting such whole-scale and comprehensive DA work in schools. The following chapter outlines the challenges faced in this journey, reflects on the experience of implementing DA work in Cheshire schools, and attempts to draw out practice that could be helpful to practitioners embarking on similar projects[1].

Multiagency context

In 1997, elected members in Cheshire requested information from officers regarding the prevalence of DA in Cheshire. This led to a multiagency conference to examine the issue at which elected members, and senior managers from both voluntary and statutory sectors, were included. Key decisions made at this event laid the foundations for the development of DA work in Cheshire, including

the formation of a multiagency group which became the CDAP. This group was charged with devising strategies to open up the DA debate in the county, auditing existing resources and developing a coordinated domestic abuse strategy. It evolved into a strong and effective multiagency working partnership which developed the ethos and vision of DA work in Cheshire, provided strong leadership within each agency and collectively coordinated the formation of policy and practice.

Multiagency work can be notoriously difficult to sustain and time taken to establish secure working practices, which allow members of the group to collaborate and challenge effectively when necessary, makes a firm foundation for future working. The CDAP's work was to challenge practice and attitudes and create countywide initiatives to address DA. Therefore it was vital that the partnership modelled abuse-free relationships with no single agency dominating the group, thus ensuring that the power between individuals was balanced. The group was ably led by the DA Coordinator and one of the first tasks was to collectively agree a definition of DA. Although this might seem unnecessary as there were many definitions available that could have been adopted, this exercise enabled all members to contribute to, and therefore own, the strategy right from the outset.

Three core principles were adopted by the CDAP. Firstly, it was agreed that future work should value and build on the existing work already being undertaken by voluntary agencies, such as Women's Aid and local refuges. Secondly, each agency was to have a named 'champion' to facilitate communication between agencies, to lead strategy and policy development within their own organisation, to establish a process to allow practice to be challenged, and to begin to establish more effective and efficient networks both internally and externally. Thirdly, a rolling programme of multiagency training was to be established with the objective of training as many front-line staff as possible in multiagency groups. This training aimed to raise awareness of the prevalence and impact of DA and to disseminate information about local resources where practitioners and potential service users could access services and support. Each training day was led by a representative from Women's Aid or from a refuge, and the workshops were co-delivered by refuge and statutory-agency personnel, including police, education, probation, social care and health. Although costly in terms of staff time, this established

strong working relationships within training teams and set a model for interagency working which the training aimed to promote. Sharing achievements and best practice as part of the training encouraged delegates to feel proud of the work. This generated a willingness to participate in challenging DA, whether through simply displaying posters in their work place or delivering services to those experiencing DA. It was believed that everyone could 'do their bit' so people were signposted to support and materials in order to enable this. All agencies affiliated to the CDAP signed up to its philosophy and representatives met regularly to discuss the progress of the strategy and to agree new initiatives. The strong lead and common purpose gave individual representatives strength to drive the DA agenda within their own agencies. The willingness of group members to share ideas, to draft policies and to give time to others created a supportive atmosphere and an energy that helped individuals who would otherwise have been working in isolation.

The education context

The immediate impact on the Education Department was that they included DA awareness elements in the child protection training available to all school communities. Briefings were delivered to head teachers through their existing meetings. Safeguarding leads in every school were given the opportunity to attend the ongoing programme of multiagency training and to acquire additional skills by attending further training in working with women and children exposed to DA. Work was also undertaken on developing an awareness-raising project for primary school children, along with supporting materials and guidance for education workers on how to deal with any concerns raised by children in school. Table 7.1 outlines the Cheshire vision for the actions schools could take to support children exposed to DA. The multiagency DA training enabled school staff to familiarise themselves with the range of professionals who could offer support when DA cases for their pupils were identified. Since schools do not work in isolation, it was considered important that a network of agencies was in place before embarking on DA projects in education. It is imperative that school staff have a thorough understanding and a readiness to deal with sensitive issues which, if mishandled, could increase the risk to children and non-abusing carers. It is widely

established that a child or young person will disclose DA to a person they trust. Research indicates that 'In 22.9 per cent of cases where a young person of 11–17 years was physically hurt by parent or guardian nobody else knew about it' (Radford et al, 2011: 9). The person tasked with dealing with safeguarding cases may not be the person to whom the child discloses. For this reason, it is vital that all school staff, including the school secretary, site manager, mid-day assistants (and in one school this included the road crossing attendant) are appropriately trained to respond to any concerns raised by the pupils and have the confidence to do so. The SCIES team's staff provided whole-school safeguarding and DA training, financed by and delivered in schools and updated on a three-year cycle. By 2011, every East Cheshire primary, secondary and special school and 60% of independent schools in the county were known by the SCIES team to have up-to-date training indicating that the training strategy was fully embedded in schools' safeguarding practice. The publication of the national *Safeguarding Children in Education and Safer Recruitment Guidance* in 2007 supported the implementation of the SCIES team's existing safeguarding training strategy by introducing various measures, such as a requirement that '… staff who work with children undertake appropriate training to equip them to carry out their responsibilities for child protection effectively, [and] that it is kept up to date by refresher training at three yearly intervals …' (DfES, 2007: 15). The Office for Standards in Education (OFSTED) enforced this through its inspection regime. Schools have a responsibility, as with any child protection issue, to ensure that any child disclosing DA receives immediate and appropriate support. This guidance also indicated that the PSHCE curriculum can be used to deliver key safeguarding messages to young people and reinforced Cheshire's message about the importance of DA work in education.

> It is important to make children and young people aware of behaviour towards them that is not acceptable and how they can keep themselves safe. The non-statutory framework for Personal, Social, Health and Citizen Education (PSHCE) provides opportunities for children and young people to learn about keeping safe and who to ask for help if their safety is threatened. (DfES, 2007: 71)

Once schools were prepared to deal with any DA issues raised by young people, the SCIES team undertook a pilot programme using local authority funding, with PSHCE teachers and safeguarding leads in secondary schools, to deliver four lessons to students of 13 years old. Ten teachers from eight secondary schools attended a one-day course which aimed to give them: a basic awareness of DA; practical experience of using materials which could be used to introduce DA to young people; appropriate responses to pupils experiencing DA; together with a knowledge of local support systems and opportunity to discuss school-based projects which could be developed with the support of Home Office funding (discussed later).

In post-training evaluation, the teachers reported that the training had given them time to familiarise themselves with the teaching materials that they would utilise with young people and to share what had worked well. They also learned how to deal with any concerns raised by pupils and how and when to refer to other agencies. This approach proved successful; when the delegates delivered the required DA PSHCE programme, the pre- and post-evaluation questionnaires indicated that the work had changed their pupils' perceptions and attitudes to DA.

In order to maximise the impact of the pilot and to embed DA work in the curriculum, pupils were involved in developing an assembly containing key messages for young people about DA. This was then delivered to students in the school year below, aged 12, with the intention of introducing DA to another year group and further embedding the DA work. This goal was achieved as DA work was established in the curriculum of eight secondary schools. However, it was resource intensive for both the local authority and the schools. Funding was needed to provide supply teacher cover to allow school staff to be released for training and debriefing. Additionally, at that time, there was only one local authority advisor with responsibility for child protection who had to oversee the work in schools, support schools in responding to any emerging case-work, and produce teaching materials. This was in addition to the advisor's main role which was quality assuring child protection policy and practice in over 350 schools. Consequently, it became clear that securing funding for resources was imperative if the work was to develop on a wider scale.

Table 7.1: Actions schools can take to mitigate against the harm of exposure to domestic abuse

Increase resilience factors	Help children deal with trauma event	Provide a positive response to allegation	Ensure on-going support
Increase self-esteem	Deploy programmes to raise awareness	Provide opportunities to discuss concerns	Safety planning
Nurture groups	Ensure *all* pupils receive clear message to tell an appropriate adult	Respond effectively to any concerns raised	*Talking to my Mum* programme
Safe school environment			*Acorn Project*
Increase confidence		Provide 'child's voice' to MARAC	*Changing Places* project
Provide support network	Good relationships between pupils and staff		Excellent multi-agency working
Bullying Prevention Programmes	Established practice in taking concerns seriously	Provide safe confidential environment	Refferal to other agencies e.g. CAMHS, drug/alcohol agencies
PSHCE programmes e.g. *He loves me, He loves me not* – to deal with sexual coercive behaviour in teenage relationships	Early disclosure could lead to shorter exposure to DA	High quality pastoral system	Acceptance of acting out behaviours
	Child knows it is not to blame	Regular staff training	

Three events were key in influencing the progress of implementing DA work in Cheshire Education Department. Firstly, the CDAP was successful in securing government funding from the Home Office to develop DA services across a range of agencies; this enabled the development of new areas of work, such as the formation of a DA Outreach Service. A data project post was developed which enabled the sources and rates of referral and re-referral into DA services to be monitored. This data informed practice; for example, although referrals were increasing there were few from the lesbian, gay, bisexual and transgender communities. This recording system also allowed cases to be tracked from referral through to outcomes, including eventual court disposal, which indicated the need to raise the awareness of DA within the judiciary, and this was then addressed. Other agencies, such as the police, used this funding to focus on the implementation of strategies to increase prosecution rates. Education pledged to use some funding to embark on a much wider programme of awareness raising in Cheshire schools across all age groups, including developing initiatives accessible to children with learning needs. The vision was to facilitate the formation of storytelling[2] projects with high quality materials. This included teacher's guides, containing lesson plans to enable work to continue in schools after the project ended, guidance on responding to allegations, and posters signposting sources of help which were designed by children. While the Home Office funding generated publicity within the county and created great energy in the partnership, this was tempered with the realisation of the enormity of the task; namely, to develop responses to DA across many areas

simultaneously and address the need to sustain the work after the two-year funding ended.

Secondly, a DA tragedy in Cheshire placed a focus on how schools could and should better support children living with DA. It also highlighted that services were needed to support schools in securing earlier disclosure of child welfare concerns.

Thirdly, the then government introduced the Vulnerable Children's Grant (Grant 210). Previous grants of this type were traditionally used to narrow the education attainment gap between groups of vulnerable children and the general population. This funding was traditionally received by initiatives relating to Looked After Children and to teenage pregnancy and those known to Youth Offending Teams. Cheshire took the bold step of creating a 'new' group of vulnerable children – those exposed to domestic abuse – and allocated some of this funding to create a new local authority team of education workers and this evolved into the SCIES team.

The team was made up of two and a half full-time posts and focused on promoting work to address DA within the Education Service. Its main tasks were to: liaise with refuges and local schools about access and continuity of schooling; promote the development of healthy personal relationships; support families experiencing school-related problems due to DA; work together with other school related agencies, such as the education welfare and psychological services and projects with shared aims; raise awareness in school communities of the scale and impact of DA on children; and, lastly, provide training, advice, resources and support to help schools develop a safe and welcoming environment for those children living with DA so they could be supported by staff equipped to respond effectively to protect them. The formation of this specialist team allowed the DA work across local authority schools to be more systematic by ensuring implementation of the DA strategy. Schools identified as reluctant to address DA were encouraged to participate in training and the SCIES team led initiatives. There was now the capacity to develop resources, establish and embed best practice.

Awareness- raising work in schools included production of posters and information cards designed 'by young people, for young people', which were widely distributed through schools, the CDAP and the Local Safeguarding Children Board (LSCB). Young people also produced an awareness piece that was broadcast on local radio. The

SCIES team collaborated with Home Grown, a local dance theatre company, and secondary schools to produce performance pieces on DA. These were performed at public events around Cheshire during the evening to the wider school community, including parents, affording young people who did not attend school the opportunity to attend. A working party of safeguarding leads and refuge workers, led by the SCIES team, produced the Cheshire Refuge/School protocol, agreeing best practice approaches to supporting children exposed to DA in their education whilst keeping them safe. The SCIES team worked with the CDAP to commission and establish group work programmes, which the SCIES team members initially established in schools with the aim of challenging and changing abusive patterns of behaviour in young people's intimate relationships. In collaboration with a community artist, staff from the SCIES team produced the 'Labyrinth', a visual and interactive arts piece in which young people and their mothers powerfully articulated their fears, feelings and hopes for the future as they journeyed towards survival. This installation was used widely in the training of practitioners at local and national events.

Since its inception, the SCIES team has ensured DA is an integral part of all safeguarding training delivered to every Cheshire school. With this in place, collaborative work with Gripping Yarns, a theatre-in-education company (TIE), produced a range of DA storytelling projects that have been delivered to young people and their teachers. These were supported by high quality teaching materials produced by the SCIES team to ensure DA work was embedded into the PSHCE curriculum at all schools, and distributed, free, to schools at high-profile launch events. Table 7.2 summarises this work and indicates the key messages being promoted in each project. The work was planned to ensure learning from each project added to knowledge that young people and school communities had gained in the previous ones. The SCIES team was anxious that schools should not believe that they had tackled the issue with a one-off session but that learning should be continuous throughout a young person's education.

Table 7.2: Storytelling projects indicating key messages

Name of project	Target ages	Key messages
Heartstrings	14-18	Promotes healthy personal relationships and emphasises that domestic abuse can take many forms including put downs, financial control, psychological cruelty, oppressive control of one partner over the other.
Standing By	5-11	Explores the collusive role of the watcher of bullying activity and encourages children to understand that just watching implicates the bystander in the violence and intensifies the impact on the target.
Out of Harm's Way	8-13	Is concerned with how children faced with distressing or threatening situations can sometimes respond in ways that are harmful to themselves, such as self-injury, absconding from home or school or becoming disillusioned in school.
Family Snap Shot	5-7	Reinforces that family breakdown is not the child's fault and that no child should feel isolated or ashamed as a result of parental separation.
Place of Safety	8-13	Provides principles for safe conduct in online and texting environments to safeguard young people who might be being harassed by their parent's ex-partner to disclose their whereabouts.
He loves me, He loves me not	16-18	Focuses on relationship abuse in 16-18 year olds and explores how alcohol, drugs and pregnancy may be used to isolate and control in teenage and young adult relationships.
Never Touched Him	5-11	Cyberbullying.
Ooo Oos Tale	3-5	Uses puppets, rhymes, stories and songs to deliver key messages to children under five around staying safe, feelings, borrowing and taking, and saying 'No'.

Learning from the Cheshire experience

Leadership

Senior managers in Cheshire recognised DA as a safeguarding issue from the outset and increased the scope of the post of SCIES Advisor to include oversight of the DA strategy across the education service. This enabled policy, training, casework advice and support to be devised, implemented and quality assured by the Advisor and the team as it developed. The Advisor was a founder member of the CDAP and was thus well placed to use existing networks, meetings and working

relationships to ensure effective and comprehensive implementation of the education aspects of the CDAP's strategy. A negative feature was that this was additional to the Advisor's existing range of safeguarding responsibilities, which was already challenging. However, most schools had an excellent working relationship with the Advisor, established through safeguarding-related projects. She also attended regular meetings with head teachers, and other education service managers, such as education welfare and educational psychologists, so the pre-existing infrastructure could be used to disseminate key messages, policy and best practice.

Securing and managing funding

Securing finance for DA work is a perpetual challenge. Cheshire had been insightful in its recognition of DA as a child protection issue and designating children exposed to DA as a discrete group of vulnerable pupils in their own right. The SCIES team worked alongside the Advisor to ensure children exposed to DA were identified, protected and supported. Although the SCIES team was envisioned to be long-term from its inception, funding for this service was determined annually, placing pressure on the team to demonstrate its effectiveness. This in itself was challenging since raw data, such as numbers of schools participating in DA projects or the number of children accessing the work, which could be collated to demonstrate the real impact of the work (keeping children safe from abusive relationships) would not be evident for several years. The CDAP provided an information-exchange forum that documented, publicised and celebrated the work undertaken using quarterly data from each of the initiatives. Although data collation was tedious and time consuming, it was worthwhile, especially when the annual report outlining collective progress was published by the CDAP, overcoming the reticence of some professionals to 'sing their own praises'. The cycle of data collation kept the work 'live' to elected members and senior managers who had oversight of both local authority and other sources of funding.

Schools received DA training free of charge but were required to pay for the storytelling performances. The local Crime and Disorder Reduction or Education Inclusion Partnerships sometimes subsidised these. The drama was presented by a single storyteller, which kept

costs to a minimum and increased uptake by schools. Each piece was multipurpose and used to raise pupils' awareness as well as for staff training. Evaluation provided vital information about the needs of service users and emerging themes were utilised in the next piece to improve delivery. For example, one young person disclosed to teachers that she was being harassed by her mother's ex-partner, through text and email, to disclose her address; this meant that the next piece overtly addressed online safety but contained messages relevant to families fleeing DA, such as not disclosing their whereabouts, which is vital to their safety. One frustration for the sustainability of the work was that local authorities were ineligible to bid for some sources of funding, such as the Big Lottery and Comic Relief, but this was overcome by working in collaboration with voluntary organisations that were eligible.

Engaging all Cheshire schools

The training programme demonstrated to education staff that DA was a child protection issue and the small pilot scheme in secondary schools proved it could be addressed within the PSHCE curriculum. The SCIES team, therefore, embarked on an ambitious strategy to implement DA work in all primary, secondary and special schools. The team promoted the view of DA as a form of adult bullying and the first play for primary schools focused on antibullying. The rationale was that schools would more readily engage with the more familiar issue of bullying than directly with DA. The SCIES team collaborated closely with Gripping Yarns to adapt an antibullying story to include DA themes. This was distributed widely through the CDAP, including to refuge residents, to ensure that key messages were given sufficient prominence. The storyline was considered to have integrity and credibility and was accessible to its intended audience. Tour dates were advertised through the CDAP to ensure that professionals from a range of agencies could attend and provide support to schools should a child disclose. This resulted in greater confidence to engage with DA work for schools and facilitated networks of professionals being established to deal with casework.

The initial tour reached 56 per cent (n=162) of Cheshire's primary schools and was seen by 15,180 children. Interestingly, head teachers' concerns that parents would raise objections about the sensitive issues

raised in the work were unfounded; only one parent objected. Since the SCIES team was keen to engage with special schools, it worked with teachers in those schools to ensure that a project was developed which included appropriate materials, such as posters adapted for the visually impaired and safety planning materials written in sign language symbols. Careful use of spoken language in the play ensured that it was not too simple or patronising for young people with learning needs but also not too complex to make it inaccessible.

Careful records of the schools which were not engaging with the DA projects were kept and those head teachers received individual letters to encourage them to buy in a performance. A review of these schools indicated that many were small rural schools that had less than a 100 pupils and therefore had less money. This led to the local authority implementing strategies such as working across clusters of schools or subsidising the work for those schools with particular needs.

Sustainability

Teachers might question the capacity of TIE performances to make an impact on the long-term belief systems and behaviours of young people as they are usually one-off performances. The challenge for the SCIES team was to ensure the sustainability of the DA work in schools so that the drama became incorporated into a series of lessons about safe relationships. Consequently, high quality, photocopiable lesson plans and activity worksheets were produced for easy use by teachers. Topics such as moving schools, staying safe, being healthy, diversity, stress and self-image were covered, and they were supported by a DVD of the original drama piece which could be used to remind pupils of the key messages and to prompt class discussion. Each school could also use the resource to develop its own module of 'keeping safe' work.

New projects were developed every year over a ten-year period to meet the identified needs of schools and young people (see Table 7.3). For example, a review was carried out of 16 cases, involving young adults which had been discussed by the multiagency risk assessment conference (MARAC); the review identified sexual coercion as a major factor in their abuse. These experiences were utilised to write 'He Loves Me, He Loves Me Not', which included elements of

Table 7.3: Key events in the development of domestic abuse services to Cheshire schools

1996	Safeguarding Children in Education Adviser post established.
1997	Elective members tabled a motion on domestic abuse (DA) leading to multi-agency conference and the formation of CDAP.
1998	DA multiagency training programme established. DA training delivered to schools as integral part of child protection training. DA awareness-raising initiatives to disseminate information about DA services.
1999	'Family Snap Shot' tour.
2001	'Can You Keep a Secret' tour.
2002	Home Office Crime Reduction Project (Violence Against Women). Cheshire initiative fully fundeed for two years after which all funding to be met by local authority and partners. 2002-3 Police DA incident reports up by 13% on previous year. Pilot DA PSHCE project.
2003	CDAP Qualitative Survey – service users indicated that provision of services to children as their priority. SCIES team in place. Home Grown DA dance project. Secondary School young people questionnaire leading to storytelling project. 'Heartstrings' tour.
2004	'Jigsaw' groupwork programme established. 'Keep Safe' primary school poster produced.
2005	'Standing By' tour.
2006	DA included in induction of head teachers and newly qualified teachers. 'Keep Safe' posters developed in Polish and Makaton sign language and for secondary schools.
2007	'Out of Harm's Way' tour. 'Labyrinth' art installation produced by women and child survivors. MARAC implemented. 'Changing Places' group work programme launched.
2008	'Family Snap Shot' tour. Forced marriage and honour-based violence introduced into school PSHCE curriculum of secondary schools for 16-18 year olds. 'Place of Safety' tour.
2009	'Acorns' groupwork programme established in selected primary schools.
2010	Review of MARAC cases for 16-20 year olds; emergent themes used in the production of storytelling project for 16-18 year olds.
2011	'He Loves Me, He Loves Me Not' tour.
2012	'Never Touched Him' tour.

stalking, harassment, and themes around "If you love me you'd stay and have my baby instead of going to uni", a theme which emerged from the MARAC cases.

Each play had its own key messages but retained the core purpose of enabling safe disclosure and access to support, challenging attitudes to domestic abuse and equipping school communities to respond effectively. This suite of resources was eventually utilised in over 80 per cent (n=162) of East Cheshire's schools, from preschool to sixth form, and from the outset was positively evaluated by Home Office evaluators:

> In the 80 schools, approximately 95 teachers took part in the evaluation. The results were overwhelmingly positive about the project and, in evaluation interviews, the teachers identified the training and support provided as a very positive factor which had enabled them to feel comfortable working with the programme. They had much valued the supporting material provided, lesson plans, disclosure advice etc. Ninety-eight per cent of teachers evaluated the project as excellent. (Hague and Thiara, 2004: 46)

More importantly, young people found confidence from watching the performances to talk about their worries to school staff: "The performance showed me that you shouldn't keep your problems locked inside as troubles can just get worse and extremely stressful" (Greenwood, 2007: 8).

Reaching the 'harder to reach'

To ensure that DA messages were delivered to young people in more vulnerable groups such as those who might not attend school, the SCIES team commissioned the local community dance group Home Grown to deliver dance workshops on DA in a number of schools with a performing arts specialism. This work was further developed with students by the teaching staff in schools. Subsequent pieces, along with the professional piece 'Behind Closed Doors' and the play 'Heartstrings', were performed to the public at community venues around the county at evening events. These were supported by the CDAP's partners, including Women's Aid staff who were on hand to give information or support to individuals. The productions were well attended, reaching approximately 1,500 people, and it was hoped

that such community events enabled young people not attending school or those who had just left, together with local parents, to have access to information about DA.

In response to government guidance on forced marriage (2005), the SCIES team began to engage with the needs of black and minority ethnic groups (BME). At the time, Cheshire's population was 94% White British and schools initially questioned the need to include forced marriage and honour-based violence in the curriculum. Drawing on the strong relationships they had with secondary schools, the SCIES team argued for the need to deliver awareness-raising sessions to sixth form students and their teachers. This initiative was particularly successful as many schools rebooked the project annually, reaching around 1,000 students each year, and it led to a number of disclosures.

Ensuring young people exposed to domestic abuse are supported

The CDAP's consultation with adult service users in 2003 identified the need for more emotional support for their children. This led to the establishment of Jigsaw groups across the local authority coordinated by the NSPCC. These community-based programmes for 5–13 year olds aimed to improve children's self-esteem, increase self-protection skills, learn ways of expressing their feelings and reduce isolation. They were delivered by professionals from partner agencies of the CDAP and are still operating.

However, further consultation with women survivors highlighted the need to provide a service to address the issue of young people taking over 'the bullying role' when an abusive adult left the family. The educational welfare service had also identified this as an issue as some survivors struggled to get their children to attend school. The SCIES team suggested the development of an intervention programme for 14–18 year olds who have abusive patterns of behaviour in their relationships or for whom there is the potential for such behaviour patterns to develop. The 'Changing Places' programme was commissioned by the CDAP Children's Sub Group and was later adapted, following further consultation, to the 'Acorns' programme for use with 8–13 year olds.

Delivering groupwork programmes presented a number of difficulties. Some agencies were unable to commit to delivery while others were only able to work with young people on their existing caseloads. This precipitated a high fall-out rate of professionals between training and programme delivery with over half the trained delegates being unavailable to participate when groups were eventually established. This was addressed by ensuring that managers agreed to their staff being released to deliver planned groups before being accepted on the training. The groups were led by experienced practitioners, often from the SCIES team, who had previously run groups and who mentored newly-trained staff. This greatly facilitated the establishment of new groups and the programme being embedded in practice. Schools provided bases and resourced many of these groups which ran as a rolling programme. An advantage of this was teachers being invested in the work and being on hand throughout the week should a young person need additional support. There was a very high completion rate as a result; 93 per cent in 2011.

However, the SCIES team had to work with teachers on selection for the groups to maintain a focus on children exposed to DA as there was potential for schools to use the groups for any pupil displaying problematic behaviours regardless of whether DA was a causal factor. Post-group evaluations indicated success in: school attendance increased, exclusions decreased as there were fewer behavioural incidents, and teachers reported that the young people were more open, had greater awareness and had more positive interactions with both teachers and peers. These positive outcomes were disseminated to schools through training which led to more schools signing up to the programme.

As the SCIES team is small, it had to focus its resources on the area of greatest need. MARAC referrals were analysed to identify where cases were concentrated and the SCIES team ensured that 'Acorns' groups ran in primary schools with the highest number of children whose parents/carers were subject to MARAC. They also made certain that these schools and individual pupils had safety plans in place. After the initial group, school staff ran subsequent groups which freed the SCIES team to support other schools. The voluntary sector, led by Women's Aid, coordinated groups in community venues to increase accessibility to the programme. Thus the SCIES team has developed a tiered approach to service delivery ranging from

universal PSHCE work to highly intensive specialist interventions, such as one to one work which includes safety planning, as indicated in Figure 7.1.

Figure 7.1: Hierarchy of intervention in Cheshire Education Service

The principle of the triangle is that at each tier children have access to the services relevant to that tier as well as those in the tiers below.

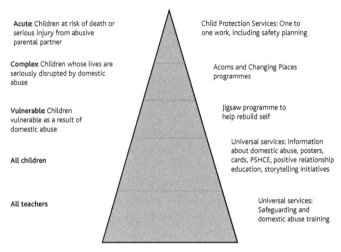

Acute: Children at risk of death or serious injury from abusive parental partner

Child Protection Services: One to one work, including safety planning

Complex: Children whose lives are seriously disrupted by domestic abuse

Acorns and Changing Places programmes

Vulnerable: Children vulnerable as a result of domestic abuse

Jigsaw programme to help rebuild self

All children

Universal services: Information about domestic abuse, posters, cards, PSHCE, positive relationship education, storytelling initiatives

All teachers

Universal services: Safeguarding and domestic abuse training

Source: Adapted from Local Government Association, 2005: 9

Ensuring DA work is embedded in school ethos

The SCIES team were responsible for ensuring that safeguarding policy and practice in schools was robust and effective. An annual safeguarding audit was introduced to ensure that high quality practice was understood by all members of the school community and embedded in the school ethos. A range of questions relating to DA were included in the annual audit. These questions aimed to prompt schools to reflect on their practice and to write an action plan, with support from the SCIES team if appropriate, to address any deficits, and they included the following:

- How does the school ensure that pupils are taught to recognise when their personal safety is being compromised (for example, in the PSHCE curriculum)?

- How does the school ensure that young people can share their concerns with a range of adults?
- How does the school empower pupils who have concerns about other students to share these concerns with supportive adults?
- Does the school have visible displays of helpful information to encourage students to share concerns and provide them with reassurance?
- How does the school ensure children exposed to DA are identified, protected and supported?
- How does the school effectively support those children whose carer has been subject to MARAC?

A number of schools were selected for a more in-depth safeguarding review. Using focus groups, staff, pupils, parents and governors were invited to discuss the school's child protection process to determine how well safeguarding was understood, embedded and effective in protecting children and adults in the school community. This process prompted schools to rectify deficits in their practice, such as updating out-of-date displays of helpful information or ensuring that the support they offered to children whose parent had been subject to MARAC was robust.

Conclusion

If children are to be protected from harm there must be no 'silent witnesses' in a school community. The SCIES team worked hard to provide and embed a comprehensive range of strategies to address the issue of DA, including training, policy development, awareness raising and groupwork, all of which are quality assured through regular audit.

Schools can do much to mitigate against the harm resulting from exposure to DA (see Table 7.3) by creating an ethos that makes pupils feel valued. They can provide a safe, protective and listening environment where the emotional wellbeing of children is nurtured, increasing their resilience and helping them to cope better with the impact of DA. Awareness raising, the PSHCE curriculum and signposting to sources of support can provide children and young people with the confidence to seek help at an earlier stage thus limiting exposure to abuse. Clear safeguarding policies and staff

training can facilitate safe disclosure and referral to agencies that can protect women and children and provide ongoing support.

Schools not only have the responsibility but also the opportunity to identify, protect and support children who are subject to DA and to ensure that such young people receive the best educational experience possible. "All I want is to take my exams, get a good job, live with maybe two dogs and a cat. I want to enjoy my life" (16-year-old male survivor). It's not too much to ask, is it?

Notes

[1] In 2000 Cheshire was a large county council covering a geographical area of 2,343 square kilometres with a population of approximately 700,000. On 1 April 2009 Cheshire was divided into two unitary authorities with Cheshire East having a population of about 370,700 people.

[2] All the stories were authored, and the dramas performed, by Simon Firth's Gripping Yarns company: www.grippingyarns.co.uk

References

DfES (Department for Education and Skills) (2006) *Safeguarding children and safer recruitment: comes into force 1 January 2007: Every child matters: Change for children*, London: DfES.

Greenwood, C. (2007) *Safeguarding audit,* Cheshire: Cheshire County Council (unpublished internal document).

Hague, G. and Thiara, R. (2004) *Crime reduction programme: Violence against women initiative evaluation*, London: Home Office.

Local Government Association (LGA) (2005) *Vision for services for children and young people affected by domestic violence: guidance for local commissioners of children's services*, London: LGA.

Radford, L., Corral, S., Bradley, C., Fisher, H., Bassell, C., Howat, N. and Collishaw, S. (2011) *Child abuse and neglect in the UK today*, London: NSPCC.

EIGHT

Preventing sexual violence: the role of the voluntary sector

Michelle Barry and Jo Pearce

The role of a voluntary sector organisation in developing and leading prevention work at a strategic and operational level in a unitary authority (an administrative division of local government) is explored in this chapter. Consideration is given to what has worked in establishing and maintaining effective local partnerships and in providing prevention, early intervention and support services for young people aged 11 and upwards.

In a city with a historically high incidence of reported sexual offending, Southampton Rape Crisis (SRC) developed an innovative and award-winning multidimensional service model that recognises the complex and interdependent factors involved in effective prevention of and response to sexual violence. In this chapter, we describe the evolution of these services in response to emerging need within a strong local culture of multiagency partnerships. In particular, we introduce the work of the 'Star Project' (Star), our outreach initiative that has reached more than 70,000 young people since its inception in 2000, delivering sessions to all of the city's secondary and some of its primary schools and gaining local, national and international recognition for best practice in sex and relationships education. Star was named as one of only ten examples of international best practice in a 2013 European Parliament Report 'Overview of the worldwide best practices for rape prevention and assisting women victims of rape'. 'Star' finds creative and innovative ways to engage young men and young women in thinking together about issues such as safety, sexual violence, coercion, consent, internet

risk and healthy relationships as well as highlighting the value and availability of specialist support.

Young people's voices – starting where they are

Having initially offered a crisis helpline and limited face to face support, in the late 1990s SRC became increasingly conscious that the few young people who were contacting the organisation for help did so with trepidation, having received, from schools or elsewhere little or no information about either protecting themselves from sexual harm or where to get help if they had experienced it. The stories we heard from our clients led us to question why education in this area was predominantly limited to 'stranger danger' messages. Most of the young women who contacted us felt vulnerable to, or had been assaulted by, somebody they knew, most often a family member or peer in a social or relationship situation, yet there appeared to be widespread silence about these risks and how they might be managed by young people. A consistent theme among our young clients was that they were blaming themselves for getting into (and feeling unable to get out of) problematic sexual situations, yet they had received no help in thinking about how they might feel more empowered or confident in making appropriate choices about sexual activity. Instead, they described feeling too ashamed to talk to others about their experiences. This became a barrier to their support needs being met and contributed, in a circular way, to the maintenance of the very silence that had made such experiences so hard to talk and think about.

Although unique amongst rape crisis services in our region in offering services to under-16s, the physical setting, therapeutic approaches and promotional materials of SRC were adult-focused and unavailable in schools or youth venues. This perpetuated a perception of SRC as an adult service which became another hurdle along the already daunting route of seeking support about sexual abuse and did nothing to reassure a young person that they were not 'the only one' this was happening to. Adolescents frequently experienced their attempts to disclose being 'swept under the carpet' and we began to realise how crucial it was that we offer a different experience – one that did not maintain a silence, overlook their needs or expect them to fit with adult agendas. As a result, SRC

made a strategic shift to 'take ourselves to young people' rather than continue to expect them to navigate a difficult course to us. As part of this process, a local Catholic Girls Secondary School agreed for their young students to participate in a consultation and pilot intervention. Pupils were asked about their understanding of sexual violence, their perception of risk factors and their knowledge about available help. The outcomes were both concerning and inspiring.

Of greatest concern was the prevalence of misconceptions about sexual violence. Sexual assault was broadly understood to be perpetrated only by unknown males when females had put themselves at risk by being alone, out late, in unsafe areas, under the influence of alcohol or dressed 'inappropriately'. Most were surprised to hear that the realities we worked with as a provider of sexual violence services painted a very different picture; that sexual abuse mainly happened within relationship contexts where the perpetrator was known to the victim, that 'grooming' over time was frequently involved, and that men and boys could be at risk too. This lack of awareness about where risk lay, and about what their options were if they felt vulnerable, reinforced the need for a proactive education initiative; one which would help young people recognise potentially concerning situations at an earlier stage and help them stay safer without frightening them into thinking danger was everywhere. Whilst not recognising it as abuse, many girls talked about the sexual pressures they experienced and the struggle of not knowing what the 'rules' were when entering relationships with boys. What was inspiring was how much the young women in this pilot welcomed the opportunity to talk about these issues in a school environment and how enthusiastic they were in offering ideas for both an educational initiative and for how we might make our support services more young-people friendly.

An assumption had been made that it would feel safer for girls to talk about sex and relationship concerns in single gender groups but what emerged was a genuine desire for mixed gender sessions on prevention issues. In their own words, "Well, it's boys most of us are going to be having sex with so what's the point in talking about it without them?" Although it was important that we continued to ensure that conversations acknowledged and included similar issues for same sex relationships, we needed to listen to the clear messages we were being given about the need for mixed gender sessions. Overwhelmingly, the girls spoke of wanting to hold conversations

with boys where they could begin to be more open and honest, in a safe and facilitated environment, about thoughts, feelings and concerns in relation to sexual conversations and behaviour. They felt they had little clue what boys really wanted or expected and they struggled with the emotional, verbal and physical fumbling that took place for both genders when entering relationships – an approach that was based solely on fantasies and assumptions about what the other wanted or expected from them. It was in this murky area of misunderstanding and miscommunication that they felt things could easily 'go wrong' for them sexually and they wanted some help.

In parallel to this developing internal awareness, a *preventative* approach to issues of sexual violence began to emerge at a national level. *Living Without Fear* (Cabinet Office, 1999) was the first document produced by a UK government to address violence against women. This document gave political commitment to tackling sexual and domestic violence at a national level, signalled by a new Home Office funding stream also announced in 1999 which aimed to kick-start innovative prevention projects across the country. SRC, motivated by the success of our pilot school project with young women, and in collaboration with our Local Authority Social Cohesion Team, made a successful bid to finance preventative education and outreach work in schools and youth projects focused on hard-to-reach groups and those identified as particularly vulnerable to sexual exploitation. In consulting with local multiagency partners about what this might look like, we recognised that any increased recognition and discussion of sexual abuse issues was likely to result in an increase in demand for support. As a relatively small service, which at that time only offered limited telephone helpline and individual counselling facilities, we realised that part of the bid would need to be for extended 'back-up' counselling where consideration could be given to what would constitute an adolescent-friendly therapeutic experience.

'A star is born' – Southampton Together Against Rape

The 'Southampton Together Against Rape (Star) Project' was launched in October 2000. Southampton had a strong history of successful multiagency working and there was great interest in, and commitment from, key partners[1] to a project that could work towards keeping the city's children and young people safer from both

immediate harm and from the longer term physical and mental health difficulties known to be associated with abuse. The name 'Star' was chosen purposefully as consultation had told us that using the words 'rape crisis' could raise too many anxieties for schools, parents and young people themselves, and it did not capture the range of sexual violence issues that we hoped to address. Our hope was that 'Star' would convey the multiagency, collaborative nature of the initiative itself and symbolise the many angles from which we would be addressing prevention work with young people.

During the development phase of the project, a multiagency 'Star Project' Steering Group[2] was set up and met on a regular basis during the initial funding period. The group's purpose was to guide and shape Star's model and methods as well as to be reflective postintervention to ensure that we were meeting not only bid targets, but also the sex and relationships education (SRE) needs of the city's young people. Such multiagency collaboration proved crucial, not only to the success of the bid to the Home Office, but also by propelling a strategic and cultural shift within SRC from an internally focused stand-alone service towards a more outward-thinking, visible and joined-up organisation. The life of the steering group came to a gradual and appropriate end as the project grew in confidence and learned to stand on its own two feet, but SRC and 'Star' have maintained and developed these partnerships, continuing to share information, expertise and referral pathways with other city-wide providers.

A key steering group member was the Director of the Southampton University Centre for Sexual Health, who has published widely on sex and relationships topics, working closely with policy makers in the UK and abroad. His work informed us, for example, about the high percentage of pregnant teenagers for whom sex was forced or coerced (Ingham et al, 2002). Southampton recorded a particularly high incidence of both sexual abuse and teenage pregnancy compared to similar localities, and this specialist insight proved hugely valuable in tailoring activities for 'Star' sessions which could begin to explore the links between nonconsensual sexual activity and teenage pregnancy. Another example of a growing recognition that sexual violence could not be addressed in isolation was the experience we shared with partnership agencies when our city was ranked 350th (almost highest) out of 354 local authorities for alcohol-related sexual offences in a report published in 2008.[3] Negotiating a response to these complex

issues required careful thought. We wanted to ensure that young people were given sufficient information to make choices about and understand how alcohol could increase their vulnerability whilst ensuring that this did not translate into allocating responsibility for sexual violence prevention to potential victims. This required fine tuning of activities and discussion in sessions and we were grateful for the input of partner agencies in attempting to get such challenging subjects as 'right' for young people as we could.

Harnessing local expertise across sectors enabled us to both think creatively and act accountably in progressing ground-breaking work that was to inevitably cause some anxiety for schools. At around that time, education was changing also. Schools were making the leap from 'sex education' to 'sex and *relationships* education' (SRE). The national curriculum had previously made no mention of domestic or sexual violence. The *Sex and Relationship Education Guidance* (DfES, 2000) changed this and a timetabled Personal, Social and Health Education (PSHE, of which SRE is a key part) space appeared to be the most suitable location for these issues to be addressed within a formal educational setting. It recommended that SRE be delivered through the PSHE and Citizenship frameworks. In addressing three main elements – attitudes and values, personal and social skills, and knowledge and understanding – SRE was designed to engage with 'the value of respect, love and care', 'learning to manage emotions and relationships confidently and sensitively', 'managing conflict' and learning 'how to recognise and avoid exploitation and abuse' (DfES, 2000:5). This seemed the perfect vehicle for encouraging thought about sexual behaviour with young people, something reinforced by research that came a year later in an extensive National Society for the Prevention of Cruelty to Children (NSPCC) study that concluded 'protective education programmes ... play an essential role in the prevention of sexual abuse. PSHE is an ideal place for discussions of appropriate and inappropriate relationships ... providing information about local counselling services ... and acknowledging the fact that girls and boys experience sexual abuse' (Baginsky, 2001: 169).

The formal aims of the project, clarified following consultation with both the steering group and young people in schools and youth services, were: to raise awareness of the issues surrounding rape and sexual abuse; to assist young people in developing skills for negotiating respect and consent within relationships; to provide information to

young people about available support, including the Southampton Rape Crisis Counselling Service for young women and men; and to develop targeted work with young people identified as being particularly vulnerable.

Tackling the concerns of schools

Whilst the established steering group, which included representatives from education, was extremely supportive of the work, it was clear that getting individual school leads to take on the sexual violence reduction agenda would be a challenge, particularly for a newly established project yet to make its mark. Early scoping told us that schools viewed the content and subject matter of planned interventions as a potential 'can of worms'; their anxieties revolved around both parental consent for such discussions and the anticipated disclosures they believed would result from young people. Whilst wanting to reassure schools that referral routes would be mapped clearly, we also felt it important to take a strong position, as a project closely linked to therapeutic services, on being open to hearing rather than closing down and 'sweeping under the carpet' potential disclosures. Surely if young people *told somebody* about a difficult experience then something might be done to help them manage it? If we and schools together could show that we were not afraid of hearing about abuse, perhaps young people who really needed help could feel less afraid of telling. Similarly, if we could model being comfortable with talking openly and thoughtfully about sexual interaction, it may support young people's confidence in developing their own language with which to communicate and listen to expressions of consent or otherwise. Early feedback from session participants told us that we were on the right track with our intention to give young people a voice, the following being typical of comments made by young people: "The 'Star' session left me feeling more in control" (Female, 12).

Whilst recognising the need for teachers to feel equipped to sensitively handle disclosures, we were also seeking to reinforce that opening up conversations about sexual behaviour could be a positive thing in terms of safeguarding. 'Star' addressed these concerns in a range of ways: we prioritised empowering young people participating in 'Star' interventions with the knowledge of how to directly access

support at SRC without having to go through school personnel and what may happen to their information if they did disclose abuse to a member of school staff. We wanted to ensure that if any of the topics discussed had been experienced by a young person participating in a 'Star' session, they would be fully aware of the parameters of confidentiality that applied in different settings, affording them an important sense of choice and control. It was agreed with schools that a range of 'back-up support' would be promoted as part of each intervention, not only by SRC in terms of counselling provision, but also in terms of wider support from 'the city' in relation to a range of wellbeing agendas (through the strategic leads who were represented on the steering group). This provided reassurance to teachers that they would not be overwhelmed by a tidal wave of sensitive emotional issues and safeguarding decisions alongside their already challenging teaching roles.

Each participant was also given a 'freebie' – a 'Star Project' keyring pen with a design young people liked and which had SRC counselling service contact details printed on the side. This simple idea proved a successful way of leaving all young people with access to a telephone number if they wanted to talk further about issues raised in the sessions but without making it obvious to anyone else that they were taking it or keeping it. These keyring pens continue to be a successful marketing tool and a useful way of getting the details of the counselling service into the homes (and families) of young people attending the workshops. One unexpected outcome was the number of mothers who have found their way to us through their children's pens to get help about their own experiences. Activities to demystify accessing support also proved helpful. At times, one of the SRC counsellors would accompany 'Star' and answer questions to make the process of engaging with support more transparent and accessible. Another method was to role play initial contact with a support service so that young people were reassured about what getting in touch might be like in reality.

The ripples from the multiagency involvement in setting up the project also had a positive influence in a range of associated ways, ensuring sexual violence awareness remained high on the City's agenda. For example, we were able to offer assistance through the education and local authority leads on the 'Star' steering group with reviewing school safeguarding procedures and ensuring staff felt

equipped to respond appropriately should parents have concerns, or should disclosures be made following a school session. Teaching staff were updated on referral routes to key services and felt reassured that 'Star' work would not occur in a vacuum. In establishing a clear role for 'Star' as part of the local PSHE curriculum, we were able to also offer input on associated concerns for schools such as sexual exploitation and sexual health awareness. Working in collaboration with other specialist agencies (for example, Contraception and Sexual Health Services and the Barnardo's local 'Sexual Exploitation Project') to deliver joint programmes added value as each of our core messages complemented the other, consolidating overall impact.

Structuring the sessions

We wanted to be transparent about our agenda from the outset in order to reduce the anxieties young people were feeling about session content and what would be expected of them. Best practice in SRE (Sex Education Forum, 2005) highlights that creating a working agreement with young people enables them to experience a sense of ownership and control over the subject area and assists in facilitating the challenging but 'safe enough' environment that is needed to discuss potentially sensitive issues. This proved demanding when allocated a 50-minute PSHE lesson with 30 young people to cover the range of prevention-related issues we had prioritised. Our '5 things you need to know …' activity was created to 'fast track' this process.

5 things you need to know

1. **Who we are** – introduction of workers, 'Star' and SRC services.
2. **Why we're here** – setting the scene for the context of the work and talking more about young people's use of the counselling service at SRC.
3. **What you can expect from us today** – unpicking the term 'confidentiality' and ensuring young people understand the implications of what they might choose to say in or after the session, in terms of school/staff safeguarding responsibilities.
4. **What we're going to do today** – detailing the activities. All sessions are as interactive as possible – there is very little of adults' 'teaching'.

> **5. What you can do next** – ensuring participants are aware of how, where and what support they can access if any of the issues arising in the session are 'live' for them or someone they know.

This approach proved very successful. Our evaluations showed young people have improved awareness of available support which meant that whilst there was only a small increase in the number of disclosures within a school setting, the number of referrals from young people (both self- and worker-led) to SRC increased six-fold within three years of the project. Feedback from teachers and pupils showed that Star's proactive outreach work was putting a friendly and approachable persona to what had previously been seen as a faceless and therefore potentially more intimidating service. This again was evidenced in feedback from session participants: "'Star Project' came in and talked about relationships and abuse. I learnt that there are different abuses. I also know where to go if any of this happened to me" (Female, 14).

Working with young men

At the time of the project's inception, SRC, in line with most other rape crisis services nationally, had historically worked with a female-only client base. Not only, then, did we have the task of changing young people's view of SRC as an adult service, but we had an even bigger mountain to climb if we wanted to reach young men and help them understand that the issues we were attempting to address were relevant to them too, in a whole range of ways. Young people of both genders who we approached at the initial phase of the project spoke of wanting a safe space to talk with the opposite sex about relationship behaviour where they could exchange ideas about un/acceptable ways of showing sexual interest in others in an environment that allowed an appropriate degree of playfulness.

We experimented with small single gender group discussions where the groups would then join together for a wider dialogue together about what had been discussed. Girls were interested in what groups of boys said about them and vice versa. We knew from the SRC counselling service that the many boys who had experienced sexual abuse carried a particular stigma and shame that prevented their seeking support. We were also conscious because of feedback from

young male counselling service users, that many, prior to the abuse, had no awareness that they could be at risk. For example, it would not be uppermost in the mind of a young man invited back to the flat of a guy he had just met to 'watch a movie', that he may be sexually assaulted, whereas girls appeared more conscious that they could be at risk. In this way, we were able to utilise experience gained from SRC service provision to raise awareness of the potential difficulties young men could face. In our consideration of sexual violence as a shared social responsibility, it was important to not just tackle the prevention agenda by addressing young people as potential victims but also to recognise that some will be potential perpetrators. Ensuring they had a sound understanding of their legal obligations with regard to gaining consent and the potential criminal implications if they did not was one way of addressing this, another was encouraging awareness of the benefits for both genders of more emotionally engaged sexual interaction. In recognition of males making up not all but the majority of perpetrators, another aim was getting boys in touch with some sense of themselves as sexually vulnerable, as opposed to seeing rape as 'nothing to do with them'. This also seemed to engender greater empathy for, and understanding of, the damaging impact of abuse and trigger greater investment in its prevention. As one male participant wrote on an evaluation form in a recent 'Star' session: "Before the lesson I thought rape wasn't a problem for boys, but now I know boys can get raped too" (Male, 15).

We were attempting to utilise 'Star' exercises to get all young people to think about their behaviour rather than categorising groups into male/female, victim/perpetrator, either/or. Much as we may wish for the divisions to be simple, there was a very real question of where we would draw the line when some of our clients at SRC, both young people and adults, could be seen as both victims and perpetrators in a whole range of ways as patterns of abuse could, for some, be re-enacted as a means of managing distress resulting from their own abuse. For those of our clients who had been abused by females, it was also important not to sweep *their* experience under the carpet. Whilst recognising that the majority of perpetrators were male, promoting a view of sexual violence along clear gender lines both perpetuated a false sense of security about females and made it harder for those who had experienced abuse from women to seek help. 'Star' and SRC developed a key guiding principle that young

males and females be understood and addressed as having an equal amount to gain by giving consideration to issues of sexual respect, consent and mutuality.

> How and what boys and young men learn about being a man undoubtedly affects how they manage their sexual health. It also affects how they feel about themselves, and how they behave with each other and with young women. In many cultures, boys learn that being dominant, aggressive and taking risks is all part of being a man. Many young men find it hard to resist overwhelming peer pressure to be seen as sexually 'successful' and they may feel compelled to take part in risk-taking behaviour to prove their manhood. These traits can have harmful consequences for both the young men themselves and their sexual partners. (Sex Education Forum, 2006)

One of the ways that we have ensured young men engaged and felt some ownership of the issues being tackled has been by having a male team member working in every session. Another way has been to ensure that, where relevant, we tackle specific issues within particular groups of young men. An example of this was recent work with young Afghani men who were newcomers to the city and in local authority care. Their support workers approached us as confusion regarding appropriate sexual behaviour in a new cultural context was leading to them experiencing additional vulnerabilities. In partnership with local sexual health services, 'Star' delivered targeted workshops to the group who, alongside their carer's, gave feedback that they felt they were more able to make safer decisions about these issues as well as feeling more supported in asking for professional help post intervention.

For the most part, however, feedback from young people has told us that the core 'Star' model of having a male and female facilitator running mixed gender sessions achieves the most positive outcomes. From modelling constructive dialogue and collaborative partnerships between the sexes to making the issues relevant and meaningful to both genders, young people are able to bounce ideas around more safely and recognise their own capacity to be considered, reciprocal and reflective about sexual behaviour. These ideas are echoed in

Respect's *Safe Minimum Practice Standards* (2012), and in particular in standard five which reinforces the importance of 'promotion of respectful relationships'.

Adapting the organisational context to meet young people's needs

SRC as an organisation has grown alongside the 'Star Project', learning what works in terms of effective emotional and behavioural support for young people vulnerable to or experiencing sexual coercion or abuse. The Young People's Counselling Service has grown and developed alongside Star, adapting what is offered in response to our learning about what works from young people. Every adolescent's needs are carefully assessed before they are offered options which include individual creative art and talking therapies as well as young people's therapeutic groups. We have also learnt much from our young service users about what works in terms of engagement and investment in improvements to their physical and emotional wellbeing. We remain very 'joined-up' with other local young people's service providers, liaising on referrals or shared support initiatives and keeping abreast of local service developments to ensure appropriate signposting when specialist concerns or needs emerge.

Many young people had told us in counselling that whilst they were making changes themselves, they found that difficulties could emerge or things could take a step backwards if their families remained uninvolved in change or were unsupported around the impact of a family member experiencing abuse. As a result of this feedback, we developed a family therapy service that provides up to six sessions for families where one or more family member's abuse is impacting on the whole unit. This ensures that young people feel helped more holistically and assists families both in overcoming the emotional distress associated with sexual abuse and in developing risk reduction strategies with their children for the future. Our Independent Sexual Violence Advisors (ISVAs) provide another complementary service in the form of intensive support to 11–18 year olds who want to report sexual violence or whose cases have already entered the criminal justice system; advisors attend legal hearings and courts to sit alongside them throughout what is commonly an extremely traumatic process and also offer help with accessing their legal rights. The ISVAs also

provide practical help with keeping safe or with addressing sensitive issues such as sexually transmitted infections or unwanted pregnancies.

Evaluation: are we getting it right for the young people of Southampton?

From the outset of the project, 'Star' has consulted and involved the young people we work with, enabling them to feel ownership of 'Star' messages. We asked them for their ideas to name the project, involved them in the production of publicity materials, scoped the specific issues they would like us to address in sessions and provide information about, and reviewed progress and impact with both the young people and staff who work with them. We have also consistently consulted before embarking on new initiatives to ensure that methods and materials are dynamic and meaningful to particular groups, culminating, for example, in a poetry project with young mums, a music and drama project with the African Caribbean Youth Centre, a healthy relationships video made by a local girls' school and a photography project with an Asian Young Women's group. This creative approach to the issues consistently earns positive feedback from session participants: "'Star' have taught me about being confident talking about issues on certain upsets that have happened" (Female, 16).

In 2007, SRC won the National King's Fund Impact Award, recognising excellence in responding to community health needs, and the 'Star Project' was both regional and national winner of the National Youth Agency's 'Actions Speak Louder' awards for innovation and best practice in work with young people. Throughout our interventions, we utilise a wide range of creative consultation tools (pre and post intervention questionnaires, focus groups etc) to gather feedback and identify what works well and where adjustments would benefit format or particular exercises. For more specific projects (for example, at a hostel for homeless young people or at Breakout Lesbian and Gay Youth Group), we spend time with the group itself and the staff who know them best before the start of the course to get a clearer sense of their particular needs.

'Star' continues to demonstrate positive outcomes. For example, in 2013, 84% of 'Star' participants said they felt better able to manage risky situations and 87% felt better informed about how to seek help

in relation to sexual violence issues as a result of our interventions. Southampton remains committed to a partnership model for tackling these issues, recognising the need for collective 'ownership' of the problems of domestic and sexual violence. SRC is an active member of the Southampton police-led multiagency Serious Sexual Offences Reduction Group and, in collaboration with a research team from Portsmouth University, we have recently begun an evaluation project aiming to measure the longitudinal impact of Star's work, looking to see how the core 'Star' messages impact over time on young people's 'real' lives outside of the school setting.

Taking Star forward

Over the past 13 years, 'Star' has evolved in response to shifting needs and priorities. We now coordinate the multiagency provision of all external provider sex and relationship education in schools and support both primary and secondary schools in effective SRE teaching. We continue to pioneer new approaches to specialist targeted work on respect and consent in relationships, a key recommendation from the recent *A Call to end Violence against Women and Girls: Action Plan* (HM Government, 2013). With the emergence and popularity of new technologies, we now offer a range of interventions on 'sexting' and keeping safe online and have also broadened our target age group, including work with children in Year 5 and 6 of primary schools, aged 9–11. We have developed session plans addressing organised sexual exploitation and have also progressed the meaning of our name so that 'Star' now officially stands for 'Southampton Talking About Relationships'.

Another recent development is that SRC services are increasingly joined up with Southampton City Council Safer Communities Team and local domestic violence providers under the banner of PIPPA (Prevention, Intervention and Public Protection Alliance), a progressive new initiative whose focus is on earlier intervention and shared support for those most vulnerable. PIPPA provides a single point of contact and training for local health and social care professionals; these encourage core services to identify, risk assess and refer victims to specialist services at an appropriate stage.

With stories of high-profile perpetrators and systematic sexual abuse emerging in mainstream media on what feels like a daily

basis, education and awareness raising about these issues and sources of support has never felt more pertinent for young people and communities alike. The current financial climate in which we must carefully resource targeted and longer-term approaches to prevention makes learning from projects such as ours increasingly relevant but should not inhibit us taking the creative and innovative approach necessary to engaging young people with such crucial issues. 'Star' and SRC are primed, and ready, to explore 'the next chapter'.

Notes

[1] Key partners included police, local authority, Child and Adolescent Mental Health Services (CAMHS), and social services.

[2] As well as SRC and Southampton's City Council Social Cohesion Team, this Steering Group included representation from Youth, Education, Contraception, Domestic Violence and Sexual Health Services alongside Hampshire Constabulary, Barnardo's, Hampshire Deaf Association, LGBT youth group, Working with Prostitutes Project and Victim Support.

[3] Local Alcohol Profiles for England Report, compiled by the North West Public Health Observatory (NWPHO).

References

Baginsky, M. (2001) *Counselling and support services for young people aged 12–16 who have experienced sexual abuse: A study of the provision in Italy, the Netherlands and the United Kingdom*, London: NSPCC.

Cabinet Office (1999) *Living Without Fear: An integrated approach to tackling violence against women,* The Women's Unit, London.

HM Government (2013) *A call to end violence against women and girls: Action plan.* Available: https://www.gov.uk/government/uploads/system/uploads/attachment_data/file/181088/vawg-action-plan-2013.pdf.

Ingham, R. and Stone, N. (2002) 'Factors affecting british teenager's contraceptive use at first intercourse: The importance of partner communication', *Perspectives on Sexual and Reproductive Health*, 34(4): 194-97.

Local Alcohol Profiles for England (2008) *Local Authority profile – South East.* Available: www.lape.org.uk/LAProfile.aspx?reg=j.

Respect (2012) *Safe minimum practice standard.* Available: www.respect.uk.net/pages/accreditation-project.html.

Sex Education Forum (2005) *Effective Learning Methods: approaches to learning about sex and relationships within PSHE and Citizenship.* Available: www.sexeducationforum.org.uk/media/6330/effective_learning.pdf.

Sex Education Forum (2006) *Boys and young men: developing effective sex and relationships education in schools.* Available: www.ncb.org.uk/media/229386/boys_updated.pdf.

NINE

'Boys think girls are toys': sexual exploitation and young people

Ravi K. Thiara and Maddy Coy

Introduction

Although prevention work on domestic violence with young people has gained currency, sexual exploitation remains an under-addressed area. This chapter draws on an evaluation of a three-year prevention programme on sexual exploitation in schools and youth settings delivered across London between 2007 and 2010 through a partnership between a community-based women's organisation and a national organisation providing services for children (for the full report, see Coy et al, 2011). The programme consisted of three strands and included workshops with young people (mixed or single gender groups), training for professionals on sexual exploitation, and facilitator training for young people to co-deliver these sessions for professionals. By highlighting the issues raised by research on sexual exploitation as well as the findings of the evaluation (focusing on one aspect of the work – the work delivered to young people) this chapter underlines the importance of prevention-education on sexual exploitation with young people as well as the need for training for professionals so they can better identify and support young people who may be sexually exploited. Evaluation findings reinforce the need to adopt a gendered approach, to involve young people as co-facilitators, to deliver work in settings such as schools and youth work and to train professionals. However, adopting a gendered frame is not without its tensions and challenges, issues which we will discuss throughout this chapter.

Context

Sexual exploitation is not a new phenomenon but it has received increased research and policy attention over the last decade. This has culminated in the recent inquiry into *Child Sexual Exploitation in Gangs and Groups* (CSEGG), conducted by the Office of the Children's Commissioner, which identified 16,500 children as at risk during April 2010–March 2011 and 2,049 children as being victims of sexual exploitation in gangs and groups during the 14-month period from August 2010 to October 2011 (Berelowitz et al, 2012: 9). However, it is likely that these numbers are far higher as many children and young people are often invisible to services. This inquiry also reinforces the findings from previous research that highlights the inability of professionals to identify child sexual exploitation (CSE) or to support victims. Recent high profile trials and subsequent convictions of Asian men involved in the sexual exploitation of white girls have resulted in a racialised discourse about the victims and perpetrators of CSE. This dominant public discourse has been challenged by recent research which has questioned the myth that only white girls are victims by highlighting the sexual exploitation of Asian-Muslim girls, often aged 13–14 but sometimes as young as 9 years, by those in their own communities:

> '… sexual exploitation is not a race issue only involving Asian offenders who target white victims. Offenders do not respect girls or women of any race or faith … girls from offenders' own backgrounds are more accessible because of their shared heritage, culture, faith and ethnicity' (Gohir, 2013: 25).

Gohir asserts that offenders in these communities were often confident they 'would not be caught because their victims were unlikely to report them' because the threat of shame and dishonour serves to silence victims (2013: 26). Notably, the research identified limited knowledge about sex and lack of information about predatory men as issues for Asian-Muslim girls, highlighting the importance of prevention-education work in schools. Moreover, in a context of limited understanding among families and communities, where women are typically blamed, the necessity for education for both

young men and young women on these issues has been emphasised. In particular, the fact that schools are not raising awareness of CSE or of violence against women more generally has been highlighted by those arguing for the need to carry out wider violence against women and girls (VAWG) prevention work in schools (EVAW, 2011).

Indeed, the importance of a proactive multiagency approach to sexual exploitation in identifying and supporting young people and tackling perpetrators has been emphasised for some years (Pearce, 2009). Current multiagency guidance and the Sexual Offences Act 2003 also make it clear that young people under the age of 18 are to be viewed as victims of abuse rather than criminalised under offences related to prostitution, though contradictions between protection and sanction remain in practice (DCSF, 2008; Phoenix, 2012). Although local authorities have been developing procedures for child sexual exploitation through local safeguarding children boards (LSCBs) in recent years, this still remains patchy and is often an 'add-on' (NWG, 2010; Berelowitz et al, 2012).

Moreover, despite increased attention to the issue, specialised support projects for sexually exploited children in the UK are sparse and most are provided by voluntary sector organisations operating on insecure funding (Coy et al, 2009; NWG, 2010). Although statutory agencies such as health, housing, education, social services and youth offending teams are daily points of contact for some sexually exploited young people, levels of awareness of risk indicators/signs of vulnerability vary widely among professionals (Jago and Pearce, 2008). The CSEGG Inquiry (Berelowitz, 2012) highlighted that professionals continue to use phrases such as 'prostituting herself', 'sexually available' and 'asking for it' to describe young people who were being sexually exploited (p 12), betraying a perspective that sees young people as complicit in and responsible for their abuse. Although equipping young people to recognise abusive behaviours and strengthen protective behaviours is crucial (Jago and Pearce, 2008), training for professionals on the spectrum of sexual exploitation also needs to be built into vocational qualifications and ongoing professional development.

Sexual exploitation prevention work

The paucity of specific prevention work on sexual exploitation within more general prevention work on violence against women (VAW) with children and young people has created concern for some time and indeed led to the development of the programme discussed here. Even this broader prevention work, as already noted in the introduction to this book, has been weak with no central government steer, and it has been further stymied by the 'silo' approaches to VAW that undermine a coherent approach. Whilst it is encouraging that the Coalition Government identifies prevention as 'the core' of a strategic approach to ending VAWG, with sexual consent an 'important theme' in the curriculum (HM Government, 2010: 9), in practice this remains unaddressed. As already noted elsewhere in the book, the impetus for prevention work on violence against women has come from within the women's sector.

Young people's experiences and perceptions of coercion and exploitation

The extensive evidence base on the range of contexts in which young people experience sexual coercion and exploitation reveals gender disproportionality:

- Young women are subject to emotional pressure/manipulation to consent to sex by partners and peers, whilst also reporting instances of rape and assault (Burman and Cartmel, 2006; Hoggart, 2006a, 2006b; Hoggart and Phillips, 2009; Maxwell and Aggleton, 2010; Noonan and Charles, 2009).
- Sexual violence and exploitation is common among young people, with rape (and threats of rape) used against girls involved in gangs and their female family members (Firmin, 2010).
- One in three teenage girls has experienced sexual violence from a partner, for a minority on an ongoing basis (Barter et al, 2009).
- The vast majority of victims of sexual exploitation are girls (Berelowitz, 2012).

A gender analysis does not mean that boys/men are never positioned as victims nor that women are not sometimes perpetrators; rather, it

alerts us to disproportionality – that the majority of victim–survivors are girls/women and the majority of perpetrators are boys/men (United Nations, 2006). Clearly, gender is also relevant to the legacies of sexual exploitation, with different potential for boys, including specific discussion of how homophobia is implicated.

The definition of sexual exploitation by the National Working Group identifies a range of contexts and common features of sexual exploitation[1]. Whilst important for professionals, our evaluation shows how young people can translate such definitions into something that is meaningful to them. In the sexual exploitation programme, the young women consulted devised a 'young people'-friendly version which was used with young people throughout sessions:

> Someone taking advantage of you sexually, for their own benefit. Through threats, bribes, violence, humiliation, or by telling you that they love you, they will have the power to get you to do sexual things for their own, or other people's, benefit or enjoyment (including: touching or kissing private parts, sex, taking sexual photos).

Whilst estimates of sexual exploitation are likely to underestimate its extent, certain contexts are known to be conducive: histories of sexual abuse (Coy, 2008; Pearce, 2009); backgrounds or episodes in local authority care (Pearce et al, 2002; Coy, 2008, 2009); and running away (Pearce, 2009). These contexts are exacerbated by homelessness, substance abuse and poverty. The absence of material and emotional support is a common thread which in turn renders young women vulnerable to manipulation and abuse by predatory men and/or to resorting to selling sex as a pragmatic survival option (O'Neill, 2001; Coy, 2008; Pearce, 2009). Research has identified three stages of risk with respect to exploitation: risk-taking behaviour such as getting in cars with boys; swapping sexual acts for gifts, alcohol, or peer approval; and involvement in more formalised prostitution (Pearce et al, 2002). Prevention work, therefore, needs to be nuanced to these behaviours, especially the first two, which may be normalised among peer networks and not viewed as potentially risky or abusive by young women themselves (Coy, 2008). Another significant route into sexually exploitative relationships and environments is the 'grooming process',[2] where older men target young women to gain

their trust with affection, isolate them from family and friends, and use manipulation, persuasion and coercion to push them into selling/ exchanging sex (Swann, 1998). Again, prevention work with young people should highlight and unpick how these abusive dynamics develop.

Sexual exploitation in online environments[3] mirrors many of the dynamics of offline exploitation, facilitated by rapid advances in digital media technology. The Child Exploitation and Online Protection Centre (CEOP) reports increases in the amount and frequency of young people sending sexualised images of themselves to strangers (CEOP, 2013), and research in the UK finds sexting to be widespread among young people, and there is a gendered pattern: young men 'pestering' young women to send sexualised images which are then often distributed without their consent (Ringrose et al, 2012; Coy, 2013).

Research on young people's attitudes also reveals adherence to gendered codes of behaviour for women and men; for example, a minority endorse notions of masculinity based on sexual conquest and condone VAW in certain circumstances (Burton et al, 1998; Regan and Kelly, 2002; Burman and Cartmel, 2006; Coy et al, 2010). For instance, in a survey young men reported that it

> ... might be acceptable to pressure a young woman into sex if he thinks she 'wants it', is drunk or is his girlfriend. Here context and vulnerability appear to legitimise coercion; where there is a relationship, boundaries of consent are blurred; where it is possible to take advantage of intoxicated young women, nearly half of boys [who responded thought it was] acceptable to do so. (Coy et al, 2010: 41; see also Burton et al, 1998).

The age-old sexual double standard, where young men are rewarded socially and by their peers for sexual activity but young women are labelled 'sluts', persists (Coy, 2013). A key task for prevention work here, therefore, is to unpick these beliefs about gender, sexuality and power, and this was central to the evaluated sexual exploitation programme.

Finally, the sexualisation of popular culture is another important feature of the landscape in which young people navigate their sexual

relationships and understandings of consent and coercion (EVAW, 2011; Coy, 2013). Again, prevention work needs to be mindful of how young people make sense of sexualised media and how it informs their sense of self and their gender expectations. In the evaluated programme, one of the themes was media messages about men and women that young people absorb and/or resist.

Prevention in education and youth settings

Prevention work in schools needs to be mainstreamed and begin from fostering an understanding of VAW and sexual harassment as a cause and consequence of gender inequality. Building on this, educational interventions should focus not only on protection advice for girls, but as importantly, boys across different cultures and communities need to be invited into exploration of how practices of masculinity and approaches to relationships can be based on principles of human dignity. (Coy et al, 2008: 35)

The fact that young people receive minimal or inadequate information on issues of violence/abuse, coercion and exploitation in schools is well documented; lessons on sexual health and relationships tend to focus on biological aspects – what has been termed the 'plumbing and prevention' approach (Coy et al, 2010). Almost all (93%) of young people in one survey (n=1,820) received no information about sexual abuse in sex education (NSPCC, 2006). A larger survey of over 20,000 young people revealed that two fifths (40%) rated Sex and Relationships Education (SRE) as poor, and almost half had received no sessions about relationships (UK Youth Parliament, 2007). In a poll conducted for the End Violence Against Women Coalition (EVAW), almost a third (29%) of girls aged between 16 and 18 had experienced unwanted sexual touching at school, and nearly three quarters (71%) of all 16 to18 year olds reported hearing sexual name-calling (language such as 'slut' or slag') towards girls at schools on a daily basis or a few times a week. Of most concern, however, was that a quarter (24%) of young people had never heard teachers saying that unwanted sexual touching or sexual name-calling are

unacceptable. Echoing previous research, two fifths (40%) had not received lessons or information on sexual consent (EVAW, 2010).

Fears of opening a 'can of worms' is cited by many schools and teachers as a reason to shy away from addressing violence and abuse (Mahony and Shaughnessy, 2007), yet one study of over 4,000 young people in schools in England found that over half requested more information and advice on how to resist sexual pressure and coercion (Forrest et al, 2004). Young people from black and minority ethnic (BME) communities in London highlight SRE as a particularly crucial source of information, ideally focussing on emotions and relationships (Testa and Coleman, 2006). A scoping exercise on sexual exploitation recommended the integration of sexual exploitation into PSHE (Jago and Pearce, 2008), something that remains unimplemented. There are clear and compelling reasons to address the emotional dimensions of the landscapes in which young people are forming relationships and negotiating consent through embedding VAW prevention work in education and youth settings.

The majority of VAW prevention initiatives that have been evaluated focus on abuse within relationships and seek to change attitudes and perceptions of equality, respect and consent (WHO, 2009). While there is fairly extensive data available from the US and Canada, the underdevelopment of prevention work in the UK means that there is less research available in this country; however, there are some key lessons that can be drawn from existing evidence in the UK, as highlighted by others in this volume. However, awareness work with young people about sexual exploitation specifically is very limited (NWG, 2010). One of the few specific initiatives that has been evaluated[4] was an innovative series of drama workshops from the West Midlands called 'Sex, Lies and Love?' which was run during 2003. The programme was jointly delivered by community arts, empowerment theatre and a specialised support project for sexually exploited young women, and it aimed to: raise awareness of abuse through prostitution and grooming; prevent young women from engaging in risky behaviour; and increase understanding of healthy and unhealthy relationships (Campbell and O'Neill, 2004). The evaluation found significantly enhanced understanding of: grooming; vulnerability to exploitation; signs of abusive relationships; and confidence in approaching adults for support. Three young women were trained as peer educators, and this is identified as a particularly

promising practice along with the drama basis of the programme. Recommendations included: ensuring support was available for young trainers; engaging boys in preventative work; statutory funding for prevention programmes; and delivering training for professionals (Campbell and O'Neill, 2004).

The sexual exploitation prevention programme

A gap in prevention work on sexual exploitation was identified through the practice of both organisations involved in the development of the programme. Content was developed by drawing on a wide range of practice, research evidence and resources. This included what has been termed 'practice-based evidence'[5] as both organisations have long histories in supporting vulnerable young people and women; it included research evidence on the prevalence, contexts and legacies of sexual exploitation and on existing resources and toolkits on prevention and intervention. A consultation with 31 sexually exploited young (and adult) women ensured young people's voices and experiences were at the heart of the programme, and it specifically addressed the skills, attitudes and knowledge that professionals need to identify and support young people. Sexual exploitation was explicitly defined and framed as a gendered issue.

While content of the programme was adjusted for specific groups, core themes included: social constructs of gender; masculinity and links with coercion/pressure; the spectrum of sexual exploitation; media representations and messages about gender and sexuality; appropriate behaviour in respectful and consensual relationships; signs of potentially abusive or exploitative dynamics; legal contexts, including the Sexual Offences Act 2003; boundaries of personal space and the body; and how to find support from informal networks and specialised services. The programme for young people was delivered in multiple sessions (n=5/6), ranging from full days to weekly workshops completed within a lesson period at schools. In total, 1,450 young people across 20 schools/Pupil Referral Units attended programme sessions, and there were a further 267 across 17 community-based settings. Delivery was covered by both universal settings and targeting of young people subject to a range of recognised markers of social exclusion: not in employment, education or training; homelessness or living in supported housing; young people affected

by domestic violence; as well as those displaying sexualised risk-taking behaviours. Some more specialised work was also undertaken, with one session specifically requested by a school for a group of young men who had been involved in a sexual assault.

Content was tailored for younger age groups (under-13s) under the umbrella of 'healthy friendships', core themes being appropriate touch, risk taking and rights and support, with the aim that these translated into intimate relationships when required. It was recognised that, as concluded by researchers in the US with respect to prevention work on violence in intimate relationships,

> ... it is possible that activities with the youngest adolescents may better fit their needs when focusing on general themes of communication and conflict-resolution skills rather than applying those themes within the context of dating relationships. (Noonan and Charles, 2009: 1099)

In addition, young people may also define their intimate partner in a looser sense than adults (Hickman et al, 2004). Research with young women associated with gangs in London found multiple layers of relationships with their own associated meanings and behaviours: labels such as 'wifey' denoted ongoing steady commitment and 'link' being a more casual, less respected status (Firmin, 2010). Understanding these as vocabularies and landscapes within which young people negotiate their connections and relationships is key to the development and delivery of any programme in this area.

Research on prevention programmes, as highlighted by a number of chapters in this book, has repeatedly shown that the methods used in work with young people are considered as crucial to the success of the programme as the content (Campbell and O'Neill, 2004; Ellis, 2004; Thiara and Ellis, 2013). To engage young people and enable them to apply key messages to their own lives and contexts, the programme sessions were devised to include a range of activity-based learning, such as drama/role plays, case studies and creative exercises. Such a participatory approach encourages young people to interact and work through their own (mis)perceptions in order to relate the content to their own lives.

Lessons from delivering the programme

Facilitators of the sessions with young people emphasised the importance of 'valuing individual opinion' in order to create space for voices to be heard, mitigating disruptive individuals, and facilitating critical reflection. Young people's openness and willingness to talk was a surprise, but perhaps this indicated the few opportunities available for this to take place and the dearth of information young people receive on sexual coercion and exploitation. An important issue raised was that although teachers sometimes asked disruptive young people to leave, they were precisely the young people that most needed to be engaged – those that might be using laughter to hide embarrassment or fear and would lose an opportunity to address this in a safe environment. Keeping groups small and consistent over a series of sessions was also critical to avoid repetition of the same ground and to ensure common understandings among young people. In some settings (Pupil Referral Units, Youth Offending Teams), the creative work and interactive style was foregrounded to prevent young people already subject to considerable adult scrutiny feeling further compulsion to engage with difficult issues, and this was regarded positively by young people themselves. That this work with young people is lacking in both format and content in school and youth settings, yet is welcomed and valued when provided by specialised, relevant and knowledgeable organisations, was evidently clear in the evaluation.

Engaging schools to host the sessions and engaging teachers in the content was critical to gaining access to young people, as well as ensuring that key messages continued to be reinforced. Some schools and local authorities were resistant to the feminist ethos of the programme and the delivering organisation. Others were fearful that bringing in external organisations to address exploitation would signal that there was a 'problem' and negatively affect the reputation of the school. The prevention programme was therefore sometime marketed as 'sexual bullying' to fit into existing school policies and priorities. While a 'whole school' approach is viewed as the most effective (Mahony and Shaughnessy, 2007), it was soon acknowledged that the programme could only be limited in this respect.

"If you're there for six sessions, you've only got one class in the whole school, you might give them a kind of slightly more nuanced understanding, but then they've got to go back out into the environment of walking down the corridor and getting harassed continually." (Project worker)

A wide variation was found in teachers' responses to the gendered framing of sexual exploitation, a theme which is reflected in evaluations of programmes on intimate partner violence and VAW (Dubois and Regan, 2006). While teachers appeared to have some understandings of discrimination and equality, lack of understanding about the dynamics of exploitation and victimisation was also evident. In some settings, facilitators were asked to talk to girls about 'letting boys' touch them and had to suggest to the school that they also spend some time with boys addressing their behaviours.

Young women's perspectives

One focus group was conducted with five young women in year 8 at a London secondary school (aged 12–13). In their feedback, the young women highlighted several valued aspects of the sessions: the openness of the deliverers; the opportunity to learn from each other through group participation; the arts and crafts; and the space to reflect on their own lives and relationships. Issues of safety, consent and grooming were also identified as particularly useful, resulting in some young women reporting a much deeper understanding of consent in sexual relationships and ability to assert their own desires while resisting pressure. In the following discussion, we present issues raised by young people in their feedback about the work in which they participated.

Difference from PSHE

Gaps in PSHE content addressing emotional intimacy, consent and gendered violence have already been noted. Supporting this, young women described the programme sessions as more open and informative than PSHE lessons, citing reluctance by teachers

to engage in candid discussions of issues that were uppermost in young people's minds.

> "In PSHE we'll talk about drugs, money ... some things we talk about here, when I ask questions, Miss says 'Ah, you lot are too young to ask about this'." (Young woman, year 8)

The limited content on consent and coercion was also keenly felt by programme deliverers.

> "I could really feel the difference between a school where this was part of an ongoing PSHE programme and where this was the PSHE for the term or the year ... if they had ongoing PSHE, obviously it was probably varying qualities, but they had a context to put this information into, you could then focus a lot more on sexual exploitation without having to very quickly do some groundwork about what is a relationship, what's a healthy relationship ... if they had ongoing PSHE they would have a much better vocabulary around things like healthy relationships and consent ... [but] there were schools where this was their PSHE for the term. I mean I went to one school, and this was their PSHE for the term, and there were 90 of them in a room, and I had an hour." (Project worker)

In sessions with boys, deliverers also encountered what has been revealed by research (Flood, 2009; Coy, 2013); that without a space to discuss sexual relationships, and have questions answered, boys will look to pornography for information. Together these observations reinforce the urgency of incorporating a gendered analysis of violence, consent and coercion into PSHE lessons as a statutory requirement. This does not negate the need for specific prevention work to be delivered by specialised organisations; rather, the two are complementary, with PSHE acting as a foundation on which those with in-depth knowledge and expertise can build.

Developing group process

The young women who participated in the focus group spoke positively about the opportunity to make connections with each other in a safe space outside of routine interaction, which was described by one young woman as her favourite aspect of the sessions:

> "Even though I know these lot, having this group meant you know a lot more about them, because everyone's being honest, and some people are brave enough to talk about stuff." (Young woman, year 8)

For these young women, the single-sex context was crucial for enabling them to talk and to explore issues collectively without the fear of judgement or trivialisation:

> P1: "If it was with boys, yeah, girls would find it harder to say things. Because when you're just around girls, you say things, and some boys are immature so as soon as mistresses [teachers] are like 'How do you feel about relationships?' they start laughing …"

> P2: "It makes you feel everybody looks at you … you don't want to say anything." (Two young women, year 8)

The value of women-only space in schools/youth settings cannot be overstated. Feedback from staff at youth centres also highlighted the benefits of enabling women to meet together as a group with positive outcomes in the form of friendships and closer engagement with the centre. Equally, deliverers noted that boys appreciated space where they could "let barriers down and actually not to be worried about being a real man". Clearly, there is value in both single-sex and mixed sessions as the latter allow for respectful dialogue between boys and girls. The point of engagement is critical here; creating safe spaces for young men and young women to explore the landscapes of relationships is a necessary precursor to subsequent mixed sessions when confidence and insight has been enhanced.

Doing gender

Exploring how young people perceive and (re)produce roles was a core theme of the programme sessions. Although young women in the focus group struggled to articulate how they had discussed gender, the social expectations of how women and men should behave were mentioned, encouragingly in the context of a 'double standard' with respect to sexual behaviour. The limited discussion here may reflect the younger age of the young women and gender roles might have been a more prominent theme in sessions with older young people. On the other hand, it is also the case that there is more limited critical engagement with gender issues than in previous decades, resulting in young people reverting to more deterministic and rigid views on what it is to 'be' female or male. Reflective practice logs completed by workers also offered some insights into young people's engagement with gender; discussion and deconstruction of masculinity in relation to sexual behaviours and 'naturalisation' of gender roles appear to have been common. An obstacle reported was young people's focus on how they ascribed to stereotypes without connecting these to wider social norms. This indicates the need for prevention work to be integrated, or at least in line with, existing lessons – perhaps sociology and/or PSHE, and for young people to be offered more information on how gender is constructed, its variations across societies and individuals, how we 'do' it and reproduce it in everyday interactions. For instance, boys in one session linked sexualised media to masculinity – "it's what boys do". It is precisely these notions of what being a man entails that should be explored as part of work on sexual exploitation, given the coercive potential for this predatory construction of masculinity to be played out.

Addressing homophobia was a pervasive theme. The young women in the focus group were ambivalent about discussions of sexuality as the majority were raised in religious families where church teachings about same sex relationships as being sinful were prominent. Following participation in the sessions, they reflected that, although their value base had not changed, they were now more able to frame their responses in terms of respecting, although not accepting, difference. For deliverers, approaches to homophobic statements varied; where there was little time, they focussed on the legal sanctions for discrimination and harassment on the grounds of

sexuality, linking this to debates around racism and attitudes towards disability. Conversations about the roots of homophobia and the underpinning social norms revealed that young people's attitudes were so deeply embedded that the sessions were likely to have little impact. This lack of knowledge and frequent voicing of stereotypes and discriminatory attitudes is undoubtedly part of why two thirds of young people who identify as lesbian, gay or bisexual experience homophobic bullying at school (Hunt and Jensen, 2007). Again this underscores the importance of PSHE addressing sexuality in the context of equality and human rights and the need for a whole school approach to underpin more targeted discussions[6].

Friendships and relationships

Whether the sessions on abusive dynamics related to relationships or friendships varied according to age. The young women in the focus group had focused on friendships during the programme and talked about new framings of trust (being sure that private information would not be spread), honest communication and refusing to engage in gossip and rumours. They praised the 'What is a good friend' exercise, and role plays, as particularly engaging which demonstrates the value of creative approaches. One young woman suggested that observing boys' friendships with each other was a way to gauge how they might behave in a relationship:

> "You have to look at how they treat any other [person]
> – sister, brother, how they treat friends or something, and
> the way that they treat them. I just don't see how boys
> treat girls, like they say that they love them, yeah, but
> really they don't. They treat them like they're garbage."
> (Young woman, year 8)

However, young women acknowledged that having the information did not necessarily mean that they would be able to put this into use; a tension described by Janet Holland and colleagues (1998) as the difference between 'intellectual' and 'experiential' empowerment:

"Some people say that they will do things, but you don't know what you're going to do 'til you get there." (Young woman, 12)

Deliverers also recognised this and hoped that the information provided in sessions would be a 'reference point' for later decision making. Research on young peoples' views of sexual consent also reveals that although many understand the concept in terms of mutuality and permission they struggle to apply it in real life scenarios (Coy, 2013). One way to address this in order that it might be translated into action is to combine information with case studies requiring application. For instance, an exercise in the programme asked young people to respond to invented letters written to 'Agony Aunt' columns and give their advice on healthy/unhealthy relationships. In part, the aim here was to enable self-reflection but in a way that was removed from personal experience. In another example, a case study of a young woman was used to illustrate the stages of the grooming process.

Young women were positive about the value of self-reflection, as the following exchange between four of them illustrates:

P1: "It actually makes you look at yourself ..."

P2: "Look inside yourself ..."

P3: "It's true. Even when we leave the sessions I found myself thinking about what they said to me."

P4: "I think this group is key because it had me thinking about life. Like the person I wanna be, in the future. [I think] 'why am I going to do that?' What am I getting out of it? In that if it's not helping me, I might as well just stop." (Young women, year 8)

Feedback from young people also reveals frequent references to seeing relationships (their own or those of friends) differently; some reported that having the information earlier might have prevented them from being involved with abusive men. In addition, young

people reported increased confidence about sources of support and in approaching adults for help.

Consent

Facilitators considered that the most beneficial subject for young people to have space to explore was sexual consent:

> "[There are] really worryingly low levels of understanding of what consent is in the context of relationships, and what impacts on somebody's ability to give consent. I think almost it would be just as valuable to go round and just do sessions on 'what is consent?'" (Project worker).

Although violence in the context of relationships was mentioned briefly, there was consensus among young women in the focus groups about 'crossing the line' to coercive sex:

> "It don't matter what age, from when you're saying 'No, no' and they still do it, that's rape." (Young woman, 12)

Feedback from young people also frequently mentioned legal frameworks about consent as useful (addressed in a 'legal/illegal' quiz). Important as work on consent is to delineate what constitutes criminal behaviour, contextualising this in discussions of 'space for action' to resist pressure and/or assert wishes is also essential – and this is addressed by the programme through discussion with young people about understandings of consent centred on 'being allowed to do something', 'agreeing to do something' and 'choosing to do something'. Discussions of power are also central, both in terms of what might inhibit someone from being able to give consent but also to challenge rape myths about women's culpability for victimisation or for men 'beating' women during sex.

Personal space

A core theme of the sessions was to explore boundaries (of the body and of personal space) to enable young women to develop a robust sense of ownership of the body that may in turn offer a

protective buffer against intimate intrusion. Exercises here included 'body mapping' where young people marked zones of the body as areas of inappropriate touch, and there were physical activities to test personal space.

> "Where both people are there, you had to keep on walking forward to them and where they felt uncomfortable you had to say 'Stop' and then if they didn't say 'Stop' and you felt uncomfortable you had to say 'Stop'. Because basically you were learning about where that person's boundaries were, and how close you can get to them." (Young women, 12)

Following this exercise, a young woman reported reflecting on how harassment from strangers in public space made her feel uncomfortable. It would appear that boys were less easily engaged with this and tended to veer towards making jokes, perhaps as a way of masking discomfort, and perhaps also revealing that bodily integrity is less of an issue for boys than for girls.

Conclusion

The dearth of prevention work with young people and training for professionals on sexual exploitation is well documented.

The evaluation revealed an overwhelmingly positive view of the programme from young people and, though not discussed here, from professionals. The latter reported increased knowledge and awareness of the dynamics of sexual exploitation, potential risk indicators and contexts, and more confidence in identifying the signs of sexual exploitation and responding appropriately and effectively (Coy et al, 2011). Embedding research evidence about sexual exploitation into the content gave it credibility for professionals and provided firm ground from which deliverers could explore myths. Equally, drawing on 'practice-based evidence' lent a depth to how aspects such as impacts and meanings of exploitation, links with gender inequality and violence against women more generally were addressed. The myths that surround sexual exploitation – young women's culpability, notions of choice and consent – necessitated careful attention to the discourses that both professionals and young people drew on in order

to deconstruct them within the programme activities. As one of the facilitators noted, "... it's not necessarily what they say that you need to challenge but the assumptions that go underneath", and this was as true for the young people as it was for the professionals. Both the content and the participatory, creative format were valued by young trainers, professionals and young people alike.

Young women valued the sessions enormously, particularly the opportunity to spend time together without boys and explore issues of friendships, ownership of the body and reflect on their sense of self. Tellingly, boys' attitudes to girls were described as disrespectful and predatory. Their experiences of gendered interactions and enjoyment of the prevention programme demonstrate that young people want and need information on the emotional aspects of sexual relationships, alongside explicit discussion of consent and coercion. Even if PSHE lessons were to address more comprehensively the contexts and landscapes in which young people navigate their lives, the need for more focused sessions/workshops on exploitation and violence delivered by knowledgeable specialists is evident. The cliché that 'it's not what you do, but the way that you do it' seems appropriate here, although we might say that it is both.

Notes

[1] Sexual exploitation of children and young people under the age of 18 years involves exploitative situations, contexts and relationships where young people (or a third person or persons) receive 'something' (e.g., food, accommodation, drugs, alcohol, cigarettes, affection, gifts, money) as a result of them performing, and/or another performing on them, sexual activities. Child sexual exploitation can occur through the use of technology without the child's immediate recognition; for example, the persuasion to post sexual images on the internet/mobile phones with no immediate payment or gain. In all cases, those exploiting the child/young person have power over them by virtue of their age, gender, intellect, physical strength and/or economic resources. Violence, coercion and intimidation are common, involvement in exploitative relationships being characterised in the main by the child's or young person's limited availability of choice resulting from their social/economic and/or emotional vulnerability (Pearce, 2009: 102–3).

[2] The recent case of men in Rochdale and Derby convicted of grooming young women for sexual exploitation has led to increased media attention and debate, and Barnardos has identified grooming occurring at younger ages amongst the young people they work with.

[3] The Child Exploitation and Online Protection Centre (CEOP) runs an 'Ambassadors' programme for professionals to train peers to deliver the 'ThinkuKnow' course to 11–16 year-olds. Content here focuses on young people's safety and risk-taking behaviours in online environments (www. thinkuknow.co.uk).

[4] Some specialised support projects for sexually exploited young people deliver sessions in schools, but few of them have had sufficient resources to commission evaluations.

[5] The term 'practice-based evidence' is proposed by Fox (2003) to describe the development of collaborative research with practitioners. We use it here to reflect knowledge accumulated by specialised organisations from their experience of supporting women and children over many decades. For instance, deliverers reported that the ongoing prevention work with young people fed into the delivery of training for professionals throughout the duration of the programme.

[6] One school in London claims to have eliminated homophobic bullying by using life stories of high profile gay and lesbian historical figures to enhance teachers' confidence to tackle discrimination, initiating conversations with young people and unpicking intolerance (Shepherd and Learner, 2010).

References

Barter, C., McCarry, M., Berridge, D. and Evans, K. (2009) *Partner exploitation and violence in teenage intimate relationships*, London: NSPCC.

Berelowitz, S., Firmin, C., Edwards, G. and Gulyurtlu, S. (2012) *'I thought I was the only one. The only one in the world'. The Office of the Children's Commissioner's Inquiry into child sexual exploitation in gangs and groups: Interim report*, London: OCC.

Burman, M. and Cartmel, F. (2006) *Young people's attitudes towards gendered violence*, Edinburgh: NHS Health Scotland. Available at: www. hebs.co.uk/research/pdf/GenderedViolence.pdf.

Burton, S. and Kitzinger J. (1998) *Young people's attitudes towards violence, sex and relationships: A survey and focus group study*, Edinburgh: Zero Tolerance Trust.

Campbell, R. and O'Neill, M. (2004) *Executive summary of the rapid evaluation of 'Sex, Lies and Love?'*, Walsall: Street Teams.

CEOP (Child Exploitation and Online Protection Centre) (2013) *Annual Review 2012-2013 and Centre Plan 2013-2014*, London: CEOP.

Coy, M. (2008) 'Young women, local authority care and selling sex', *British Journal of Social Work*, 38(7):1408-24.

Coy, M. (2009) 'Moved around like bags of rubbish nobody wants': How multiple placement moves make young women vulnerable to sexual exploitation', *Child Abuse Review*, 18(4): 254-66.

Coy, M. (2013) 'Children, childhood and sexualised popular culture' in J.Wild (ed) *Exploiting childhood: how fast food, material obsession and porn culture are creating new forms of child abuse*, London: Jessica Kingsley Publishing.

Coy, M., Kelly, L., Foord, J. (2009) *Map of gaps 2: The postcode lottery of violence against women support services in Britain*, London: End Violence Against Women Coalition/ Equality and Human Rights Commission.

Coy, M., Lee, K., Roach, C. and Kelly, L. (2010) *A missing link? An exploratory study of connections between teenage pregnancy and non-consensual sex*, London: CWASU.

Coy, M., Lovett, J, and Kelly, L. (2008) *Realising rights, fulfilling obligations: A template integrated strategy on violence against women for the UK*, London: End Violence Against Women Coalition.

Coy, M., Thiara, R.K. and Kelly, L. (2011) *Boys think girls are toys?: An evaluation of the Nia Project Prevention Programme on Sexual Exploitation*, London: Child and Woman Abuse Studies Unit.

DfE (Department of Children, Schools and Families) (2009) *Review of Sex and Relationship Education (SRE) in schools: A report by the external steering group*, Nottingham: DCSF.

Dubois, L. and Regan, L. (2006) *Challenging a violent future. Final report of the evaluation of the Trust Education Theatre Project*, London: CWASU.

Ellis, J. (2004) *Preventing violence against women and girls: A study of education programmes*, London: Womankind Worldwide.

EVAW (End Violence Against Women) (2010) *Almost a third of girls experience unwanted sexual touching in UK schools – new YouGov poll* Available at www.endviolenceagainstwomen.org.uk

EVAW *A different world is possible: Promising practices to prevent violence against women and girls* London: EVAW.

Firmin, C. (2010) *Female Voice in Violence Project: A study into the impact of serious youth violence on women and girls*, London: ROTA.

Flood, M (2009) 'The harms of pornography exposure among children and young people', *Child Abuse Review*, 18(2): 384-400.

Forrest, S., Strange, V., Oakley, A and the Ripple Study Team (2004) 'What do young people want from sex education? The results of a needs assessment from a peer-led sex education programme', *Culture, Health and Sexuality*, 6(4): 337–54.

Fox, N.J. (2003) *Practice-based evidence: Towards collaborative and transgressive research*, Sheffield: University of Sheffield.

Gohir, S. (2013) *Unheard voices: The sexual exploitation of Asian girls and young women*, Birmingham: Muslim Women's Network UK.

Hickman, L., Jaycox, L.H. and Aronoff, J (2004) 'Dating violence among adolescents: Prevalence, gender distribution, and prevention program effectiveness', *Trauma, Violence and Abuse*, 5(2): 123-42.

HM Government (2010) *Call to end violence against women and girls*, London: The Stationery Office .

Hoggart, L (2006a) 'Risk: Young women and sexual decision making', *Forum: Qualitative Social Research*, 7(1): Art. 28, Available at http://nbn-resolving.de/urn:nbn:de:0114-fqs0601283

Hoggart, L. (2006b) *Young women, sex and choices: a study of young motherhood in Haringey*, London: Middlesex University.

Hoggart, L. and Phillips, J. (2009) *London teenage abortion and repeat abortion research report*, London: Policy Studies Institute.

Holland, J., Ramazanoglu, C., Sharpe, S. and Thomson, R. (1998) *The male in the head: Young people, heterosexuality and power*, London: The Tufnell Press.

Hunt, R. and Jensen, J. (2007) *The experiences of young gay people in Britain's schools*, London: Stonewall.

Jago, S. and Pearce, J. (2008) *Gathering evidence of the sexual exploitation of children and young people: A scoping exercise*, Luton: University of Bedfordshire.

Mahony, P. and Shaughnessy, J. (2007) *The impact of challenging violence: Changing lives*, London, Womankind Worldwide.

Maxwell, C. and Aggleton, P. (2010) 'Agency in action – young women and their sexual relationships in a private school', *Gender and Education*, 22(3): 327-43.

National Working Group (2010) *What's going on to prevent the sexual exploitation of children and young people? An interim report (Special edition of online newsletter)*. Available at www.kscb.org.uk/pdf/Whats%20 Going%20On%20Special%20Edition1.pdf.

Noonan R.K. and Charles, D. (2009) 'Developing teen dating violence prevention strategies: Formative research with middle school youth', *Violence Against Women*, 15: 1087-105.

NSPCC/Sugar (2006) 'Teenage girls reveal unwanted sexual experiences'. Available at: www.femalefirst.co.uk/parenting/Teenagers-515.html.

O'Neill, M. (2001) *Prostitution and feminism: Towards a politics of feeling,* Cambridge: Polity Press.

Pearce, J (2009) *Young people and sexual exploitation: Hard to reach and hard to hear,* London: Routledge Falmer.

Pearce, J. Williams, M. and Galvin, C. (2002) *It's someone taking a part of you: A study of young women and sexual exploitation,* London: National Children's Bureau.

Phoenix, J. (2012) *Out of place: The policing and criminalisation of sexually exploited girls and young women: A summary,* London: The Howard League for Penal Reform.

Regan, L. and Kelly, L. (2002) *Teenage tolerance: The hidden lives of young Irish people – a study of young people's responses to violence and abuse,* Dublin: Women's Aid.

Ringrose, J., Gill, R., Livingstone, S., and Harvey, L. (2012) *A qualitative study of children, young people and 'sexting',* London: NSPCC.

Shepherd, J. and Learner, S. (2010) 'Lessons on gay history cut homophobic bullying in North London school', *The Guardian,* 26 October.

Swann, S. (1998) *Whose daughter next? Children abused through prostitution,* Barkingside: Barnardo's.

Testa, A. and Coleman, L. (2006) *Sexual health knowledge, attitudes and behaviours among black and minority ethnic youth in london: A summary of findings,* London: Naz Project.

Thiara, R.K. and Ellis, J. (2013) *Centralising young people: An evaluation of the Crush programme,* Hereford: West Mercia Women's Aid.

UK Youth Parliament (2007) *SRE: Are you getting it?,* London: UK Youth Parliament.

United Nations (1989) *Convention on the rights of the child,* Geneva: UN.

United Nations (2006) *Secretary-General's in-depth study on violence against women,* A/61/122/Add.1. Available at: http://daccessdds.un.org/doc/ UNDOC/GEN/N06/419/74/PDF/ N0641974.pdf

WHO (World Health Organisation) (2009) *Promoting gender equality to prevent violence against women,* Geneva: WHO.

MsUnderstood: the benefits of engaging young women in antiviolence work

Carlene Firmin

Drawing on research the author is conducting at the University of Bedfordshire and the outcomes of a pilot programme, 'The Gendered Action on Gangs (GAG) Project', which trained young women[1] to influence local policy and services, this chapter will explain the process, and consider the benefits, of 'gender-proofing'[2] antiviolence work through the engagement of young women. Using Bourdieu's theory of social fields and agency, the chapter: outlines key policy and research on peer-on-peer abuse generally and on serious youth violence[3] specifically; assesses the relevance of serious youth violence policy and practice to the lived experiences of gang-affected young women; considers the benefits and challenges of engaging gang-affected young women in policy and service development; and discusses the means by which different agencies could directly engage young women in antiviolence work in the future. Finally, the chapter also considers the potential for applying this approach to engaging boys and young men[4] in antiviolence work and explores whether there is a role for young men in preventing gang-related violence against young women.

Introduction

From 2008 onwards, evidence has been generated on the impact of street gangs and serious youth violence on women and girls across England (Pitts, 2008; Firmin, 2010, 2011, 2013a; Pearce and Pitts, 2011; Beckett et al, 2012; Berelowitz et al, 2012). While regional

and national policy has increased recognition of the impact of gang violence on women and girls, consistent local responses are yet to develop (DCSF, 2010; GLA, 2010; HM Government, 2011, 2013). These inconsistencies are rooted in broader challenges in acknowledging, understanding, and conceptualising young people's experiences of gender-based violence specifically, and gendered identities and hierarchies more generally. As a response, in 2010 'The GAG Project' was piloted to engage gang-affected girls and young women in local policy and practice development. This pilot project advocated a gender-proofed approach to working with gang-affected girls within a youth offending service, and it challenged local agencies to improve their strategic and operational responses to violence affecting young women.

Impact of street gangs and serious youth violence on women and girls

> "I'm scared that I've forgotten how to feel things. I don't cry any more. One of my boys got killed and I couldn't even cry at the funeral. You learn not to care cos there's no point. If you care too much it makes you weak and that's why most girls don't last in this way of life, cos they can't take it. Hold another girl down while your boys do stuff to her, gun-butt someone in the face with blood everywhere; you have to just think – whatever. If you care you're finished." (Young woman, 17; Race on the Agenda (ROTA) 'Female Voice in Violence [FVV] Project' [Firmin, 2010])

In recent years, research has begun to identify the impact of street gangs and serious youth violence on women and girls in England (Firmin, 2010, 2011, 2013b; Pearce and Pitts, 2011; Southgate, 2011); some work has also been developed in Scotland (Batchelor, 2005). Women and girls can be affected by street gangs and serious youth violence due to their association with men and boys involved in such violence; they may be a familial relation (mother, sister, aunt, cousin, grandmother), be in an intimate relationships (wife, girlfriend, sexual partner), or they may be friends, a female associate or a gang member themselves.[5] Research has indicated that these associations

can impact in multifaceted ways on women and girls (Firmin, 2011, 2013a, 2013b; Pearce and Pitts, 2011; Beckett et al, 2012). These include: women and girls' involvement in offending on behalf of the males they are associated with, including weapon and drug possession; alibi provision; 'setting-up' rivals to be assaulted; as victims of sexual exploitation within street gangs; as victims of sexual violence between street gangs; domestic abuse; and being positive influences for change.

It is important to note that many of the experiences of gang-associated women and girls, such as domestic abuse or sexual exploitation, also take place outside, and independently, of a street gang context (Barter et al, 2009; Barter, 2011; Coy et al, 2011). However, within street gangs such victimisation can have specific characteristics, such as motive, which are unique to the gang context (Firmin, 2011; Beckett et al, 2012; Berelowitz et al, 2012; Firmin, 2013a). For example, if a boy is a gang member his girlfriend may be sexually assaulted by rivals as part of the conflict process. As a result, existing policy and practice to address broader domestic abuse, sexual exploitation, and young women involved in offending will also be of relevance to women and girls affected by gang violence, in addition to that specifically designed to tackle street gangs.

Relevance of policy and practice to young women's experiences

Research has indicated that policy and practice rarely addresses? the impact of gang and serious youth violence on women and girls (Firmin, 2011, 2013a; Pearce and Pitts, 2011; Southgate, 2011). This gap exists for two key reasons. Firstly, serious youth violence and street gang policy, in addition to broader youth justice policy, has historically failed to recognise the victimisation, or involvement, of women and girls associated to street gangs. Secondly, violence against women and girls and child sexual exploitation policy has failed to recognise the relevance of the street gang context. Furthermore, violence against women policy has tended to focus on adult women rather than girls and young women (HM Government, 2013) resulting in additional insufficiencies for meeting the needs of younger victims.

Regional and national policy has gradually started to address these gaps. The London Mayor's *Violence Against Women and Girls* (VAWG) strategy included specific actions to tackle the use of sexual

violence within street gangs (GLA, 2010). In 2011, the Westminster Government published an action plan to end gang and youth violence and, for the first time, made recommendations and committed funding to specifically address the impact of gang violence on women and girls (HM Government, 2011). To a lesser extent, policy developed to address child sexual exploitation made reference to street gangs (DCSF, 2009) as did safeguarding guidance for schools (DCSF, 2010). However, these documents acknowledged the impact of gang violence on women and girls rather than making recommendations that were specific to gang-affected women and girls. Most recently, the Westminster Government updated the VAWG action plan and within it they recognised gang-associated young women as an under-recognised group and made specific commitments to address this (HM Government, 2013).

In relation to practice, a range of services come into contact with gang-associated women and girls but very few are able to offer a specialist response (Pearce and Pitts, 2011; Southgate, 2011). Often those operating within a VAWG or child sexual exploitation framework lack specialism in relation to street gangs, and those working with street gangs or within youth justice lack expertise in relation to gender. These gaps are evident within training offered to professionals, the assessments used to measure risk, and the differing multiagency frameworks used to identify and respond to the needs of young women (Firmin, 2013c; HM Government, 2013).

Fears about how information is shared, about an inability to safely access existing support, and the underacknowledged importance of community-based interventions were just some of the concerns about service provision articulated throughout the Race on the Agenda (ROTA) 'FVV Project':

> "Getting help only makes things worse, especially when you are young, no one can promise that they won't tell." ('FVV Project', aged 15, 2010)

> "If you told someone it would get to your family and I would never want my mum to know, she would be ashamed." ('FVV Project', aged 14, 2010)

"[Help] should come from within our communities, through support networks of other people who are going through what we are going through." ('FVV Project', aged 26, 2010)

Highlighting the range of concerns expressed by women and girls helps us to understand the existing gaps in service provision and the challenges faced by professionals in ensuring the safety and confidence of gang-associated women and girls.

Gender-neutral policy and gendered lives

One of the key barriers to improving the policy and practice response to gang-associated women and girls is the gender-neutral approach to working on issues affecting children and young people (Firmin, 2011, 2013b). Consequently, policy targeted at children and young people, as opposed to adults, regularly fails to acknowledge gender biases: for example, gang and youth violence policy is generally targeted at boys and young men but is described as targeting young people (Home Office, 2008). This is equally true of child sexual exploitation policy which is used to identify vulnerable young women in the majority of cases but is described as safeguarding young people (DCSF, 2009).

This trend in the development of gender-neutral children and young people policy runs in direct contrast to research on the gendered experiences of children and young people. In reality, gender construction is played out in a range of environments, and children and young people navigate gendered spaces through multiple lenses (Firmin, 2013c). International and UK research has highlighted the various ways in which gendered hierarchies and inequalities are apparent within the environments navigated by children and young people. These include the sexualisation of childhood in general (Aapola et al, 2005; Coy, 2009; Papadopoulos, 2010; Family Lives, 2012), the impact of misogyny and violence in music (Weitzer and Kubrin, 2009), violent and sexualised images on the internet (Peter and Valkenburg, 2007), the increased prevalence and harm of 'sexting' (Ringrose et al, 2011) and pornography (Flood, 2009). Research has also indicated that peer groups (Berridge and Barter, 2011), residential care homes (Barter, 2006) and schools and neighbourhoods (Thorne, 1993; Mac an Ghaill, 1994; Ringrose and Renold, 2011; Stanley et

al, 2011) all operate within gendered hierarchies. Although such social fields have been identified, questions remain about the control that children and young people themselves have in adopting and/or constructing their individual gender identity within the gendered hierarchies of their relationships, peer groups and neighbourhoods.

However, whilst research has evidenced the fact that children navigate gendered environments, it has focused less on children's individual agency in constructing and determining their gendered identity (Firmin, 2013c), whereas research which evidences that adults live gendered lives argues that adults are involved in the construction and reproduction of gendered identities (McNay, 2000; Connell and Messerschmidt, 2005; Talbot and Quayle, 2010). This work demonstrates that men and women, in addition to societies, governments, and institutions, construct multiple masculinities and femininities, and it also demonstrates the hierarchies within which they relate and operate (Connell, 1995). Where young people's gendered identities are considered, this is in relation to the role of institutions in creating gendered stereotypes or identities (Butler, 1999; Barter, 2006) rather than the young people's agency in creating these identities (Talbot and Quayle, 2010). Placing gender construction within Bourdieu's theory of social fields[6] (Bourdieu, 1990, 2001) enables us to consider agency (alongside structural inequalities within social fields that individuals navigate) as contributing to the subordination of femininities and nonhegemonic masculinities. For example, Powell drew on Bourdieu's theory to conceptualise consent to sexual activity (Powell, 2008), stating that the social rules within peer groups and other social environments influence young men and young women's understanding of consent but understanding these rules can also enable individuals and groups to challenge the rules should they feel or be empowered to do so. When applied to gender identity and gendered behaviours, this approach enables us to consider both the role of social structures and environments as well as individuals in constructing, shaping and changing their gendered identities.

According to the United Nations Convention on the Rights of the Child (UNCRC) (1989) and the Convention on the Elimination of Discrimination Against Women (CEDAW) (1979), girls are specifically discriminated against and disadvantaged as a result of gender inequality. Such discrimination is explored through the

concept of the 'girl child' and the specific ways in which institutions and local/regional/national/global structures result in reduced access to education and increased exposure to gendered violence. However, while such conventions take us some way in recognising that young people live gendered existences, three questions remain unanswered through gender-neutral social policy. Firstly, to what extent do boys and young men's gendered lives disadvantage their growth/development or lead them to experience harm/abuse? Secondly, to what extent are girls and young women, and boys and young men, actively involved as agents in constructing their gendered identities, and to what extent are their gendered identities the result of adult agency and structural inequality and relational hierarchies? Finally, given structural inequalities, should boys and young men's agency in relation to gender identity construction be viewed differently to the agency of young women?

As discussed in Chapter Nine, an evaluation of an intervention targeted at young people stated that 'boys treat girls like toys' (Coy et al, 2011: 1). As elaborated in Chapter Three, research into young people's experiences of violence in teenage relationships has also indicated a differential impact of violence between boys and girls with girls suffering more as a result of relationship abuse (Barter et al, 2009). Research into child sexual exploitation is increasingly identifying young people as both the perpetrators and victims of sexual exploitation (Jago et al, 2011). The objectification of girls and young women by young men and young women's experiences of sexual harassment and assault in schools (EVAW, 2010) have also been highlighted. While this mounting evidence on young people's experiences of 'gender-based violence' could lead us to conclude that young people are constructing and contributing to gendered identities and inequalities more consideration is required (Firmin, 2013c). Longitudinal research into 'masculine attitude trajectory' (Marcell et al, 2011) looked at the process of 'gender intensification' and sought to identify the points at which young people's gendered identities are shaped as they grow into adulthood. As young people are forming gendered identities throughout adolescence, and this identity is informed by, amongst other influences, social structures and adults within their lives, how young people use and experience gender-based violence needs to be considered within this context. Such thought is particularly required when considering the three-way

relationship between young people's individual agency, the structural inequality they experience, and those agencies, professionals and individuals that are responsible for protecting and nurturing young people themselves as well as their identities and relationships. Until the process of gender formation is better understood, it is a challenge to assume an understanding of young people's lives beyond the understanding that they are gendered by virtue of the fact that they operate within gendered fields.

A way to take this thinking forward is to consider whether there are points at which young people can be held responsible for their own individual gendered identity, and to consider the way that they perceive, respond to, and relate to others based on age. At a practical level, it is useful to consider how one can explore the link between agency and structural inequality with young people. Supporting young women to explore their access to services, and their experiences of violence, through a gender and age specific lens, can be one way to facilitate this process.

Establishing 'The GAG Project': engaging gang-affected young women in policy and service development

'The GAG Project' was established to engage young women in a gendered analysis of their experiences of violence and abuse and their access to services. Following the findings of the FVV Project and as a result of requests from professionals for support in improving their response to young women, 'The GAG Project' was piloted in early 2010. Working with a youth offending service, the project piloted a 10-week groupwork programme aimed at engaging gang-associated young women in policy and service development. The original group participants were all in contact with the youth offending service; however, during the second and third weeks they also invited friends to attend the remainder of the programme. Given that street gangs and youth offending services are both male dominated spaces, it was important that the groupwork was delivered in a safe women-only space by all-female staff, ensuring an alternative environment for participants to explore their experiences and their service needs.

Each week the group members focused on a particular aspect of gang violence that could affect women and girls, and they discussed this in relation to relevant policy and services within the local

authority. For example, when discussing how youth violence can affect young women in education, particularly considering sexual harassment and assault in schools or pupil referral units (PRUs), girls would also learn about education policy and discuss school-based interventions. Such a conversation was particularly poignant for girls in PRUs, as these were mainly attended by boys, and as such girls were outnumbered and some reported feeling unsafe within the facility. Each week participants were asked whether they would have taken part in the discussion if the group had been mixed-gender. In the vast majority of cases the importance of a girl-only space was identified by participants as a factor which enabled their engagement in the group; they said things that they wouldn't have shared if boys had been in the group, particularly in terms of body image and relationships

'The GAG Project' was not an intervention designed to support young women to exit gang violence. Participants were required to be either in receipt of support from other statutory or voluntary sector agencies charged with addressing any offending behaviour or to have experienced specific victimisation. Indeed, participants in the group were either young women being supported by the youth offending service and other voluntary sector organisations to address their offending behaviour and victimisation (these young women were referred by professionals) or they were living in gang-affected neighbourhoods and were, therefore, at risk of gang-related violence, but they were not currently engaged in offending (these young women were referred by peers rather than professionals).

Given the specific aims of 'The GAG Project', participants were not required to disclose examples of their victimisation. While they drew upon their experiences, this was mainly in relation to services rather than abuse or youth violence. The services mentioned included education, youth justice, health, violence against women and girls, gangs and serious youth violence, and housing. Discussion covered the policy context, local service delivery, and commissioning. References to central government policy and media reporting were also made in between the introductory and the evaluative sessions which topped and tailed the programme. Throughout the process, the following concerns were raised consistently by participants: a lack of girl-only space in schools and youth justice provision; concerns about information-sharing processes and safety planning; training and the need for awareness raising about the experiences of gang-

affected women and girls with all professionals; the scale of intimate partner abuse, sexual exploitation, and sexual violence experienced by young women living in gang-affected areas; and a need to evaluate and improve local interventions to improve accessibility for girls and young women. Ultimately, participants were concerned that professionals did not understand the gendered experiences of gang-affected young women and that most of the gender-specific services in the local authority were targeted at adult women rather than those under 18 years of age.

At the end of the intervention, young women felt that they had benefitted by having an increased awareness of local policy, services and strategy:

> "Now I know how this all works I feel like I can make a change. It's the first time I can understand how I can do things and how other people can do things with me, to make girls like me safer." ('The GAG Project' evaluation)

Being able to understand that professionals were taking action, even if this was not action that participants valued, was an important position from which they could work. Being aware of both the resources that were being committed and the processes by which they could influence service provision contributed to participants feeling able to make a case for a change. Focusing on how services and professionals could support young women to change, rather than simply focusing on young women in isolation from services, was welcomed by those on the programme.

Participants each met with the project founder at the end of the programme to discuss next steps and to agree local actions that they wanted to take part in. These actions included: lobbying local schools to offer girl-only spaces and girl groups in education; raising awareness amongst gang-affected local schools about the impact of gang violence on the girls and young women they were educating; writing to the local Safeguarding Children Board to ask about training and strategic planning in the local area in relation to young women affected by gang violence; and mapping out all local services that are open to girls and young women in the local area and seeking to influence them through meetings and letter-writing. Three of the young women who took part in the groupwork continued as

volunteers with 'The GAG Project' and, along with two other young women in the group, they strived to deliver the local action plan that participants had put together.

The success of the programme was partly evidenced by the commitment of the young women to attend each week, in addition to the ownership they took of developing and delivering their action plan. The programme further resulted in participants having increased engagement in local policy and practice. Three young women committed to ongoing voluntary work to influence local and national policy and practice and three schools agreed to offer girl-only spaces to their students. The youth offending team asked for the GAG group to be run with another group of young women, co-delivered by some of the young women on the original group, and four other local authorities requested local GAG groups to be established.

Following the success of the pilot, 'The GAG Project' was established as a not-for-profit organisation, and it began to build partnerships with larger organisations to respond to the high level of interest and to offer robust evaluation for the interventions. 'The GAG Project' is hosted by a VAWG Black, Asian, Minority Ethnic and Refugee (BAMER) agency, Imkaan, and is being developed in partnership with the University of Bedfordshire. This capacity-building programme is ongoing and, in the interim, requests for GAG group establishment continue from around the UK. Requests from the United States and South Africa have also been received. These requests are being built strategically into the 'MsUnderstood Programme', which will be rolled out from August 2013, working directly with services in local authority areas, and young women within these areas, to gender-proof policy and services designed to respond to peer-on-peer abuse.

'The GAG Project' shows that there are a number of young women who are, along with the professionals who work with them, seeking to improve the policy and services which are in place to address gang and serious youth violence. By offering them a stake in developing the services designed to support gang-affected young women, engagement is improved from the outset. Girls and young women who live in areas where services are being delivered have much to offer in the way of service improvement, accessibility and

evaluation, and harnessing this can assist in ensuring interventions are relevant to them.

Benefits of gender-proofing antiviolence work

Throughout 'The GAG Project' pilot, it became clear that interventions designed to prevent serious youth violence were focused on violence committed by young men against young men. This finding is in keeping with other emerging research evidence of service provision for gang-associated women and girls (Southgate, 2011; Firmin, 2013b). 'The GAG Project' takes us some way in demonstrating the value of gender-proofing interventions for two key reasons.

Firstly, the project itself was a gender-proofed antiviolence intervention. It was delivered in a girl-only space with women practitioners, the content of the intervention was designed with the experiences of young women in mind (in terms of both their experiences of gang and serious youth violence and their experiences of services) and the evaluation process sought to capture whether the gender-specific aspects of the programme were relevant and/ or beneficial to participants. Secondly, the project identified the importance of ensuring that broader antiviolence interventions were gender-proofed. Participants stated that they benefitted from engaging in a girl-only space and wanted to see this replicated in their schools and within the youth offending service. They identified with the gendered impact that gang and serious youth violence had on their lives and wanted these specific experiences to be recognised and addressed by professionals. They also felt that professionals needed improved awareness of the impact that gang violence had on the lives of local young women and they identified gaps in local antiviolence provision, the vast majority of which focused on boys and on their use of violence against other boys rather than girls. 'The GAG Project' pilot demonstrated that gender-proofing antiviolence work both improved the engagement of young women with interventions, as well as providing ideas for ensuring the relevance of other services to tackle gang and serious youth violence.

Next steps: the roles for young men and boys in prevention

During 'The GAG Project', young women challenged professionals about the work currently being delivered to boys and young men. While they stated that they benefitted from being in a girl-only space, they also wanted to think about how young men could engage in this type of antiviolence work. In particular, participants were concerned that interventions to tackle the impact of gang violence on young women were delivered only to young women and that antiviolence work with boys and young men continued to solely focus on violence they used against their male peers. Participants believed that this status-quo needed to be challenged, and they thought that until this happened they would continue to feel like they were being held responsible for preventing the violence that was being used against them.

This tension is not unique to the field of gangs and serious youth violence. Broader work on tackling violence against women and girls tends to focus on interventions with women who are victims of abuse (HM Government, 2012) rather than those who are causing/perpetrating the abuse. Perpetrator programmes, although they are delivered, are less widespread[7]. Prevention campaigns, such as the 'White Ribbon Campaign' led by men to tackle gender-based violence, have been developed internationally, and to an extent these have been picked up in the UK (Kaufman, 1999). Some organisations within the violence against women sector have also actively sought to engage men in the agenda, such as Women's Aid's 'Real Man' campaign (Women's Aid, 2010). Recent national campaigns[8] to tackle what the government has termed 'teen abuse' has sought to shift the responsibility for preventing intimate partner violence and sexual violence onto those who perpetrate this abuse (Home Office, 2011); this has been based on the evidence that the vast majority of perpetrators of 'teen abuse' are young men.

It is worth returning to the point made earlier in the chapter about the construction of gendered identities and young people's navigation of gendered social fields. While 'The GAG Project' supported girls and young women to engage in debates about the ways in which their lives are gendered and the relevance of this for services, it is not evident that such interventions are currently offered to young

men and boys. At the very least, there is an evidence gap in relation to work with young men on masculinities, particularly those that are engaged in offending (Home Office, 2013).

It is useful to consider this gap in interventions with young men within the broader research on 'hegemonic masculinity' (Connell, 1995). Over the past two decades, research about notions of harmful masculinity has demonstrated how masculinities which subordinate perceived weaker masculinities and femininities can be associated with men and boys involvement in criminality (Newburn and Stanko, 1994) or in sexual violence (Powell, 2008). While this research offers a useful starting point for understanding men and boys' use of violence, the vast majority of work has focused on adult men. We do not fully understand young men's use of violence in their relationships and peer groups, particularly in relation to gender. Given that the UK policy definition of domestic abuse was limited to adult relationships, and that it was only amended to cover 16–17 year olds in 2013 (Home Office, 2013), the meaning of this work for young men is yet to be sufficiently considered. By defining domestic abuse in young people's relationships in exactly the same way that we do for adults, and in the absence of age-specific research on perpetrators, we risk assuming that boys and young men use gender-based violence in the same way as adult men (Firmin, 2013c). It also places the power that some boys and young men hold in their individual relationships and/or peer groups within a vacuum, and it fails to acknowledge that in relation to older men in their lives (for example, older gang members in a street gang context) some young men may be relatively powerless and powerful simultaneously. For example, if a 25-year-old gang member asks young members of a gang aged 14 and 15 to stand in a line and allow a 13-year-old girl to perform an oral sex act on them, those 14 and 15 year old boys are powerful in relation to the 13-year-old girl but may feel powerless in relation to the 25-year-old gang member; it is all of these power hierarchies that will influence whether any of these individual boys choose to say no to the 25-year-old gang member (Berelowitz et al, 2012; Firmin, 2013c).

As manifestations of 'peer-on-peer abuse' continue to be recognised (Barter et al, 2009; Jago et al, 2011; Coy et al, 2011; Beckett et al, 2012; Berelowitz et al, 2012; Firmin, 2013c) in both policy and practice, so, too, will the responsibilisation of boys in relation to their adoption of harmful gendered identities and their use of gender-based violence.

And yet to prevent gender-based violence it is crucial to consider how we prevent its use, as well as protect those who it is used against. With a continuing lack of clarity about gender identity formation, and the relationship between young people's individual agency and the gendered inequalities that persist within the social fields that young people navigate, the young women on 'The GAG Project' were right to question the place of work with young men in preventing violence against young women. Engaging young men about their gendered access to services, and their gendered victimisation and/or use of violence, offer us an opportunity to holistically engage young people in the prevention of gender-based violence.

Conclusion

As policy has begun to acknowledge that young people live gendered lives, reference has been made to the need for commissioning interventions to tackle young people's vulnerability to gender-based violence (HM Government, 2013). As this chapter has illustrated, offering a gendered framework within which young people can assess both their experiences of violence and access to services offers a process through which serious youth and gang related violence can be responded to. 'The GAG Project' pilot offers a start in this process. Engaging a group of gang-associated young women in policy and practice improvement can support them in understanding their experiences of abuse and improve local responses. However, this pilot has also identified where further work is required. Specifically, further research is required to understand how young people adopt and use gendered identities, and how interventions can work with boys and young men to prevent their use of gender-based violence. Ultimately, this process needs to influence central, as well as local, government policy to ensure that strategies to address young people's experiences of violence are gendered from the outset.

Notes

[1] For the remainder of this chapter, the terms 'girls', 'young women' and 'girls and young women' will refer to females aged 11–17. Those who took part in the pilot project were aged 13–15.

[2] The term 'gender-proofing' refers to the process of assessing policy or practice to ascertain its suitability for girls and women as well as for boys and men,

and where differential impact is identified that steps are taken to ensure that outcomes for boys and men and for girls and women are equally beneficial.

[3] For the remainder of this chapter, the term 'serious youth violence' is defined as 'Any offence of most serious violence or weapon-enabled crime where the victim is aged 1–19' (i.e. murder, manslaughter, rape, wounding with intent and causing grievous bodily harm).'Youth violence' is defined in the same way, but also includes assault with injury offences (London Safeguarding Children Board 2009: 6).

[4] For the remainder of this chapter, the terms 'boys', 'young men' and 'boys and young men' will refer to males aged 11–17.

[5] Any individual woman or girl can have multiple associations; for example, one may be a sister of one gang member while also being the girlfriend of another gang member.

[6] The Bordieuian concept of 'social fields' is employed to conceptualise the environments that young people navigate and the rules and power hierarchies that exist with them.

[7] Delivered by organisations such as Respect or the Domestic Violence Intervention Project (DVIP).

[8] 'This is Abuse' campaign: http://thisisabuse.direct.gov.uk/.

References

Aapola, S., Gonick, M. and Harris, A. (2005) *Young femininity: Girlhood, power and social change*, Basingstoke: Palgrave.

Barter, C. (2006) 'Discourses of blame: deconstructing (hetero)sexuality, peer sexual violence and residential children's homes', *Child and Family Social Work*, 11(4): 347-56.

Barter, C. (2011) 'A thoroughly gendered affair: teenage partner violence and exploitation in children behaving badly?' in C. Barter and D. Berridge (eds) *Peer violence between children and young people*, West Sussex: John Wiley & Sons Ltd.

Barter, C. McCarry, M., Berridge, D. and Evans, K. (2009) *Partner exploitation and violence in teenage intimate relationship*, London: NSPCC.

Batchelor, S. (2005) 'Prove me the bam! Victimisation and agency in the lives of young women who commit violence offences', *Probation Journal*, 52(4): 358-75.

Beckett, H., Brodie, I., Factor, F., Melrose, M. and Pearce, J. (2012) *Research into gang-associated sexual exploitation and sexual violence: Interim Report*, Luton: University of Bedfordshire.

Berelowitz, S., Firmin, C., Edwards, G. and Gulyurtlu, S. (2012) *I thought I was the only one. The only one in the world: The Office of the Children's Commissioner's Inquiry into Child Sexual Exploitation in Gangs and Groups Interim Report,* London: Office of the Children's Commissioner.

Berridge, D. and Barter, C. (2011) *Children behaving badly? Peer violence between children and young people,* West Sussex: John Wiley & Sons Ltd.

Bourdieu, P. (1990) *In other words: Essays towards a reflexive sociology,* Stanford CA: Stanford University Press.

Bourdieu, P. (2001) *Masculine domination,* Stanford CA: Stanford University Press.

Butler, J. (1999) *Excitable speech: A politics of the performative,* New York: Routledge.

Connell, R. (1995) *Masculinities,* Cambridge: Polity Press.

Connell, R. and Messerschmidt, J.W., (2005) 'Hegemonic masculinity: rethinking the concept', *Gender and Society,* 19: 829-59.

Coy, M., (2009) 'Milkshakes, lady lumps and growing up to want boobies: how the sexualisation of popular culture limits girls' horizons' *Child Abuse Review,* 18(6): 372-83.

Coy, M., Thiara, R. and Kelly, L. (2011) *Boys think girls are toys: An Evaluation of the Nia Project Prevention Programme on Sexual Exploitation,* London, CWASU London Metropolitan University.

DCSF (Department for Children, Schools and Families) (2009) *Safeguarding children from sexual exploitation, Supplementary guidance to Working Together to Safeguard Children,* London: DCSF.

DCSF (2010) *Safeguarding children and young people who may be affected by gang activity,* London: DCSF.

EVAW (End Violence Against Women) (2010) *Almost a third of girls experience unwanted sexual touching in UK schools – new YouGov poll.* Available at www.endviolenceagainstwomen.org.uk.

Family Lives (2012) *All of our concern: Gommercialisation, sexualisation and hypermasculinity,* London: Family Lives.

Firmin, C. (2010) *Female voice in violence: A study into the impact of serious youth violence on women and girls,* London: Race on the Agenda.

Firmin, C. (2011) *This is it, This is my life: Female Voice in Violence Final Report,* London: Race on the Agenda.

Firmin, C. (2013a) 'Busting the 'gang-rape' myth: girls' victimisation and agency in gang-associated sexual violence' in Horvath, M.A.H. and Woodhams, J. (eds) *Handbook on the study of multiple perpetrator rape: A multidisciplinary response to an international problem*, London: Routledge.

Firmin, C. (2013b) 'Criminal gangs, male dominated services, and the women and girls who fall through the gaps' in Rehman, Y., Kelly, L. and Siddiqui, H. (eds) *Moving in the shadows: Violence in the lives of minority women and children*, London: Ashgate Publishing.

Firmin, C. (2013c) 'Something old or something new: Do pre-existing conceptualisations of abuse enable a sufficient response to abuse in young people's relationships and peer-groups?' in Melrose, M. and Pearce, J. (eds) *Critical perspectives on child sexual exploitation and trafficking*, Basingstoke: Palgrave Macmillan.

Flood, M. (2009) 'The harms of pornography exposure among children and young People', *Child Abuse Review*, 18(2): 384-400.

GLA (Greater London Authority) (2010) *The way forward: Taking action to end violence against women and girls*, London: Greater London Authority.

HM Government (2011) *Ending gang and youth violence: A cross-government report including further evidence and good practice case studies*, London: The Stationery Office.

HM Government (2012) *The next chapter: Action plan to end violence against women and girls*, London: The Stationery Office.

HM Government (2013) *The next chapter: Action plan to end violence against women and girls*, London: The Stationery Office.

Home Office (2008) *Tackling gangs action programme: Tackling gangs: a practical guide for local authorities, CDRPS and Other Local Partners*, London: Home Office.

Home Office (2011) *Home Office teenage relationship abuse campaign*, Available www.homeoffice.gov.uk/crime/violence-against-women-girls/teenage-relationship-abuse/

Home Office (2013) *Information for local areas on the change to the definition of domestic violence and abuse*, London: Home Office.

Jago, S., Arocha, L., Brodie, I., Melrose, M., Pearce, J. and Warrington, C. (2011) *What's going on to safeguard children and young people from sexual exploitation? How local partnerships respond to child sexual exploitation*, Luton: University of Bedfordshire.

Kaufman, P. (1999) *The seven P's of men's violence*. Available at www.whiteribbon.ca/educational_materials/default.asp?load=seven

Kelly, L. (2009) 'Gender and child harm', *Child Abuse Review*, 18: 367-71.

London Safeguarding Children Board (2009) *Safeguarding children affected by gang activity and/or serious youth violence*, London: LSCB.

Mac an Ghaill, M. (1994) *The making of men: Masculinities, sexualities and schooling*, Buckingham: Open University Press.

Marcell, A.V., Eftim, S.E., Sonenstein, F.L. and Pleck, J.H. (2011) 'Associations of family and peer experiences with masculinity attitude trajectories at the individual and group level in adolescent and young adult males', *Men and Masculinities*, 14(5): 565-87.

McNay, L. (2000) *Gender and agency: Reconfiguring the subject in feminist and social theory*, Cambridge: Polity Press.

Newburn, T. and Stanko, E.A. (1994) *Just boys doing business? Men, masculinities, and crime*, New York: Routledge.

Papadopoulos, L. (2010) *The sexualisation review of young people*, London: Home Office.

Pearce, J., and Pitts, J. (2011) *Youth gangs, sexual violence and sexual exploitation: A scoping exercise for The Office of the Children's Commissioner for England*, London: Office of the Children's Commissioner.

Peter, J. and Valkenburg, P. (2007) 'Adolescents' exposure to a sexualised media environment and their notions of women as sex objects', *Sex Roles*, 56: 381-95.

Pitts, J. (2008) *Reluctant gangsters: The changing shape of youth crime*, Exeter: Wilan Publishing.

Powell, A. (2008) 'Amor fati? Gender habitus and young people's negotiation of (hetero)sexual consent', *Sociology*, 44(2): 167-84.

Ringrose, J., Gill, R., Livingstone, S. and Harvey, L. (2011) *A qualitative study of children, young people and 'sexting'*, London: NSPCC.

Ringrose, J. and Renold, E. (2011) 'Boys, girls and performing normative violence in schools: A gendered critique of bully discourses' in C. Barter and D. Berridge (eds) *Peer violence between children and young people*, West Sussex: John Wiley & Sons Ltd.

Southgate, J. (2011) *Seeing differently: Working with girls affected by gangs*, London, The Griffin Society.

Stanley, N., Ellis, J. and Bell, J. (2011) 'Delivering preventative programmes in schools: Identifying gender issues in children behaving badly' in C. Barter and D. Berridge (eds) *Peer violence between children and young people*, West Sussex: John Wiley & Sons Ltd.

Talbot, K. and Quayle, M. (2010) 'The perils of being a nice guy: Contextual variation in five young women's constructions of acceptable hegemonic and alternative masculinities', *Men and Masculinities*, 13: 255-78.

Thorne, B. (1993) *Gender play*, New Brunswick, NJ: Rutgers University Press

Weitzer, R. and Kubrin, C. (2009) 'Misogyny in rap music: A content analysis of prevalence and meanings', *Men and Masculinities*, 12: 3-29.

Women's Aid (2010) *Women's Aid real man campaign*, Available at www. womensaid.org.uk/page.asp?section=0001000100100016§ionT itle=Real+Man+Campaign.

Shifting Boundaries: lessons on relationships for students in middle school

Nan Stein

Introduction

Terms matter in any social movement, and each term carries its own perspective, analysis and policy implications; different terms emphasise different dimensions of the problem. For example:

> ... 'family violence' refers to acts within a family context but downplays the gendered dimensions while 'wife battering' emphasizes gender but excludes violence between unmarried people. 'Spouse abuse' broadens the form of violence under consideration from 'spousal assault' but still restricts the term to marriage (same with 'wife battering') ... 'Domestic violence' also does not specify the perpetrator or the victim in gendered terms ... 'Intimate partner violence' highlights the intimacy of the relationships but ignores gender as well as the acts that are not embedded in intimate relationship. (Merry, 2009: 28)

Similarly, 'gender violence' or 'gender-based violence', the terms which are most frequently used in international documents, such as the 1995 Beijing World Conference on Women, broaden discussions of relationship violence beyond heterosexual relationships, but they

do not indicate that it is women who are disproportionately the victims of such violence (Merry, 2009: 28).

Teen dating violence (TDV) is an incomplete, placeholder term – young people may not yet be teens, may not be dating or going anywhere together and there might not be any standard measures of the physical or sexual violence present in their relationships. Nonetheless, young people are affiliating ('going together') at younger and younger ages; their affiliated relationship may only last for a day or a week, and it may consist of nothing beyond verbal interactions, yet the notion of coupling and exclusivity may be present in their affiliation.

For over 30 years, my research has focused on the precursors to TDV – by which I mean the enactment of sexual harassment in schools, the location where most young people meet, hang out and develop, for better or worse, patterns of social interactions. Schools may also serve as the location or training ground for domestic violence; a place where sexual harassing behaviors conducted in public may provide license to proceed in private (Stein, 1992, 1993, 1995, 1999).

Interpersonal violence among teenagers who are involved in a dating relationship[1] is recognised as a major public health, education and legal problem in the US (Levesque, 1997; CDC, 2012). TDV results in injuries, poorer mental/physical health, more 'high-risk'/ deviant behavior, and increased school avoidance (Fineran and Gruber, 2004; Howard et al, 2007a, 2007b; Gruber and Fineran, 2008). Resolutions are regularly passed by the Congress of the United States to bring attention to this problem and to promote public policy and remediation efforts at the state and local level (Senate Resolution 362, 2012).

This chapter will summarise a multiyear, random assignment research project in the New York City schools (Grades 6 and 7, ages 11–13 years old). This research project focuses on precursors to TDV, including sexual harassment in schools among peers, and consists of interventions in both the classroom, and/or school-wide

Gender violence and sexual harassment in schools

Gender violence (including interpersonal or dating violence) and sexual harassment have been documented as serious problems in

middle (ages 11–14) and secondary (ages 14–18) schools in the United
States (Stein, 1993, 1995, 1999, 2005; Stein et al 1993; AAUW, 1993,
2001, 2011) and have been recognised as impediments to receiving
a positive educational experience. The terms 'gender violence' (GV)
and 'sexual harassment' (SH) are broadly defined under both national
and international laws, and also invoke social movements associated
with efforts to end violence against women. The movement against
GV/SH in the United States originally centred on sexual assault and
domestic violence among adults (Schechter, 1982) but now covers
a wider range of violations, including sexual abuse in prisons, sexual
harassment in the workplace, and attacks based on perceived or actual
sexual orientation. Gender violence is defined as any interpersonal,
organisational, or politically oriented violation perpetrated against
people due to their gender identity, sexual orientation, or location in
the hierarchy of male-dominated social systems (O'Toole et al, 2007).

Sexual harassment in education is defined as: unwelcome conduct
of a sexual nature. It can include unwelcome sexual advances, requests
for sexual favours, and other verbal, nonverbal, or physical conduct
of a sexual nature. Sexual harassment of a student that is sufficiently
severe, persistent or pervasive to deny or limit the student's ability
to participate in or to receive benefits, services, or opportunities in
the school's programme is a form of sex discrimination prohibited
by Title IX (US Department of Education OCR, 2001).

Prevalence and impact of gender violence and sexual harassment

Research and lawsuits attest to the presence and negative impact
on students of GV/SH (Stein, 1995, 1999). Despite this, few studies
have been conducted on the effectiveness of GV/SH prevention
programmes in schools and those that exist often lack research designs
of sufficient rigour, with only a few having used an experimental
design (Hickman et al, 2004) or samples of students younger than
13 or 14 years old.

GV and SH among teenagers have serious health consequences,
including significantly poorer mental and physical health and more
trauma symptoms (Molidor et al, 2000; Howard et al, 2007a, 2007b).
Prevalence rates vary widely, but research studies on teen GV/SH
suggest that as many as 40% to 60% of teenagers experience dating

violence, including sexual, physical, and psychological abuse (Foshee, 1996, Foshee et al, 1996; Hickman et al, 2004; Jouriles et al, 2009). The National Longitudinal Study of Adolescent Health revealed that physical and psychological violence are similar in opposite sex and same sex romantic relationships among adolescents in Grades 7–12 (generally ages 12–18), reporting at 11% in same sex relationships and 12% in opposite sex relationships for physical violence, and at 21% for same sex relationships and 29% in opposite sex relationships for psychological violence (Halpern et al, 2001, 2004).

Related to the problem of TDV is peer sexual harassment. Teen victims of sexual harassment exhibit greater school avoidance than those not sexually harassed (Larkin, 1994; Gruber and Fineran, 2008). In comparison with boys who reported harassment, studies have found that girls fare consistently worse on such measures (AAUW, 1993, 2001, 2011; Fineran and Gruber, 2004, Gruber and Fineran, 2008). Data from the most recent national study of 1,965 students in Grades 7–12 (ages 12–18) found 48% of the students experienced verbal, physical or online sexual harassment during the 2010–11 school year; 44% of that harassment was 'in-person', which included being subjected to unwelcome comments or jokes, inappropriate touching or sexual intimidation. Not surprisingly, 87% of the harassed students reported negative effects such as absenteeism, poor sleep and stomach aches (Anderson, 2011). Regardless of the form of harassment, more girls were victims: 52% of girls said they had been harassed in person and 36% online; this compared with 35% of boys who were harassed in person and 24% experiencing online harassment. Unwelcomed touching was reported by 13% of the girls compared with 3% of the boys, and 3.5% of the girls said they were forced to do something sexual compared to less than 1% (0.02%) of the boys.

The consequences of the harassment also varied by gender with girls reporting more negative reactions: 37% said they did not want to go to school compared to 25% of the boys; 22% of the girls who were harassed reported they had trouble sleeping compared to 14% of the boys; and 37% of the girls reported stomach ailments compared to 21% of the boys. Findings from the previous survey by AAUW in 2001 indicated that the female students identified that onset of their sexual harassment began in Grade 6 (generally age 11) which

is an argument for early intervention (Pellegrini, 2001; McMaster et al, 2002).

While girls and boys both experience high rates of GV/SH, they think of, and react to, GV/SH differently (O'Keefe and Treister, 1998; Gruber and Fineran, 2008). Firstly, girls are more likely than boys to be sexually victimised (Foshee, 1996; Molidor et al, 2000; Wolitzky-Taylor et al, 2008) and sustain more injuries related to relationship violence than their male counterparts (Makepeace, 1987; O'Keefe, 1997; Molidor and Tolman, 1998; Jackson et al, 2000; Howard et al, 2007a, 2007b). These studies have also revealed that while males and females both perpetrate GV/SH at high levels, the motivations (O'Keefe, 1997; Mulford and Giordano, 2008), attitudes (LeJeune and Follette, 1994; Jackson et al, 2000) and consequences (Molidor and Tolman, 1998; Wolitzky-Taylor et al, 2008) are often very different, and girls fare consistently worse on a number of physical (AAUW, 1993, 2001; Foshee, 1996; Malik et al, 1997; O'Keefe, 1997; Watson et al, 2001; Fineran and Gruber, 2004; Gruber and Fineran, 2008) and emotional outcomes (Foshee, 1996; O'Keefe and Treister, 1998; Molidor et al, 2000). Teenage girls are more often killed by male dating partners (or ex-partners) than the reverse (Sousa, 1999); data from the American Bar Association between 1993 and 1999 found that 22% of all homicides against females aged 16–19 were committed by an intimate partner (Blow, 2009). Moreover, sexual risk behaviors, pregnancy, and suicidality are also associated with victimisation in girls (Silverman et al, 2001, 2004).

A wide variety of non-profit/civil society groups have created a plethora of interventions to reduce the severity of TDV or prevent its inception; for example, staff from sexual assault and domestic violence agencies, state and federal policy makers, criminologists, educators, psychologists and medical personnel (Mulford and Giordano, 2008). School-based programmes to prevent and reduce the precursors to TDV have become one of the most popular modes of intervention to disrupt the normalcy of TDV.

The use of randomised controlled trials in teen dating violence research

Despite the high incidence of TDV, few rigorous studies have been conducted on the effectiveness of dating violence prevention

programs for 11–14 year olds in middle school (Foshee et al, 2004a, 2004b; Taylor et al (2008, 2010a, 2010b, 2011, 2013). However, these few evaluations have demonstrated that dating violence can be prevented or reduced in school settings (DeGue et al, 2014). In the first study Taylor and I conducted, which was in greater Cleveland, Ohio (USA) with students in Grade 6 and 7 (ages 11–13), we implemented a randomised control trial[2] (RCT) of a dating violence prevention program that we had developed called 'Shifting Boundaries: lessons on relationships for students in middle school'.

Our study has been the only evaluation (Taylor et al, 2010a, 2010b) that has addressed students in Grades 6 and 7 (ages 11–13) that assessed behavioural measures with an experimental design of random assignment to one of the four conditions of interventions (Cornelius and Resseguie, 2006; Whitaker et al, 2006). When evaluating two components of this prevention programme, overall, we found that the intervention improved knowledge and attitudes related to youth dating violence and reduced self-reported peer violence victimisation and self-reported perpetration (Taylor et al, 2010a, 2010b). However, there was a conflicting finding regarding self-reported dating violence perpetration. The intervention seemed to increase self-reported dating violence perpetration (but not self-reported dating violence victimisation). This iatrogenic finding (an increase in violence perpetration) was examined closely and was interpreted to be most likely due to reporting issues as opposed to actual increases in perpetration between the intervention and control group (Taylor et al, 2010a, 2010b). This research was important because it demonstrated, through an experimental method, that a condensed five-session classroom curriculum could be effective for students as young as sixth and seventh graders (ages 11–13).

Our next study (2008–10) assessed 'Shifting Boundaries' through a randomised controlled trial with 30 New York City middle schools. This research also showed positive results in terms of decreasing sexual harassment, peer violence and dating violence. Although not a replication of the Cleveland study, the NYC study built on assessing modified versions of the classroom curricula from the earlier study and added building-wide[3] intervention components that took place across the school.

Our purpose was to provide high-quality evidence concerning the effectiveness of targeting a young, universal primary prevention

audience with interventions at multiple levels. The study was designed to yield data that could help increase the capacity of schools to prevent DV/SH. We hypothesised that the interventions would reduce sexual harassment in all three groups that received any one of the three interventions compared to the control group. Further, we expected the three interventions would reduce the occurrence of dating and peer violence compared to the control group. These two overarching hypotheses applied to all the treatment conditions. Our final hypothesis was that creating a broader environmental intervention (the combined treatment of the classroom and building-level interventions) would be more effective in reducing sexual harassment and violence than the classroom intervention on its own.

Why use a randomised controlled trial?[4]

Based on their review of the dating violence and harassment prevention research, Cornelius and Resseguie (2006) noted that most evaluations had documented at least a short term positive change in knowledge and/or attitudes related to youth DV/SH prevention. However, many of these studies did not use randomised experiments or other rigorous designs. In recent years, new research has been conducted on the effectiveness of youth DV/SH prevention programmes (Jaycox et al, 2006; Foshee and Reyes, 2009; Wolfe et al, 2009; Taylor et al, 2010a, 2010b). However, these studies are few and generally address only eighth and/or ninth grade (age 14) or older students. As already noted, research indicates that adolescents may experience DV/SH and sexual harassment as early as sixth grade suggesting that prevention programmes should target students in middle school (McMaster et al, 2002; Schewe, 2002; Espelage and Holt, 2007; Wolitzky-Taylor et al, 2008). According to one sample of seventh grade students who indicated that they had begun dating, one third reported having committed acts of physical, sexual, or psychological aggression towards their dating partner (Sears et al, 2007). Finally, DV/SH during adolescence is a significant risk factor for young adult intimate partner violence (Gómez, 2010); as much as half of TDV may persist into adulthood (Halpern et al, 2009).

Rationale for randomised control trials

Among the flaws found in the prevention literature are studies with noncomparable comparison groups. Our team (Taylor et al, 2010a, 2010b) and others (Foshee et al, 1998; Wolfe, 2009) have conducted TDV randomised experiments, and there have been some quasi-experiments (QEs) with matched control groups. With QEs, the many unmeasured variables related to the outcome variable (for example, motivation to change) cannot be controlled. Our team has successfully implemented experimental designs (Taylor, 1997, 1998, 1999, 2001, Taylor et al, 2008, 2010c, 2011). We use a RCT design because it is generally considered the best method to ensure consistency across studies (Lipsey and Wilson, 1993), for eliminating threats to internal validity in evaluating programmes (Campbell, 1963, 1969; Riecken et al, 1974; Boruch et al, 1978; Berk et al, 1985; Dennis and Boruch, 1989; Weisburd, 2003, 2010), and for estimating the true effect of the intervention (Rubin, 1974; Holland, 1986). When RCT results are contrasted with results from other major designs and statistical alternatives, different effect sizes are found (Lalonde, 1986; Fraker and Maynard, 1987).

Challenges in conducting randomised experiments

Conducting RCTs is a challenging undertaking in several ways. Researchers must carefully examine the many forms of contamination that could emerge; for example, if the control group learns about the treatment from elsewhere. Other problems could be due to the interventionists (facilitators), uncontrollable environmental changes (for example, staff turnover) and differential rates of mobility/subject mortality by condition. It is critical to have a plan to measure and address contamination (Campbell, 1969; Riecken et al, 1974; Shadish et al, 2002). Among those elements are the following:

- **Assuring true randomness in the assignment process.** One must verify that the assignment of subjects is random. By assigning unique identification numbers to each individual, an audit trail is generated and compared to administrative records to ensure consistency.

- **Developing detailed descriptions on intervention/ treatment implementation and addressing contamination concerns**. Treatment implementation is multifaceted, including treatment delivery, receipt, and adherence (Lichstein et al, 1994). One must construct detailed descriptions of each of the assigned and received study conditions.
- **Testing for statistical differences between treatment and control on an empirically relevant third dimension**, for example, threats to internal validity, such as contamination.
- **Assessing the impact of environmental changes**, for example, a change in personnel at a participating centre or the occurrence of a high-profile local violent incident.

'Teen Dating Violence Intervention Project': New York City (2008–10)

Our New York City (NYC) classroom-based intervention synthesised the lessons from the two components from our earlier study in middle schools in the Greater Cleveland, Ohio area (2005–07): a set of lessons that emphasised personal interactions and a second separate set of lessons that focused on laws and consequences. We further refined the classroom and building-based interventions with significant input from the New York City Department of Education (NYC DOE) central office personnel. The lessons were implemented by trained school personnel known as SAPIS (Substance Abuse Prevention and Intervention Specialists), generally over a period of six to ten weeks. The six-session curriculum emphasised the consequences for perpetrators of DV/SH, state and federal laws related to DV/SH, the setting and communicating of boundaries in interpersonal relationships, and the role of bystanders as interveners. The key features of the classroom curriculum focused on the processes by which one determines and sets personal boundaries in relationships, and secondly to underscore that laws are also a notion of boundaries. Educators introduced the concept of boundaries in all of its manifestations (such as walls, country borders, rules, notions of privacy and personal space, etc) and taught about the implications and applications of relevant laws; lessons prompted the students to consider their interpersonal interactions and use of physical spaces within the school walls. Activities included exploring the concepts

of laws and boundaries, plotting the shifting nature of personal space, and considering implication and application of laws by gender and activities related to sexual harassment prevention. The lessons employed both concrete and applied materials as well as activities requiring abstract thinking.

Our building-level interventions were comprised of three separate activities: one, the introduction of temporary building-based restraining orders (termed a 'Respecting Boundaries Agreement' or RBA); two, the placement of posters about teen relationships in school buildings to increase awareness and reporting of DV/SH to school personnel; and three, mapping safe and unsafe areas of the school. Based on research by Astor et al (1999; 2001), this mapping component helps school personnel work with students to identify any unsafe areas of schools through 'hotspot mapping', a technique long used by criminologists and law enforcement to plot the location of crimes and more recently by researchers interested in school safety (Astor et al, 19992001, 2005; Astor and Meyer, 2001). The students used crude or actual blueprint maps of their school to indicate where they felt safe and unsafe. School leaders in turn used the information from these maps to plan for a greater presence of faculty or school security personnel in identified 'hot spots' or to alter the flow patterns in hallways and stairways. These building-based components all echoed the notion of personal boundaries and personal space, and so did the classroom curriculum, albeit through different mechanisms, not tied to delivery in the classroom by the teacher.

Results from the 'Teen Dating Violence Intervention Project'

Our research explored the effectiveness of a DV/SH prevention programme for sixth and seventh grade students in 30 middle schools. This sample size exceeds other published experiments on youth DV/SH (Foshee et al, 2000; Jaycox et al, 2006; Wolfe et al, 2009) allowing for a more powerful examination of treatment effects. Therefore even if fairly small statistical differences between the treatment and control groups were to emerge we would have a stronger probability of detecting those differences than earlier studies. We report on sexual harassment and sexual violence behavioural measures although violence outcomes are sometimes not even measured in TDV prevention studies (Nightingale and Morrissette,

1993; Rosen and Bezold, 1996) where the focus has often been on attitude/knowledge changes (Macgowan, 1997; Whitaker et al, 2006).

Sexual harassment, both in frequency of perpetration and victimisation was reduced overall by the building-level intervention. While reports of the *prevalence* of any experience of sexual harassment victimisation for students exposed to the building-level intervention increased at six months post-treatment, the *frequency* reported by students in the building-only intervention was lower, as were frequency reports from students in the combined classroom and building intervention. Further, when delivered in combination with the classroom intervention, the building intervention did not increase the reported prevalence of sexual harassment.

For sexually violent behaviour, the building-only treatment and the combined interventions were consistently effective in the reduction of sexual violence victimisation which involved either peers or dating partners at six months post-intervention. This was mirrored by reductions in sexual violence perpetration by peers for students in the building-only intervention. While the focus of the classroom intervention was on sexual harassment and dating partner violence, we believe that the building intervention (with its broader prevention elements and possible relocation of school personnel based on results from hotspot mapping) can be effective for addressing a variety of forms of sexual violence, even when combined with the classroom focus on sexual harassment and dating relationships. This phenomenon of diffusion of benefits from interventions has been documented in other aspects of criminal behaviour, such as hotspots policing of violent crime areas where areas near a treated area received similar benefits as the treated areas (Clarke and Weisburd, 1994). Also, this finding of reductions in sexual violence is important given the general scarcity of positive results in reducing sexual violence in adults (Lonsway et al, 2009).

In our research, we believed that a building-level intervention would make an important addition to 'Shifting Boundaries', and we had hypothesised that the combined approach would be more effective. Our data provides support for the value of this new building component both as a standalone intervention and implemented in combination with the classroom intervention. More specifically, our hypothesis that the broader environmental intervention (combined treatment) would be more successful in reducing DV/SH than

classroom alone was supported, in that the classroom intervention failed to achieve the programme goals on its own. The success of the combined treatment in comparison to the building-only condition was mixed. In one case (for the Dating Sexual Violence Victimisation Prevalence measure), building-only is better than the combined treatment, but in two cases (for the Peer Sexual Violence Victimisation Prevalence and Frequency measures.) the combined treatment was better than the building-only treatment. Thus, our initial inference that the classroom intervention paired with the building intervention could be effective was partially supported.

Classroom sessions can and might be effective, but based on our research in NYC they are more effective when done in combination with the building intervention. The building-only intervention included more material that focused on violence prevention more broadly; the classroom curriculum focused more particularly on dating violence. Perhaps adjusting school personnel for hotspots of violence can reduce peer violence as well as dating violence. These findings raise the question of whether we should be thinking of dating violence in the context of youth violence more broadly rather than addressing dating violence as an isolated problem. This approach has been taken by others with some success (Wolfe et al, 2009).

The building intervention alone has great potential. To date, most of the dating violence prevention efforts in schools have relied on classroom curricula, but after the results of our NYC study, we believe that there are other points for intervention. The accessibility of an effective building intervention requiring fewer resources in terms of teacher time, class time, and materials may be particularly appealing to school districts operating with constrained resources in the era of state and national requirements for student testing and teacher evaluation. Given the mixed findings regarding the relative effectiveness of the building intervention programme, schools (districts) might want to consider a scaled programme, such as initiating a building intervention and if resources allow working in the classroom component to complement the building-level approach. A gradual 'ramping up' from implementing just the building-only component and gradually introducing the classroom component may be the most realistic and feasible approaches for many middle schools.

Wider implications

To achieve a school that is gender-safe, we need to employ multiple, simultaneous strategies to ensure that sexual harassment and gender violence will be located and identified, and accurately named and prevented (Stein and Mennemeier, 2011). Gender violence in schools has been treated as a secret problem despite its public nature with witnesses and bystanders, many of whom are adults, and it has been repeatedly converted into terms and labels that are more palatable for the public. Instead, we must agree to locate gender violence and accurately name it, but not by merely proclaiming that we will have 'zero tolerance' for sexual harassment and gender violence. It is incumbent upon school personnel to notice behaviours, comment on them, intervene, and make corrections accordingly (Stein, 2001a, 2001, 2007).

Furthermore, when we frame the problems of sexual harassment and gender violence as manifestations of school violence, resolving these problems will be elevated and their solution will become integral to the creation of a safe school. Building an all-encompassing framework might also increase the receptivity of the school personnel to seriously pursue solutions to these problems, and it may serve to expand the discourse of violence prevention to one that includes matters of gender-based violence (Stein, 1995; Meyer and Stein, 2004; Brown et al, 2007).

Notes

[1] In our federally funded research projects since 2005, Taylor and I have defined 'dating' in the following manner for our students in the survey that we administer as part of this research project: 'Girls or boys you are going with, dating, going steady with, or have gone out with, dated, or gone steady with for at least one week. This group includes anyone who is or was your boyfriend/girlfriend for at least one week.'

[2] In keeping with randomised control trials: schools were assigned to one of four different treatments (three treatments and one control group); this was not a matter of choice, but rather of a scientific software package that randomly assigned the schools to one of these four treatments.

[3] 'School-wide' or 'building wide' means that these interventions did not take place in classrooms and were not dependent on a teacher. They were dispersed around the building, such as posters or mapping, for example.

[4] Discussions of randomised controlled trials are largely drawn from Taylor et al (2013) *Prevention Science*, 14: 64-76.

Acknowledgements

Sections of this chapter were previously published by Stein in coauthored articles with Taylor in: *Violence & Victims* (May 2010); *Prevention Science* (2013, 14: 64-76), and *Journal of Experimental Criminology* (2010). The author thanks her co-author in those previous publications, especially Dr Bruce Taylor.

In addition, Wellesley College student, Nari Savanorke-Joyce, assisted in organising the references, which was no small chore as we had to use a system that was completely alien to us.

References

AAUW (American Association of University Women) (1993) *Hostile hallways: Sexual harassment in school*, Washington DC: AAUW.

AAUW (2001) *Hostile hallways II: Bullying, teasing, and sexual harassment in school*, Washington, DC: AAUW.

AAUW) (2011) *Crossing the line: Sexual harassment at school*, Washington DC: Author.

Anderson, J. (2011) 'National study finds widespread sexual harassment of students in grades 7-12', *New York Times*, 10 November, p A10.

Astor, R.A. and Meyer, H.A. (2001) 'The conceptualization of violence-prone school subcontexts: Is the sum of the parts greater than the whole?', *Urban Education*, 36(3): 374-99.

Astor, R.A., Benbenishty, R., Marachi, R. and Meyer, H.A. (2005) 'The social context of schools: Monitoring and mapping student victimization in schools', in Jimerson, S.R. and Furlong, M.J. (eds), *Handbook of school violence and school safety: From research to practice*, Mahwah, NJ and London, UK: Lawrence Erlbaum Associates.

Astor, R.A., Meyer, H.A., and Behre, W.J. (1999) 'Unowned places and times: Maps and interviews about violence in high schools', *American Educational Research Journal*, 36(1): 3-42.

Astor, R.A., Meyer, H.A. and Pitner, R.O. (2001) 'Elementary and middle school students' perceptions of violence-prone school subcontexts', *Elementary School Journal*, 101: 511-28.

Berk, R.A., Boruch, R.F., Chambers, D.L., Rossi, P.H. and Witte A.D. (1985) 'Social policy experimentation – a position paper', *Evaluation Review*, 9(4): 387-429.

Blow, C.M. (2009) 'Love shouldn't hurt', *New York Times*, 12 February. Available at http://blow.bolgs.nytimes.com/.

Boruch, R.F., McSweeny, A.J. and Soderstrom, E.J. (1978) 'Randomized field experiments for program planning, development, and evaluation – an illustrative bibliography', *Evaluation Quarterly*, 2(4): 655-95.

Brown, L.M., Chesney-Lind, M. and Stein, N. (2007) 'Patriarch matters: Toward a gendered theory of teen violence and victimization', *Violence Against Women,* 13(12): 1249-73.

Campbell, D.T. (1969) 'Reforms as experiments', *American Psychologist*, 24(4): 409-29.

Campbell, D.T. and Stanley, J.S. (1963) *Experimental and quasi-experimental designs for research*, Boston: Houghton Mifflin.

CDC (Centers for Disease Control and Prevention) (2012) *Understanding teen dating violence*. 2012 Fact Sheet, Available www.cdc.gov/ViolencePrevention/pdf/TeenDatingViolence2012-a.pdf.

Clarke, R. and Weisburd, D. (1994) 'Diffusion of crime control benefits: Observations on the reverse of displacement', *Crime Prevention Studies,* 2: 165-84.

Cornelius, T. and Resseguie, N. (2006) 'Primary and secondary prevention programs for dating violence: A review of literature', *Aggression and Violent Behavior,* 12: 364-75.

DeGue, S., Valle, L.A., Holt, M.K., Massetti, G.M., Matjasko, J.L. and Tharp, A.T. (2014) 'A systematic review of primary prevention strategies for sexual violence perpetration', *Aggression and Violent Behavior,*19: 346-62.

Dennis, M.L., and Boruch, R.F. (1989) 'Randomized experiments for planning and testing projects in developing-countries – threshold conditions', *Evaluation Review*, 13(3): 292-309.

Espelage, D.L. and Holt, M.K. (2007) 'Dating violence and sexual harassment across the bully–victim continuum among middle and high school students', *Journal of Youth and Adolescence,* 36: 799-811.

Fineran, S. and Gruber, J.E. (2004) 'The impact of sexual harassment victimization on the mental and physical health and coping responses of 8th grade students', 8th Annual Conference for the Society for Social Work and Research, New Orleans, LA.

Foshee, V.A. (1996) 'Gender differences in adolescent dating abuse prevalence, types, and Injuries', *Health Education Research*, 11: 275-86.

Foshee, V.A. and Reyes, M.L. (2009) 'Primary prevention of adolescent dating abuse: When to begin, whom to target, and how to do it', in D. Whitaker and Lutzker, J. (eds), *Preventing Partner Violence*, American Psychological Association: Washington DC.

Foshee, V. A., Linder, G.F., Bauman, K.E., Langwick, S.A., Arriaga, X.B., Heath, J.L., et al (1996) 'The Safe Dates project: Theoretical basis, evaluation design, and selected baseline findings', *American Journal of Preventative Medicine*, 12: 39-47.

Foshee, V. A., Bauman, K. E., Arriaga, X.B., Helms, R.W., Koch, G.G. and Linder, G.F. (1998) 'An evaluation of Safe Dates, an adolescent dating violence prevention program', *American Journal of Public Health*, 88(1): 45-50.

Foshee, V.A., Bauman, K.E., Greens, W.F., Koch, G.G., Linder, G.F. and MacDougall, J. E. (2000) 'The Safe Dates program: 1-year follow-up results', *American Journal of Public Health*, 90: 1619-22.

Foshee, V.A., Bauman, K.E., Ennett, S.T., Linder, G.F., Benefield, T.S. and Suchindran, C. (2004a) 'Assessing the long-term effects of the Safe Dates Program and a booster in preventing and reducing adolescent dating violence victimization and perpetration', *American Journal of Public Health*, 90: 619-24.

Foshee, V.A., Benefield, T.S., Ennett, S.T., Bauman, K.E. and Suchindran, C. (2004b) 'Longitudinal predictors of serious physical and sexual dating violence victimization during adolescence', *Preventive Medicine*, 39: 1007-16.

Fraker, T. and Maynard, R. (1987) 'The adequacy of comparison group designs for evaluations of employment-related programs', *Journal of Human Resources*, 22(2): 194-227.

Gomez, A.M. (2010) 'Testing the cycle of violence hypothesis: Child abuse and adolescent dating violence as predictors of intimate partner violence in young adulthood', *Youth & Society*, 43(1): 171-92.

Gruber, J.E., and Fineran, S. (2008) 'Comparing the impact of bullying and sexual harassment victimization on the mental and physical health of adolescents', *Sex Roles*, 59(1-2): 1-13.

Halpern, C.T., Oslak, S.G., Young, M.L., Martin, S.L, and Kupper, L.L. (2001) 'Partner violence among adolescents in opposite-sex romantic relationships: Findings from the National Longitudinal Study of Adolescent Health', *American Journal of Public Health*, 91(10): 1679-85.

Halpern, C.T., Spriggs, A.L., Martin, S.L., and Kupper, L.L. (2009) 'Patterns of intimate partner violence victimization from adolescence to young adulthood in a nationally representative sample', *Journal of Adolescent Health,* 45: 508-16.

Halpern, C.T., Young, M.L., Waller, M.W., Martin, S.L. and Kupper, L.L. (2004) 'Prevalence of partner violence in same-sex romantic and sexual relationships in a national sample of adolescents', *Journal of Adolescent Health,* 35(2): 124-31.

Hickman, L.J., Jaycox, L.H. and Aranoff, J. (2004) 'Dating violence among adolescents: Prevalence, gender distribution, and prevention program effectiveness', *Trauma, Violence & Abuse,* 5: 123-42.

Holland, P.W. (1986) 'Statistics and Causal Inference', *Journal of the American Statistical Association,* 81(396): 945-60.

Howard, D.E., Wang, M.Q. and Yan, F. (2007a) 'Psychosocial factors associated with reports of physical dating violence among U.S. adolescent females', *Adolescence,* 42: 311-24.

Howard, D.E., Wang, M.Q. and Yan, F. (2007b) 'Prevalence and psychological correlates of forced sexual intercourse among U.S. high school adolescents', *Adolescence,* 42: 629-43.

Jackson, S.M., Cram, F. and Seymour, F.W. (2000) 'Violence and sexual coercion in high school students' dating relationships', *Journal of Family Violence,* 15: 23-36.

Jaycox, L.H., McCaffrey,D., Eiseman, E., Aronoff, J., Shelley, G.A., Collins, R.L., and Marshall, G.N. (2006) 'Impact of a school-based dating violence prevention program among Latino teens: randomized controlled effectiveness trial', *Journal of Adolescent Health,* 39: 694-704.

Jouriles, E.N., Platt, C. and McDonald, R. (2009) 'Violence in adolescent dating relationships', *The Prevention Researcher,* 16: 3–7.

Lalonde, R.J. (1986) 'Evaluating the econometric evaluations of training-programs with experimental data', *American Economic Review,* 76(4): 604-20.

Larkin, J. (1994) 'Walking through walls: The sexual harassment of high school girls', *Gender and Education,* 6(3): 263-80.

Lejeune, C., and Follette, V. (1994) 'Taking responsibility: sex differences in reporting dating violence', *Journal of Interpersonal Violence,* 9: 133-40.

Levesque, R.J.R. (1997) 'Dating violence, adolescents, and the law', *Virginia Journal of Social Policy & The Law,* 4: 339-79.

Lichstein, K.L., Riedel, B.W. and Grieve, R. (1994) 'Fair tests of clinical trials – a treatment implementation model', *Advances in Behaviour Research and Therapy*, 16(1): 1-29.

Lipsey, M.W. and Wilson, D.B. (1993) 'The efficacy of psychological, educational, and behavioral treatment – confirmation from meta-analysis', *American Psychologist*, 48(12): 1181-209.

Lonsway, K.A., Banyard, V. L., Berkowitz, A. D., Gidycz, C. A., Katz, J. T., Koss, M.P. and Ullman, S.E. (2009) Rape prevention and risk reduction: Review of the research literature for practitioners: *National Online Resource Center on Violence Against Women*. Available: http://new.vawnet.org/category/Main_Doc.php?docid=1655.

Macgowan, M.J. (1997) 'An evaluation of a dating violence prevention program for middle school students', *Violence and Victims*, 12: 223-35.

Makepeace, J.M. (1987) 'Social factor and victim-offender differences in courtship violence', *Family Relations*, 36: 87-91.

Malik, S., Sorenson, S.B. and Aneshensel, C.S. (1997) 'Community and dating violence among adolescents: Perpetration and victimization', *Journal of Adolescent Health*, 21: 291-302.

McMaster, L.E., Connolly, J., Pepler, D.J. and Craig, W. M. (2002) 'Peer to peer sexual harassment in early adolescence: A developmental perspective', *Child Development*, 67(5): 2417–33.

Merry, S.E. (2009) *Gender violence: A cultural perspective*, West Sussex, UK: Wiley-Blackwell.

Meyer, H. and Stein, N. (2004) 'Relationship violence prevention education in schools: What's working, what's getting in the way, and what are some future directions', *American Journal of Health Education*, 35(4): 198-204.

Molidor, C. and Tolman, R. (1998) 'Gender and contextual factors in adolescent dating violence', *Violence Against Women*, 4(2): 180-94.

Molidor, C., Tolman, R.M. and Kober, J. (2000) 'Gender and contextual factors in adolescent dating violence', *Prevention Research*, 7(1): 1-4.

Mulford, C. and Giordano, P.C. (2008) 'Teen dating violence: a closer look at adolescent romantic relationships', *NIJ (National Institute of Justice) Journal*, 261: 34-40.

Nightingale, H. and Morrissette, P. (1993) 'Dating violence: Attitudes, myths, and preventive programs', *Social Work in Education*, 15: 225-32.

O'Keefe, M. (1997) 'Predictors of dating violence among high school students', *Journal of Interpersonal Violence*, 12: 546-68.

O'Keefe, M. and Treister, L.T. (1998) 'Victims of dating violence among high school students: Are predictors different for males and females?' *Violence Against Women*, 4: 195-223.

O'Toole, L., Schiffman, J.R. and Edwards, M.L.K. (2007) *Gender Violence: Interdisciplinary Perspectives* (2nd edn), New York and London: New York University Press.

Pellegrini, A.D. (2001) 'A longitudinal study of heterosexual relationships, aggression, and sexual harassment during the transition from primary school through middle school', *Applied Developmental Psychology*, 22: 119-33.

Riecken, H.W. and Boruch, R.F. (1974) *Social experimentation: A method for planning and evaluating social programs*, New York: Academic Press.

Rosen, K. H. and Bezold, A. (1996) 'Dating violence prevention: A didactic support group for young women', *Journal of Counseling and Development,* 74: 521-25.

Rubin, D.B. (1974) 'Estimating causal effects of treatments in randomized and nonrandomized studies', *Journal of Educational Psychology*, 66(5): 688-701.

Schechter, S. (1982) *Women and male violence: The visions and struggles of the battered women's movement*, Boston, MA: South End Press.

Schewe, P.A. (2002) 'Preventing violence in relationships: Interventions across the life span'. In: P.A. Schewe (ed) *Guidelines for developing rape prevention and risk reduction interventions*, Washington, DC: American Psychological Association, pp 107-36.

Sears, H.A., Byers, E.S. and Price, E.L. (2007) 'The co-occurrence of adolescent boys' and girls' use of psychological, physically, and sexually abusive behaviors in their dating relationships', *Journal of Adolescence,* 30: 487-504.

Senate Resolution.362 (2012) A resolution designating the month of February 2012 as 'National teen dating violence awareness and prevention month', 12 January 2012, Session 112, United States Congress: Washington, DC.

Shadish, W.R., Cook, T.D. and Campbell, D.T. (2002) *Experimental and quasi experimental designs for generalized causal inference*, New York: Houghton Mifflin Company.

Silverman, J., Raj, A. and Clements, K. (2004) 'Dating violence and associated sexual risk and pregnancy among adolescent girls in the United States', *Pediatrics,* 114(2) 220-25.

Silverman, J., Raj, A., Mucci, L. and Hathaway, J. (2001) 'Dating violence against adolescent girls and associated substance abuse, unhealthy weight control, sexual risk behavior, pregnancy, and suicidality', *Journal of the American Medical Association*, 286(5): 572-79.

Sousa, C.A. (1999) 'Teen dating violence: The hidden epidemic', *Family and Conciliation Courts Review,* 37(3): 356-74.

Stein, N. (1992) 'School harassment – an update', *Education Week,* 2(9): 37.

Stein, N. (1993) *Secrets in public: Sexual harassment in public (and private) schools,* Working Paper #256, Wellesley, MA: Wellesley College Center for Research on Women.

Stein, N. (1995) 'Sexual harassment in K-12 Schools: The public performance of gendered violence', *The Harvard Educational Review, Special Issue: Violence and Youth,* 65(2): 145-62.

Stein, N. (1999) *Classrooms and courtrooms: Facing sexual harassment in K-12 schools.* New York: Teachers College Press.

Stein, N. (2001) 'Sexual harassment meets zero tolerance: Life in K-12 schools', in Ayers, W.. Dohrn, B. and Ayers, R. (eds) *Zero tolerance: Resisting the drive for punishment. A handbook for parents, students, educators, and citizens,* New York, NY: New Press, pp 143-54.

Stein, N. (2005) 'A rising pandemic of sexual violence in elementary and secondary schools: Locating a secret problem', *Duke Journal of Gender Law & Policy,* 12: 33-52.

Stein, N. (2007) *Gender violence: Interdisciplinary perspectives. Locating a secret problem: Sexual violence in elementary and secondary schools* (2nd edn), New York and London: New York University Press, pp 323-32.

Stein, N. and Mennemeier, K.A. (2011) *Sexual harassment overview: Concerns, new directions, and strategies. Invited paper, "The National Summit on Gender-Based Violence among Young People", April 6-7, 2011,* Washington, DC: US Department of Education, 1-28. Available www2.ed.gov/about/offices/list/osdfs/gbvreading.pdf.

Stein, N., Marshall, N. and Tropp, L. (1993) *Secrets in public: Sexual harassment in our schools: A report on the results of a Seventeen magazine survey,* Wellesley, MA: Wellesley College Center for Research on Women.

Taylor, B. (1997) 'A practitioner's brief', in B. Smith (ed) *An experiment on the effects of a joint police and social service response to elder abuse,* Washington, DC: Government Printing Office.

Taylor, B. (1998) *A randomized experiment on the effects of a joint police and social service response to elder abuse: Six and twelve month follow-up results,* Annual Conference of the Academy of Criminal Justice Sciences, 10-14 March, Albuquerque, NM.

Taylor, B. (1999) *The use of the ADAM program as an evaluation platform: The Sacramento domestic violence treatment experiment,* 3rd Annual Arrestee Drug Abuse Monitoring Program Conference, Chicago, IL.

Taylor, B., Davis, R.C. and Maxwell, C.D. (2001) 'The effects of a group batterer treatment program: A randomized experiment in Brooklyn', *Justice Quarterly,* 18(1): 171-201.

Taylor, B., Stein, N., Mack, A.R., Horwood, T. J. and Burden, F. (2008) *Experimental evaluation of gender violence/harassment prevention programs in middle schools,* Washington DC: National Institute of Justice.

Taylor, B., Stein, N.D. and Burden, F. (2010a) 'Exploring gender differences in dating violence/harassment prevention programming in middle schools: Results from a randomized experiment', *Journal of Experimental Criminology,* 6: 419-45.

Taylor, B., Stein, N.D. and Burden, F. (2010b) 'The effects of gender violence/harassment prevention programming in middle schools: A randomized experimental evaluation' *Violence and Victims,* 25(2): 202-23.

Taylor, B., Koper, C. and Woods, D. (2010c) 'A randomized control trial of different policing strategies at hot spots of violent crime', *Journal of Experimental Criminology,* 7(2): 149-81.

Taylor, B., Stein, N. D., Woods, D. and Mumford, E. (2011*) Shifting boundaries: Final report on an experimental evaluation of a youth dating violence prevention program in New York City Middle Schools,* Washington, DC: National Institute of Justice.

Taylor, B., Stein, N.D., Mumford, E. and Woods, D. (2013) 'Shifting boundaries: An experimental evaluation of a dating violence prevention program in middle schools', *Prevention Science,* 14: 64-76

Title IX of the Education Amendments of 1972, 20 U.S.C. § 1681, § 1687.

Title VII of the Civil Rights Act of 1964, as amended by the Equal Employment Opportunity Act of 1972 and the Civil Rights Act of 1991, 42 U.S.C. sec 2000e.

US Department of Education OCR (Office for Civil Rights) (2001) Revised sexual harassment guidance: Harassment of students by school employees, other students, or third parties, From the Office of the Assistant Secretary of Civil Rights, 19 January. Available at www2. ed.gov/about/offices/list/ocr/docs/shguide.html.

Watson, J. M., Cascardi, M., Avery-Leaf, S. and O'Leary, K.D. (2001) 'High school students' responses to dating aggression', *Violence and Victims*, 16: 339–48.

Weisburd, D. (2003) 'Ethical practice and evaluation of interventions in crime and justice: The moral imperative for randomized trials', *Evaluation Review*, 27(3): 336–54.

Weisburd, D. (2010) 'Justifying the use of non-experimental methods and disqualifying the use of randomized controlled trials: Challenging folklore in evaluation research in crime and justice', *Journal of Experimental Criminology*, 6(2): 209–27.

Whitaker, D.J., Morrison, S., Lindquist, C., Hawkins, S.R., O'Neil, J.A., Nesius, A.M. et al (2006) 'A critical review of interventions for the primary prevention of perpetration of partner violence', *Aggression and Violent Behavior*, 11(2): 151–66.

Wolfe, D.A., Crooks, C., Jaffe, P., Chiodo, D., Hughes, R., Ellis, W., et al (2009) 'A school-based program to prevent adolescent dating violence: a cluster randomized trial', *Archives of Pediatrics & Adolescent Medicine*, 163(8): 692–99.

Wolitzky-Taylor, M.A., Ruggiero, K.J., Danielson, C.K., Resnick, H.S., Hanson, R.F., Smith, D.W. et al (2008) 'Prevalence and correlates of dating violence in a national sample of adolescents', *Journal of the American Academy of Child and Adolescent Psychiatry*, 47: 755–62.

Concluding remarks

Ravi K. Thiara and Jane Ellis

As this collection has demonstrated, prevention work with young people through education has gained increased interest and currency amongst those seeking to prevent VAWG in both the short and long term. Starting with calls to develop educational work in the 1980s, a recognition of the harm caused by domestic violence and child sexual abuse to children and young people, as well as violence in their own intimate relationships, has led to intensified demands for prevention work. There is no doubt that practice has preceded policy in this area and despite the ongoing absence of a clear policy mandate, certainly in England, practitioners continue to carve out spaces for prevention work with children and young people in school and non-school settings. The motivations for this work inevitably differ and clearly shape both the kind of programmes that are developed and the ways in which they are implemented. Despite this variation, some commonalities are evident, including: a commitment to fostering healthy relationships and behaviours among young people; challenging violence and the harm it causes to not only women but also to children; engendering in children and young people the skills to resolve conflict through non-violent means; and building their confidence to seek help by equipping them with knowledge and information. Since schools provide access to almost all children and young people, they have been considered an important site for prevention work on VAWG. However, as noted by Crooks et al (2008), 'effective programs have achieved neither widespread nor sustained implementation' in schools' (p 111). Clearly the reasons for this are many, as discussed in the foregoing chapters in this volume. However, there is some learning from the prevention work that has been developed that needs to be borne in mind by anyone seeking to develop prevention work with young people.

As can be seen by the diverse prevention programmes that have been developed in the UK and elsewhere, a range of issues and dilemmas have been encountered. Together, the contributors' work highlights some key lessons for those embarking on their journeys. It is clearly evident that the ideological, conceptual and moral arguments underlying prevention work are complex and perhaps unresolvable. However, there is broad consensus about the need to carry out this work even if the motivations for it continue to differ. Contributors provide some varied and interesting examples of prevention work and there are many more existing models and programmes that have been developed in various geographical and professional settings, some of which are mentioned in the Appendix at the end of this book. For those contemplating such work, it is important not to reinvent the wheel but to consider what is already in existence in terms of available resources, how others have done this work and what lessons they have highlighted. The key message here is *talk to people and look at what the research says*. Indeed, this collection is aimed at providing such insights for those with an interest in developing and delivering prevention work in their professional settings, including in schools.

Schools can be cautious or resistant to work focused on addressing VAWG especially where this is framed through a feminist perspective. Having a clear rationale at the outset of *why* the work is being done, *how* and what achievements are sought – what it is that you are going to do that is going to make a change – is important. Equally important is the engagement of schools from the start. To this end, rather than simply presenting them with the programme, having a discussion with head teachers about the idea to get them on board at the beginning is crucial. Having someone to lead prevention initiatives who has knowledge and understanding of how schools and education systems work can achieve positive results. Ideally, prevention work requires partnerships between schools and voluntary sector specialist services where the former can influence school processes and culture and the latter bring knowledge and expertise in VAWG, especially in supporting children and young people who might disclose abuse. This is a way also of countering staff anxiety about disclosures and such partnerships can free staff from fears about feeling unskilled to do this on their own. Indeed, ensuring that a support system is in place for disclosures is a crucial starting point for any school or non-school based programme.

Given the complexity of prevention work, not least because gaining access to schools can be a challenge, starting small and building up, rather than being over ambitious at the start, is considered a good way forward. The reputation of the work, through word of mouth, can then assist to further widen the reach of a programme. In some places, prevention work has targeted schools with known high rates of domestic violence. If this is what is intended, careful thought is required as support for children and young people has to be in place from the outset.

Gender is generally regarded as key to prevention programmes, although not all programmes centralise gender or are viewed to be theoretically informed by an understanding of gendered power relations. However, there can be reluctance on the part of programme developers and/or schools to centralise gender. As contributors to this book have argued, a gendered understanding of VAWG is of great importance to prevention work as it shapes the approach, content, delivery methods, outcomes and evaluation of programmes. At the very least, there must be a conceptualisation of VAWG as a part of larger processes of gendered power relations and not as aberrant individual acts, and the reasons for why men/boys predominate among perpetrators also requires inclusion. An analysis of the power embedded in gendered relations, even within programmes that might be badged as 'Healthy Relationships', is also important. To frame VAWG as an individual problem misses important opportunities to critically examine these processes with children and young people. One of the dilemmas presented is how this can be done in ways that does not alienate boys and recognises that they can be victims too in terms of their exposure. To address this dilemma, a 'gender strategic' approach has been advocated in the US, as already highlighted in this volume, to overcome resistance or gain entry into schools.

It has been argued that to engage in prevention work in any meaningful sustainable way requires a whole school approach, which incorporates longer programmes rather than shorter instructional ones. A whole school approach reflects the idea that VAWG is reflected in gendered power relations in society and that the school space itself, as a microcosm of society, needs to reflect the challenge to VAWG. This approach not only targets children and young people but seeks to transform the entire school environment, including staff. It follows then that if ideologies, institutions, attitudes and behaviours

underpinning VAWG are to be challenged, a whole school approach is necessary in order to effectively tackle VAWG.

The transformation of unequal relationships, and the attitudes and behaviours that underpin these, is at the heart of prevention work. While it is important to include elements that examine equality and diversity issues, even where diverse social groups may not be part of the local population, this has to be socioculturally relevant without negatively labelling communities and reproducing existing stereotypes. However, it is also important to shape the work to the local population and context to make it more meaningful, as highlighted by contributors to this book.

There is some debate about the gender of groups and whether prevention work should be conducted in single and/or mixed groups. Being responsive to particular groups in a particular context is important here and it may be that separate activities in some classes can be accompanied by some mixed activities. Another key debate in the research and practice is over whether teachers or external staff should facilitate the work, and both models are discussed in the book. There are pros and cons to both approaches and, whilst there is no agreement, the crucial thing is that facilitators are skilled enough to manage any group dynamic and be flexible, which requires them to have undertaken training in not only the content of VAWG but also in group skills. There is a further debate about the gender of facilitators as some research shows that boys value male facilitators. However, it might be that mixed gender facilitator teams, where possible, can reflect positive gender equality messages. Skilled facilitators who relate positively to children and young people, and who use them as their starting point, are a way of practising the message in child–adult relationships and are essential for the success of prevention work. Such facilitators with insight into the operations of power and especially gendered power relations can also create space for great learning. As has been shown by many of the contributors, children and young people are extremely positive about participative methods that are creative, and that engage and empower them. Clearly, following the much-heard phrase 'the process is as important as the content', interactive and experiential methods, though often expensive, can be extremely effective and wherever possible should be incorporated within any prevention programmes.

Given the numerous pressures placed on schools to be a panacea for a range of societal issues, it is unsurprising that there can be reluctance among schools to engage in prevention programmes. As has been suggested by contributions to this book, a way to overcome resistance and counteract the lack of a clear mandate for schools is to link up with schools' agendas and make connections between VAWG prevention and other aspects of work required of schools, such as safeguarding, and bullying and drug abuse prevention, so that it is integrated into the curriculum. If developing work across age groups, it might be better to start with younger children and adapt content for older ones so that continuity and progression are built in. This also enables different content to be used with the different age groups – for example, it might be desirable to talk to older children about rape but not to five year olds. Prevention work is most often delivered through Personal, Social, Health and Economic (PSHE) education, and this volume provides some good examples of how this can be used to embed prevention work in schools. As is evident, it is important for there to be flexibility in the content of prevention programmes so it can be adapted and adopted in different schools rather than having a 'one model fits all' approach.

From the early days in the UK when prevention programmes focused mostly on domestic violence, there has been a shift towards incorporating other forms of VAWG in prevention work, as shown by contributors to this book, and for this work to take place not only in schools but also in non-school settings. Rather than looking at forms of violence as separate and disconnected, the importance of focusing on the intersection of various forms of VAWG has been shown to be crucial. Thus, a focus on VAWG, rather than just domestic violence, is important in prevention programmes given the multiple and overlapping forms of violence in young people's lives.

School-based prevention work that is developed within a multiagency context, though not entirely unproblematic, has the potential for creating a wider support base and can lead to greater sustainability. Linking it to the wider VAWG multiagency context also ensures that prevention work is linked to work targeted at adults so that the sole responsibility for social change is not just placed on children and young people but also focused on adults. However, it is important at the outset to have a common understanding of VAWG, its causes/underpinning explanation, the aims of the prevention

programme, and the desired impact and how it is to be achieved. It has been shown that having a dedicated post to coordinate local developments is crucial to expanding and sustaining prevention work. The ways in which children and young people are constructed within programmes and how their participation is sought requires thought and discussion among those seeking to develop prevention work. Research and practice show that prevention work has to be appropriate, meaningful and take cognisance of children's agency and subjectivity.

Evaluating the impact of prevention work on children and young people's behaviour is underdeveloped. Where done, evaluations are based on pre- and post-evaluations of attitudes and knowledge and most report positive changes in this regard. Without the required evidence base, it is not yet possible to categorically know if prevention work impacts on perpetration or victimisation. It is thought that longer programmes – time and sessions – are more likely to result in changes in behaviour. As has been highlighted repeatedly throughout the volume, evaluations of VAWG prevention in the UK are scant although the North American literature has more to offer in this regard. This lack of an acceptable evidence base can impact on funding for prevention work though there are important qualitative based evaluations in existence which can be drawn on. While funding for longitudinal evaluations remains absent, it is important at the very least to build short-term proxy measures into any programme, such as changes in attitudes, greater awareness of existing services, and greater knowledge and understanding of the issue, in order to identify some level of impact on children and young people.

To disrupt the view of prevention work on VAWG as a 'scary subject' which creates anxieties among schools and many staff, some of the contributions to this book suggest how this work can generate a creative space for staff and students alike. However, while challenging VAWG through education is not new, it is complex. Contributors to this book provide a road map, through numerous examples, for the development and delivery of prevention programmes in schools and in non-school settings. It needs to be said that the goal of transforming gendered power relations cannot be a task only for schools. Neither can the responsibility for ending VAWG be that of children and young people alone. Prevention work through education can certainly build

Appendix: Examples of programmes in the UK

There are a considerable number of resources available to those wanting to work with children and young people about violence against women and girls. Below is a short list of some of the most well-known programmes and resources in the UK, five of which are discussed in this book. Our aim in including them here is to provide introductory information to readers and not an endorsement of them.

Cheshire East/Cheshire West and Chester

A range of resources for children and young people aged 5–18.

Contact Cheshire East Domestic Abuse Partnership (CEDAP, website: www.cheshireeast.gov.uk/social_care_and_health/domestic_abuse. aspx) and/or Cheshire West and Chester Domestic Abuse Partnership (CWACDAP, website: www.cheshirewestandchester.gov.uk/residents/ crime_prevention_and_emergenci/domestic_abuse/domestic_abuse_ partnership.aspx).

CRUSH

West Mercia Women's Aid

An awareness-raising and support programme to help young people make safe and healthy relationships. The sessions are run in small groups and are specifically designed for 13–19 year olds.

Website: www.westmerciawomensaid.org/crush

Expect Respect

Women's Aid

The Expect Respect Educational Toolkit consists of one easy-to-use 'core' lesson for each year group from Reception to Year 13 and is based on themes that have been found to be effective in tackling domestic abuse.

Website: www.thehideout.org.uk/over10/adults/resources/educationaltoolkit/default.aspa

The GREAT Project

Equation

The GREAT Project enables primary school children to gain knowledge about healthy relationships, to explore what domestic abuse is and to know where to go for help and support. It is delivered to children in Years 5 and 6 by facilitators trained by Equation.

Website: www.thegreatproject.org.uk

Helping Hands

Women's Aid Federation Northern Ireland

Helping Hands is a preventative education programme, developed by Women's Aid Federation Northern Ireland, in partnership with the Department of Education (NI), for primary school children at key stages 1 and 2. The programme aims to increase children's understanding of feeling safe and to explore and promote behaviours which will contribute to a safe environment.

Website: www.womensaidni.org/about-us/our-work/preventative-education/working-with-children-in-primary-schools

Learning to Respect

Hounslow Domestic Violence Education Programme

Learning to Respect is a domestic violence education initiative for Hounslow schools and other settings. The aim of the programme is to educate all young people in Hounslow about safe nonabusive relationships. The programme has a multiagency team of facilitators drawn from statutory and voluntary agencies in the borough. The facilitators deliver training to staff who then deliver to young people.

Website: Hounslow Knowledge Hub (registration with Hounslow needed to gain access):

www.hounslowservicesforschools.co.uk/knowledge-hub/content/early-intervention-service-eis/learn-respect or contact the Learning to Respect Domestic Violence Education Programme Co-ordinator, Early Intervention Service Hounslow 020 8583 2424

Mentors in Prevention (MVP) Scotland

Violence Reduction Unit

A bystander approach which aims to empower students in high schools to take an active role in promoting a positive school climate. It is designed to train students to speak out against rape, dating violence, sexual harassment, bullying and all forms of violent and abusive behaviour.

Website: www.actiononviolence.co.uk/content/mvp-scotland

MsUnderstood

The MsUnderstood partnership between the University of Bedfordshire, Imkaan, and the Girls against Gangs project aims to improve local and national responses to young people's experiences of gender inequality.

Website: www.msunderstood.org.uk

RESPECT Education Resource

Zero Tolerance

The **RESPECT** programme has been developed for both primary and secondary schools in Scotland. Through a series of activities the programme seeks to develop the discussion with children and young people about the links between violence against women and wider gender equality issues.

Website: zerotolerance.org.uk/respect

Southall Black Sisters (SBS)

The SBS schools project aims to create long-term attitudinal and behavioural change among young people through challenging social, religious and cultural values and practices which justify violence against black and minority ethnic women and girls. The project is focused in London.

Website: www.southallblacksisters.org.uk

The Star Project

Southampton Rape Crisis

The Star Project is an award winning, innovative education and outreach programme working with young people (aged 10 upwards) on a wide range of sex and relationship issues with a particular focus on sexual violence prevention.

Website: www.southamptonrapecrisis.com/star_project.html

Tender

Tender offers workshops and projects to suit the individual needs of schools and youth centres. They work in mainstream schools, special schools, pupil referral units and youth centres. The work is designed to empower young people to take responsible choices and to think about relationships in a mature and safety-conscious way.

Website: www.tender.org.uk

Index

Note: The following abbreviations have been used – *f* = figure; *n* = note; *t* = table